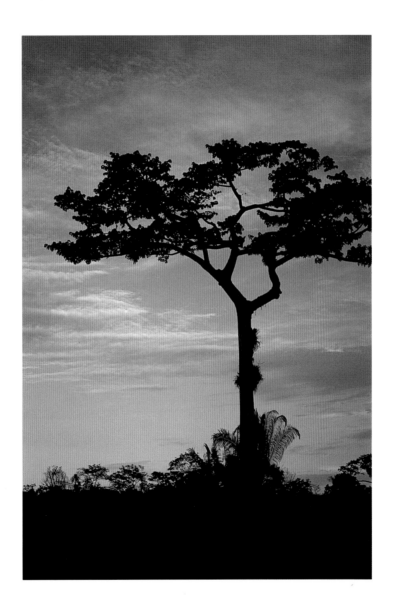

before there was a world,

a solitary deified tree

 was at the center of all that was

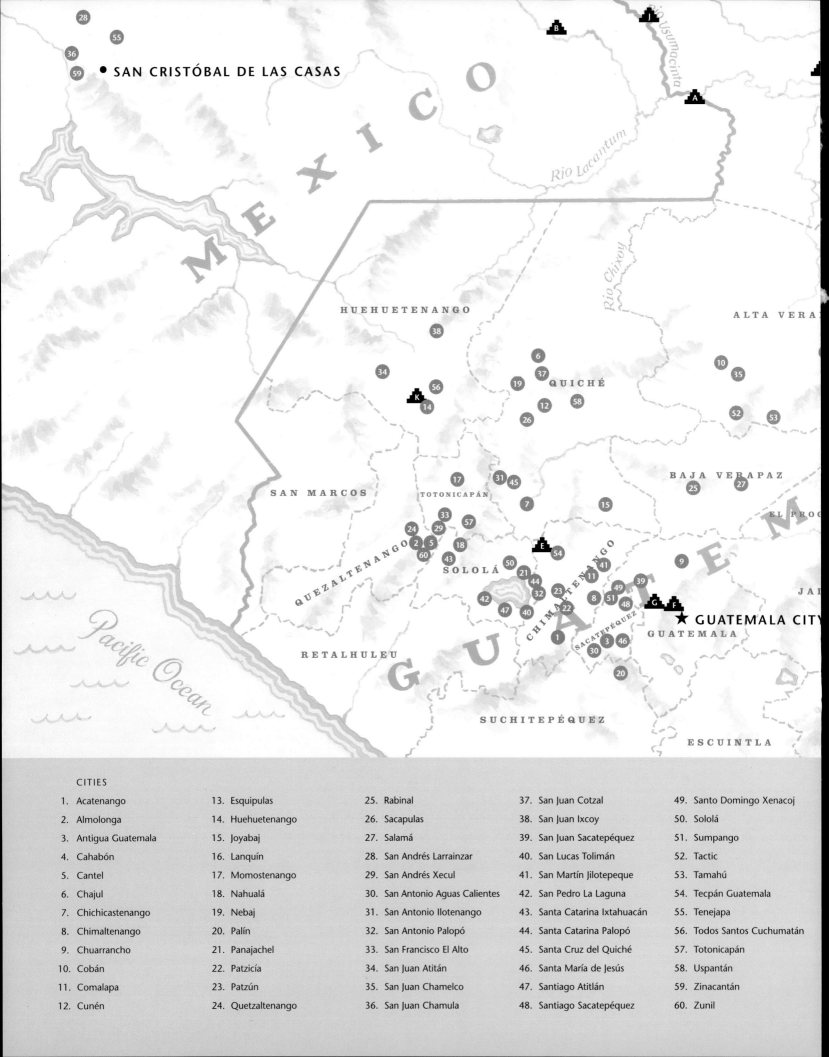

SAN CRISTÓBAL DE LAS CASAS

MEXICO

Río Usumacinta

Río Lacantum

Río Chixoy

HUEHUETENANGO

ALTA VERA

QUICHÉ

BAJA VERAPAZ

EL PRO

SAN MARCOS

TOTONICAPÁN

QUEZALTENANGO

SOLOLÁ

CHIMALTENANGO

GUATEMA

JA

SACATEPÉQUEZ

GUATEMALA

★ GUATEMALA CITY

RETALHULEU

Pacific Ocean

SUCHITEPÉQUEZ

ESCUINTLA

CITIES

1. Acatenango
2. Almolonga
3. Antigua Guatemala
4. Cahabón
5. Cantel
6. Chajul
7. Chichicastenango
8. Chimaltenango
9. Chuarrancho
10. Cobán
11. Comalapa
12. Cunén

13. Esquipulas
14. Huehuetenango
15. Joyabaj
16. Lanquín
17. Momostenango
18. Nahualá
19. Nebaj
20. Palín
21. Panajachel
22. Patzicía
23. Patzún
24. Quetzaltenango

25. Rabinal
26. Sacapulas
27. Salamá
28. San Andrés Larrainzar
29. San Andrés Xecul
30. San Antonio Aguas Calientes
31. San Antonio Ilotenango
32. San Antonio Palopó
33. San Francisco El Alto
34. San Juan Atitán
35. San Juan Chamelco
36. San Juan Chamula

37. San Juan Cotzal
38. San Juan Ixcoy
39. San Juan Sacatepéquez
40. San Lucas Tolimán
41. San Martín Jilotepeque
42. San Pedro La Laguna
43. Santa Catarina Ixtahuacán
44. Santa Catarina Palopó
45. Santa Cruz del Quiché
46. Santa María de Jesús
47. Santiago Atitlán
48. Santiago Sacatepéquez

49. Santo Domingo Xenacoj
50. Sololá
51. Sumpango
52. Tactic
53. Tamahú
54. Tecpán Guatemala
55. Tenejapa
56. Todos Santos Cuchumatán
57. Totonicapán
58. Uspantán
59. Zinacantán
60. Zunil

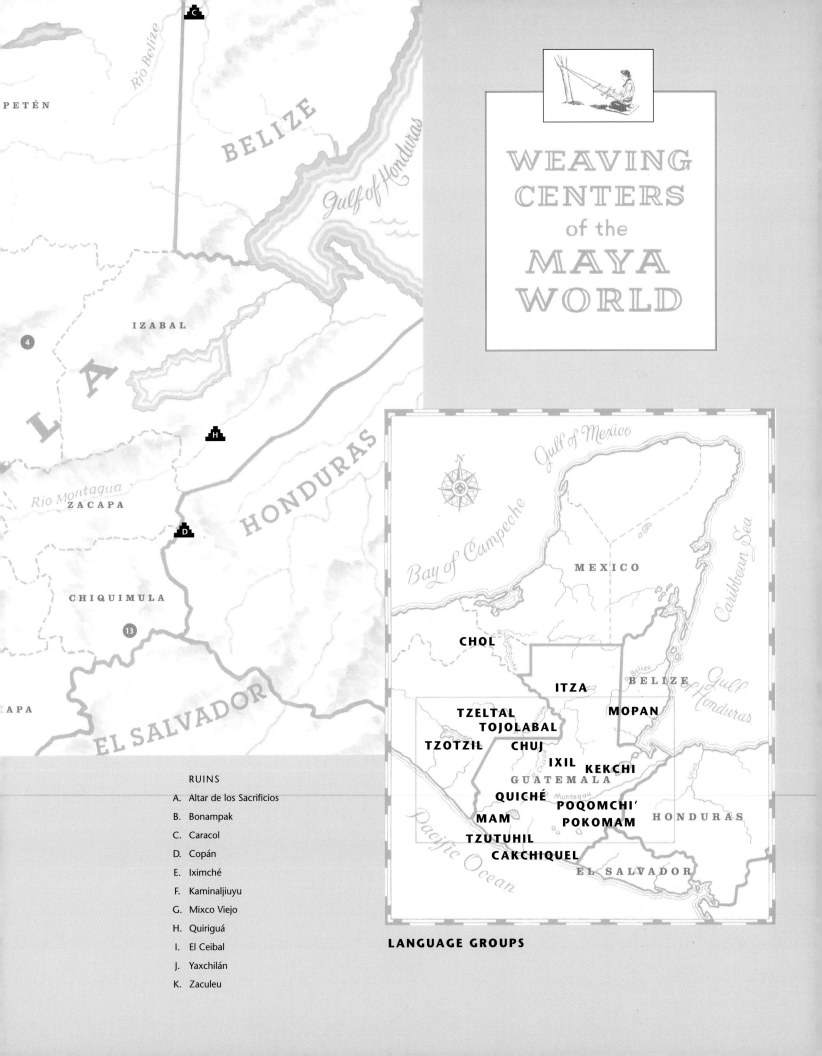

WEAVING CENTERS of the MAYA WORLD

PETÉN

BELIZE

Rio Belize

Gulf of Honduras

4

IZABAL

LA

Rio Montagua

ZACAPA

HONDURAS

CHIQUIMULA

13

EL SALVADOR

APA

RUINS

A. Altar de los Sacrificios

B. Bonampak

C. Caracol

D. Copán

E. Iximché

F. Kaminaljiuyu

G. Mixco Viejo

H. Quiriguá

I. El Ceibal

J. Yaxchilán

K. Zaculeu

LANGUAGE GROUPS

Gulf of Mexico

N

Bay of Campeche

MEXICO

Caribbean Sea

CHOL

ITZA

BELIZE

Gulf of Honduras

TZELTAL

MOPAN

TOJOLABAL

TZOTZIL

CHUJ

IXIL

KEKCHI

GUATEMALA

QUICHÉ

POQOMCHI'

MAM

POKOMAM

HONDURAS

TZUTUHIL

CAKCHIQUEL

Pacific Ocean

EL SALVADOR

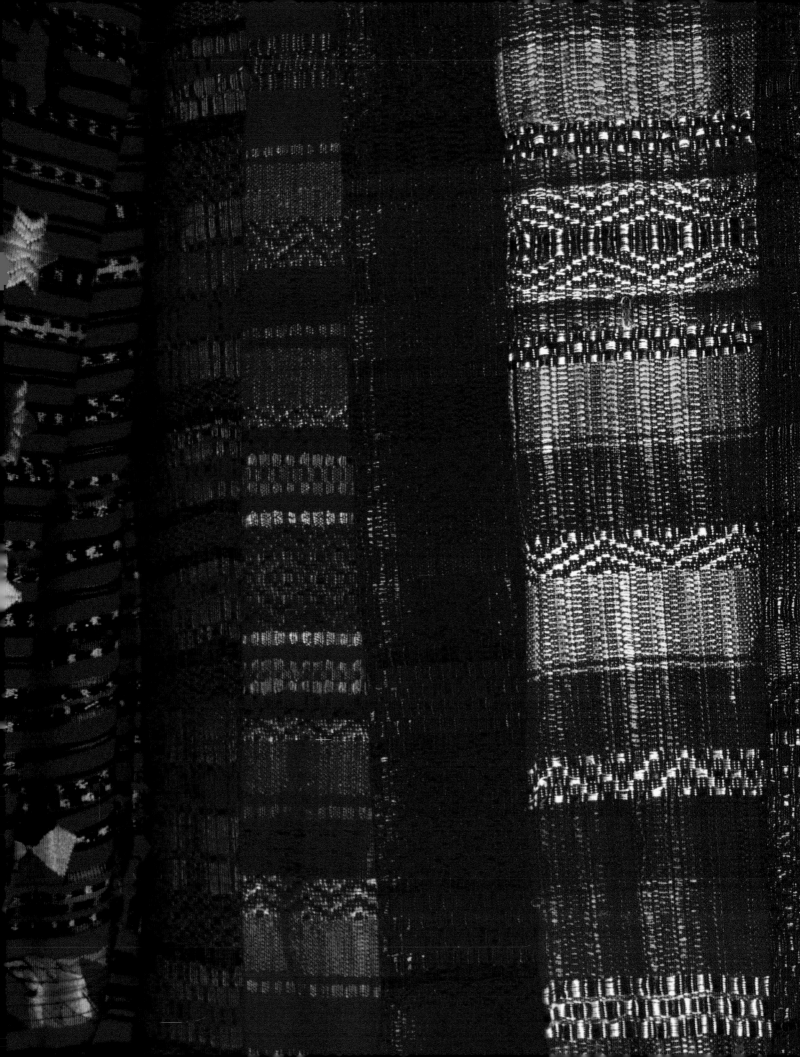

The Maya Textile Tradition

Photographs by Jeffrey Jay Foxx

Edited by Margot Blum Schevill
with the assistance of Linda Asturias de Barrios

Foreword by Linda Schele

Texts by
Linda Asturias de Barrios
Robert S. Carlsen
James D. Nations
Margot Blum Schevill

Harry N. Abrams, Inc., Publishers

Special thanks to the Museo Ixchel del Traje Indígena of Guatemala City for its gracious participation

Project Manager: Beverly Fazio Herter
Designer: Judith Hudson

Page 1: Ceiba tree, Belize

Page 4: Textiles on sale at the Guarkas textile shop in Sololá, Guatemala

Page 7: Shadows of clouds are projected onto the surface of Lake Atitlán, as seen from the overlook near San Andrés Semetabaj, Guatemala

Page 8: Paya, a ceremonial veil, embroidered with plain satin stitch. Collection of the Museo Ixchel (02666). c. 1950. Location: Samayac, Suchitepéquez. Linguistic group: Quiché. Guatemala

Page 11: The Universe design is brocaded into the *huipiles* of the women of San Andrés Larrainzar. The four cardinal directions with west at the top are symbolized in the diamond shape; supplementary weft brocade; Collection of Sna Jolobil Weavers' Cooperative. c. 1970. Linguistic group: Tzotzil. Chiapas, Mexico

Page 12: Fossils show the jagged mountains of Chiapas which were once the floor of an ancient sea.

Additional photography by Christiana Dittman, pages 44 and 100.

Library of Congress Cataloging-in-Publication Data
The Maya textile tradition / photographs by Jeffrey Jay Foxx ; edited by Margot Blum Schevill ; foreword by Linda Schele ; texts by Linda Asturias de Barrios, Robert S. Carlsen, James D. Nations, Margot Blum Schevill.
 p. cm.
Includes bibliographical references.
ISBN 0—8109—4291—7 (clothbound)
1. Maya textile fabrics. 2. Mayas—Costume. 3. Mayas—Social life and customs. I. Schevill, Margot.
F1435.3.T48M39 1997
746'.089'974—dc20 96—30451

Published in 1997 by Harry N. Abrams, Incorporated, New York
A Times Mirror Company

Printed and bound in Japan

Contents

LINDA SCHELE

Foreword

Creation and the actions of the gods in making the world we know has been at the heart of the Maya religion and thought for 2,500 years. While the most famous version of the story occurs in the *Popol Vuh* or *Community Book* of the K'iche' Maya of the Guatemala highlands, ancient scribes recorded its most detailed Pre-Columbian version in the inscriptions of the Group of the Cross at Palenque and on Stela C at Quirigua.

The divine protagonists of the ancient story, the Maize God and his cohorts, planted three stones in the stars of Orion to create the cosmic hearth on the night of the Fourth Creation, August 13, 3114 B.C. Exactly 542 days later, on February 5, 3112 B.C., the Maize God laid out the four sides and four corners of the cosmos; in the center he erected the World Tree. With the space of the Cosmos organized, the Maize God then generated time by setting the stars, the planets, and the Milky Way into motion.

The glyph recording this final action represents a disk with a small circle inside. Nikolai Grube recognized it as a depiction of a flat spindle whorl, called *pet* or *petet* in many Maya languages. The glyphic verb reads *pethi*, "to make round motion," as when a weaver spins her spindle in making thread. Thus, like a weaver the gods spun the sky, and they drew out time like the thread that the weaver weaves into cloth. The patterns built into that fabric by the divine weavers provide the patterns that human beings use to perceive the passage of time and the sacred symmetries of both time and space.

This relationship of the spindle and weaving to time continued past the European invasion and remained a principal metaphor for time and its repeated cycles, even though most books on the Maya today explain their calendar by using a metaphor of interlocking gears drawn from the machinery of the industrial revolution. Daniel Brinton, one of the first scholars to translate many of these Maya chronicles, gave us a different and more appropriate metaphor. He pointed out that the scribes who recorded the Books of the Chilam Balam used the term *u pet k'atun* or *u peten k'atun* to describe the cycle of the thirteen *k'atuns* (*The Maya Chronicles*, Brinton's Library of Aboriginal Literature. Philadelphia: 1882; reprinted 1969, AMS Press, New

York). This cycle provided the temporal framework for the *k'atun* histories recorded in these books and provided Brinton and other early scholars with the idea of a "round." The two terms for "round" that Brinton recovered from these sources were *met*, "a rope or cane circle used as a stand for pots," and *pet*, "spindle whirl." Thus, the turning of the weaver's spindle provided the metaphor for the motion of the stars begun by the gods at the beginning of the Fourth Creation, and the cycles that unfolded as the Cosmic Spindle turned on its axis created motion and time itself.

The centrality of the weaver's art played other essential roles in the Maya conception of the cosmic order. The grandmother of the Classic-period Hero Twins, who was the midwife of Creation, carried the name Chak-Chel, or "Great Rainbow," in the Dresden Codex and that of Na Huntan, "Mother Caretaker," at Palenque. Her portraits in the codices show her wearing skeins of yarn in her hair. Both she and her daughter-in-law Sak Ixik, the Moon Goddess mother to the Hero Twins, were weavers. In fact, the principal term for "to weave" in Yucatec was *sakal*, a word related to the young Moon Goddess's name. In Cholan, the other language of the inscriptions, *hal* was the word for "to weave." It was homophonous for "to speak" and "true."

The central role of weaving to the worldview and the economic life of the Maya has not changed in the five hundred years since the invasion of the Europeans. Weaving, especially in Chiapas and the highlands of Guatemala, remains more than craft. It still serves as an instrument of ethnic identity and, during the last sev-

eral decades, has become a major source of income to the Maya communities. Women still wear their blouses and skirts — *huipiles* and *pik* in Yucatec and Cholan, *pot* and *uq* in K'iche' — to identify themselves as Maya.

The weavings worn by Maya women and men and used by both in the rituals that give meaning to their lives are more than pretty patterns to attract the eyes of tourists. As with their ancestors millennia before them, the patterns they incorporate into their weavings encompass creation and the forces of nature. Maya people center themselves in the cosmos and creation by the cloth they weave and the clothes they wear, just as the gods of the ancient Maya story of creation spun out the yarn of time and space to weave the patterns and orders that human beings perceive in the fabric of the Cosmos. This book offers special insight into the nature of those patterns and perceptions as it is encoded into the cloth of weavers who still ply their craft today.

JAMES D. NATIONS

History and Ecology
of the Maya World

THE NEW LAND'S FORM

Legend has it that when the Spanish conquistador Hernán Cortés first returned to Spain from the New World in the early sixteenth century, the king asked him what this new land looked like. Cortés reached for a sheet of parchment, crumpled it into a ball, then partially smoothed it out on the table before him. Pointing to the convoluted ridges and folds of the paper, he said, "This is the new land's form."

But Cortés already knew that there was more to this region of the world than crumpled mountains and steep river valleys. He had also encountered wild expanses of tropical rain forest, wetland savannas, and short, dry scrub forest, growing on the flat, lime-stone shelf of the Yucatán Peninsula. In 1525, Cortés had set out from the Valley of Mexico toward the Caribbean coastal settlement of Nito, near the mouth of the Río Dulce in modern-day Guatemala. The captain Cortés had sent to conquer that region had rebelled with all his ships and soldiers, and Cortés was determined to punish the man in person.

Cortés left Mexico City with 400 Spanish infantry and cavalry and 3,500 Indian warriors from the Valley of Mexico. Traveling southeast, he entered the land of the Maya in present-day Tabasco. His army spent week after week cutting their way through immense, flat stretches of tropical forest, suffering "hunger, bruises, illnesses, hard roads, worse lodgings, and other insup-portable trials," according to the Spanish chronicler Juan de Villagutiérrez.[1]

As Cortés traveled this route through the land of the Maya, he encountered small settlements and the island city of Tayasal, where thousands of Itzá Maya still worshiped a pantheon of ancient gods in giant stone temples. Hacking a pathway through the forest, Cortés had also stumbled over the ruins of ancient Maya cities, most of which by the time of his adven-ture had already been abandoned for more than six centuries. These ruins were the stone remnants of the Classic Maya civilization, which flourished in south-eastern Mexico and northern Central America for almost a thousand years. When their civilization disin-

tegrated around A.D. 900, the Classic Maya left behind a legacy of mythology, technology, and ecology that was still very much alive in the time of Cortés's travels and that, today, continues to echo down the canyons of a dozen centuries of New World history.

Given the impact it has carved on New World history and on the careers of hundreds of explorers, archaeologists, and photographers, the Maya region is surprisingly small. About half the size of Texas, the Maya world covers all of Guatemala and Belize, western Honduras and El Salvador, and the Mexican states of Yucatán, Campeche, Quintana Roo, Tabasco, and Chiapas.

Long before the Maya came to occupy the region, geology had divided it into highlands and lowlands. Photographs taken from NASA's space shuttles as they pass over Guatemala show a long chain of volcanic mountains streaming westward along the Pacific Ocean into Chiapas and eastward into El Salvador and Honduras. Here and there, a few of these highland volcanoes belch smoke and ash and spew red, iridescent lava down slopes blanketed with pine and oak forests.

In the scores of river valleys that lie north of this long chain of volcanoes, the modern Maya live in dispersed villages surrounded by forests of pine, oak, laurel, and madrone. Wheat and cabbages — crops introduced by the conquering Spaniards — grow on hillsides with the corn, squashes, and beans that the Maya have depended on for millennia. Sheep and cows, also brought to the New World by Spaniards, graze in small clearings while young women dressed in colorful *huipiles* weave on backstrap looms in the shelter of nearby trees.

In the volcanic highlands, much of Maya history seems to be still alive. The Sunday markets of Chichi-castenango, Antigua, and San Cristóbal de las Casas are kaleidoscope theaters of colored textiles, exotic vegetables, and burning incense. Weekend excursions will take you to centuries-old highland Maya cities — Iximché and Mixco Viejo — where French and Italian tourists sort through Maya weaving at handicraft stalls and black-haired boys with Maya features chase soccer balls between the mounds.

In the lowlands of the Selva Lacandona, Peten, Belize, and Yucatán, the traveler must search for history in the dense vegetation. Here, the tropical forest that Cortés struggled across has long since reclaimed the stone cities of Bonampak, Caracol, Altun Ha, and El Mirador.

Immediately south of the volcanic chain lies a thin edge of coastal lowlands that slope into the Pacific Ocean. During the time of the ancient Maya, and later during the centuries of Spanish occupation, this fertile Pacific coast was the source of great agricultural wealth. Some of the earliest Maya sites appear along this thin edge of prime land between the mountains and the sea, and its easy riches of cacao — and later sugar cane and coffee — have made it prized territory for millennia.

Looking north toward the Gulf of Mexico and the Caribbean, the space shuttle photographs show the Maya highlands of Mexico and Central America fading gradually into the flat Yucatán Peninsula, which juts like a swollen thumb into the Caribbean Sea. Yucatán is an ancient limestone shelf left suspended between gulf and sea by geological upheaval and eons of lowered ocean levels.

The Maya lowlands are, in turn, divided into two regions — southern and northern. The southern lowlands include the low-lying wetlands and savannas of

the Mexican state of Tabasco, the Selva Lacandona of eastern Chiapas, the Guatemalan Peten and nearby Lake Izabal, and the Republic of Belize – the last despite the sudden appearance of an echo of highland mountains in southern Belize called, appropriately, the Maya Mountains. The ancient Maya cities of the southern Maya lowlands range from Copán, Honduras, in the east to the sites of Yaxchilán, Palenque, and Toniná, Chiapas, in the west.

The original vegetation of the southern Maya lowlands was a mixture of moist tropical forest, tropical savanna, and wetlands called *bajos*, dominated by vines, lianas, bromeliads, and logwood. During the past thirty years, much of this vegetation has fallen victim to loggers, settlers' axes, and the giant fires of would-be cattle ranchers.

The northern Maya lowlands of the Yucatán Peninsula encompass the dry, flat Mexican states of Campeche, Yucatán, and Quintana Roo. Moving northward from the foothills of the Maya highlands across the landscape of the Yucatán Peninsula, the land becomes flatter and the forest drier, until the peninsula, covered with thorny scrub brush and dotted with sinkholes called cenotes, disappears into the sea.

THE RISE OF MAYA CIVILIZATION
While the land itself divides the Maya region into highlands and lowlands, it was left to the archaeologists and historians to divide human time into five periods of Maya history: the Pre-Classic (1500 B.C.–A.D. 200), Classic (A.D. 200–900), Post-Classic (A.D. 900–1521), Colonial (1521–1821), and Modern (1821–present).

Sometime after 5000 B.C., groups in the Maya region began to turn from hunting and gathering to a more settled life in village communities, supported by agriculture that included maize (corn), squash, avocados, peppers, and beans. The earliest of these sites appeared along the Pacific coast of Mexico and Guatemala, in the region known today as the Soconusco. By the period between 2500 and 2000 B.C., the villagers began to produce well-made clay pottery, and by 1000 B.C. almost all of the Maya region was inhabited by villagers living in family compounds similar to those that can still be found in the Maya region today.

Houses were built around a framework of wood poles with walls of poles or stones slathered with mud. Roofs of palm or thatched grass were lashed together with vines, leaving wings that extend out over the walls to keep out the torrential tropical rains.[2]

This earliest era of Maya history, called the Pre-Classic or Formative Period (1500 B.C.–A.D. 200), also saw the development of the first Maya pyramids – low, flat-topped earthen platforms with a simple Maya house perched on top and used for religious ceremonies.

Mayanist Charles Gallencamp notes that, gradually through the centuries, "this religious architecture became more elaborate, incorporating masonry, sculptural embellishments, and stairways; and important temples were arranged around open courtyards to form ceremonial precincts within the core of each settlement."[3] Recent excavations at the site of Nakbe, in what is now the Guatemalan Peten, reveal a settlement that, by 750 B.C., could properly be classified as an early city.

Through the centuries, these villages and incipient cities evolved into vibrant centers of economic and ceremonial activities, and the temples and courtyards grew larger and more complex. Structures at some of the sites reached twenty to thirty meters in

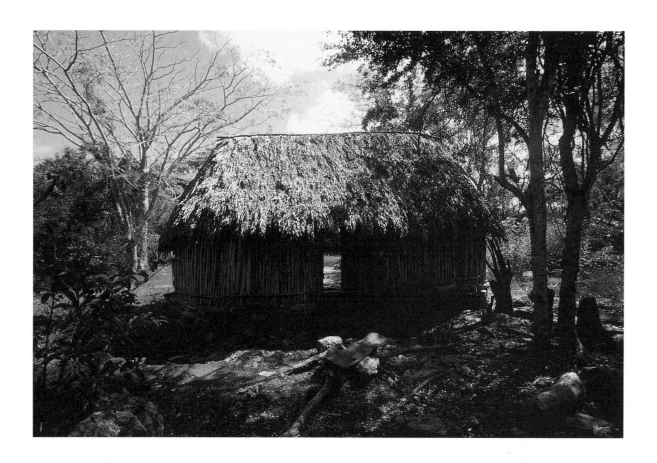

Yucatec Maya house that
functions today as it has for
centuries. Yucatán, Mexico

height. The southern Maya lowland site of El Mirador, in the Guatemalan Peten, is the largest known site for this period. Flourishing between 150 B.C. and A.D. 150, it grew to cover sixteen square kilometers of tropical forest land and was one of the first large cities on the North American continent. One of its pyramids, Tigre, may be the largest structure ever built by the Maya. It looms upward to fifty-four meters through a sequence of earth and stone platforms.

Standing inside the tropical forest that today covers the Pre-Classic city of El Mirador, you find it difficult to form a picture of what the city must have looked like in its glory. The forest hides enormous mounds of earth that the site map indicates are the eroded temples of El Mirador – once the largest city in the Maya world. Only when you climb the tallest of the mounds – called Danta (the tapir), Tigre (the jaguar), or Monos (the spider monkeys) – and look out over the ocean of tropical forest to see other temples poking their heads through the dense canopy do you get a sense of the absolute size of this abandoned city.

From the high perch of Danta, you can watch the sun set on tropical forest that radiates out from the pyramid in all directions as far as you can see. Yet beneath the green waves of this living ocean lie the bones and stones and distant dreams of a city that flourished here for more than three centuries: traders hawking cotton cloth and fine-slipped pottery from the open-walled stalls of the marketplace, priests garbed in wooden masks and macaw feathers chanting whispered prayers to a pantheon of gods, hunters straggling in from the edge of the forest with red brocket deer thrown over their shoulders.

Today, El Mirador is mute. Only the distant roar of a howler monkey and the gliding circles of an orange-breasted falcon overhead remind you that it is still a place of life.

On the horizon, a full day's walk away – if you have water and know the way – lies the slightly earlier Pre-Classic Maya site of Nakbe. The forbidden city, it lies shrouded in jungle like a child's toy shoved under a carpet of green.

Located at the base of the Yucatán Peninsula, Nakbe lay at the conjunction of the canoe portages for the primary overland trade routes. Through this early city flowed the lifeblood of early Maya commerce: jade, obsidian, feathers, skins, cacao, and salt. Through time, El Mirador wrenched control of the trade routes away from Nakbe and went on to become the major power in the Maya lowlands prior to the Classic era. Similar patterns emerged in the Maya highlands; Pre-Classic cities such as Kaminaljuyú and Chalchuapá grew up along major trade routes and vied with one another for control.

Strangely, most of the Pre-Classic cities of the southern Maya lowlands were abandoned between A.D. 150 and 250. Some archaeologists point to drought or shifts in trade patterns as the cause of this hiatus. More recently, hypotheses have also focused on the fiery eruptions of Ilopango volcano in what is today west-central El Salvador around A.D. 200–250.

This natural disaster, it is believed, joined with still unknown economic and political changes during the Pre-Classic era to replace the influence of some cities with that of others. Before Ilopango exploded, Maya trade routes followed along the Pacific coast of what are now Mexico, Guatemala, and El Salvador. Subsequent to the explosion, trade routes wound through the tropical forest region of the southern Maya lowlands.

THE CLASSIC MAYA

There was no transition between the Pre-Classic and Classic periods that the Maya themselves would have recognized. Archaeologists point to the Classic as the period when traits of civilization that had begun in the Pre-Classic era blossomed into the full glory we think of when we say the phrase "ancient Maya."

The city most closely associated with this rise to glory is Tikal, in today's Guatemalan Peten. As Tikal rose to power in the southern Maya lowlands, it began to overshadow cities of previous prosperity, some of which, like El Mirador, were completely abandoned to the forest.

From a stone platform on the top of Temple IV in the ancient Maya city of Tikal, travelers look out on an expanse of green that stretches to the horizon in all directions. The forest hides the traces of all human activity save four other limestone pyramids that pop their roof combs through the blanket of vegetation. During the rainy season, the forest turns a hundred shades of green, and bursts of yellow, white, and purple flowers splotch the canopy. In the dry season, the forest fades to a paler green than its wet season glory. Some of the trees turn chartreuse; others — especially the cedars and ceibas — lose their leaves completely. And some trees shed their leaves only to immediately break out in brilliant red-orange flowers.

At seventy meters, Temple IV is the tallest Maya structure ever built. It also symbolizes the heights to which Maya civilization ascended to become, as Gallencamp described it, "The most brilliant civilization ever known in pre-Columbian America."[4]

Look out in any direction from the highest platform of Temple IV and you'll see ridge after ridge of forested landscape fading across the slope of the Guatemalan Peten. On some of these ridges, jungle-covered mounds form silhouettes against the sunset. Other ridges look unperturbed. That all these ridges — and the valleys in between — were deforested for Maya agriculture, as some archaeologists believe, seems illogical.

The dozens of Maya cities that spread over the landscape of the southern Maya lowlands demonstrate the importance of the region during the Classic Maya period. Of these, the largest are Tikal and Calakmul, in what is now southern Quintana Roo, Mexico. Tikal had more than three thousand structures — from skyscraper temples to simple palm huts — at its peak around A.D. 800. A system of defensive earthworks on the north and south enclosed an area of 123 square kilometers. As many as ninety thousand people may have called the city home, making it as large as many post-Roman cities of the Old World.[5]

During this peak period of Maya civilization, the lowlands hosted an interconnected web of cities and ceremonial centers interspersed with food-producing settlements that lay in the forest between. Surrounding the region's major cities, hundreds of smaller towns spread through the forests. In Belize, the sites of Altun Ha and Xunantunich joined in trade networks that may have stretched to Copán, Honduras, across Guatemala, to cities such as Bonampak, Toniná, and Palenque in Chiapas, Mexico. Along the Usumacinta River, which today separates Mexico from Guatemala, the Classic Maya cities of Yaxchilán and Piedras Negras controlled river traffic of trade canoes loaded with animal skins, macaw and quetzal feathers, polychrome pottery, incense, medicinal plants, and tobacco.

It was during the Classic period that Maya civilization expounded on the characteristics first developed during the Pre-Classic, among them writing, astron-

omy, water control, sophisticated architecture, and a calendar still more accurate than the modern Gregorian version. These years were the Golden Age of the Maya, during which as many as eight to ten million people lived in sixty regional capitals in the Maya lowlands.[6]

In the highlands of Guatemala, Maya characteristics flourished until around A.D. 400, when warriors from the city of Teotihuacán, near today's Mexico City, seized such sites as Kaminaljuyú and began to rule over the Maya population. The Mexican invaders added Maya ways to their own, but the vanquished Maya of the highlands began to depend culturally, if not politically, on the Mexican altiplano.[7]

Teotihuacán's Valley of Mexico influence shows up in the stelae and pottery of the tropical lowlands around A.D. 500, but it dissipates in the second half of the sixth century after a period in which no stelae are erected and many stone monuments are defaced and mutilated. The cities of the tropical lowlands are not abandoned, however, and by A.D. 620, Classic Maya characteristics take off again without Teotihuacán influences. Not unpredictably, this blip in history coincides with the sacking of Teotihuacán around A.D. 600. While Teotihuacán falls into ruins, the lowland Maya go on to unparalleled heights of glory, producing the pottery, ornate sculptures, and sprawling cities that we associate with the Classic Maya.

THE DISINTEGRATION
Lowland Maya civilization also begins to disintegrate between A.D. 700 and 900. One by one, the star cities of the Maya constellation blink and go dark. In some places, religious and political monuments are broken and vandalized. As much as 90 percent of the population either dies or flees the area.

Although archaeologists still have not determined what caused the disintegration of Classic Maya civilization in the southern lowlands, they have found plenty of fuel for hypotheses. They cite evidence for climatic deterioration, soil exhaustion, mysterious diseases, military invasions. The late J. Eric S. Thompson proposed that Maya civilization collapsed in the area from the "overthrow of the small ruling group" by the peasant underclass. Invited once to a seminar on the mystery of the Maya collapse, Thompson telegraphed back: "No need for seminar — peasant uprising."

More recently, archaeologists have begun to consider the Maya collapse not in terms of a single cause but in terms of "the stresses that were inherent in the very fabric of Late Classic Maya society," as T. Patrick Culbert puts it.[8] These internal stresses may have included population increase, growing demands for food production, malnutrition and disease, warfare between political units, and increased appropriation of wealth by the society's ruling elite.

Strong evidence also has emerged that a severe drought devastated Central America, including the Maya area, between A.D. 800 and 1000. Lasting at least two centuries, this dry period may have hastened a process of decline already initiated by population growth, environmental degradation, and war.

As these stresses tore at the fabric of Classic Maya society, they brought about a gradual but final disintegration of Classic-era civilization. Archaeologist Michael Coe calls it the Maya apocalypse, "surely one of the most profound social and demographic catastrophes of all human history."[9]

More fortunate were the northern lowland cities of the Yucatán Peninsula. Cities such as Uxmal, Chichén Itzá, Kabah, and Sayil began to reach their

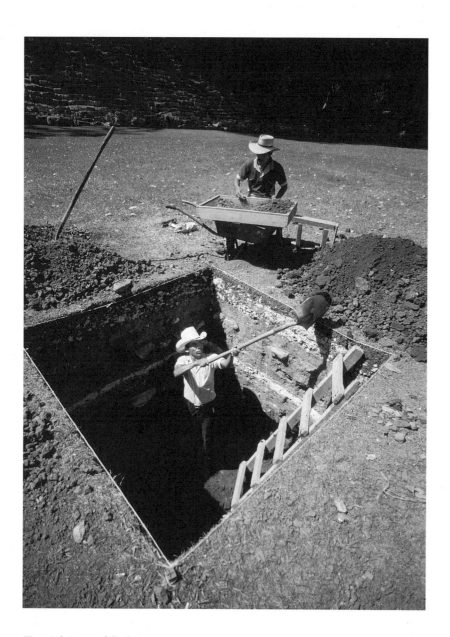

Test pit being carefully dug
in search of artifacts near the
bottom of the Great Heiro-
glyphic Stairway at Copán.
Honduras

greatest levels of prosperity and power just as the cities of the southern lowlands declined. Evidence indicates that foreign groups moved in to take advantage of the disintegration of Classic society in the southern lowlands and simultaneously helped bring about the rise of the northern Post-Classic cities around A.D. 900.

These changes are associated with the geographic expansion of groups of warrior-merchants from the coastal lowlands of the Gulf of Mexico, in what is now Tabasco, Mexico. Collectively called the Putún Maya, they were a Chontal Maya–speaking association of communities living as geographic intermediaries between the Maya and the Toltecs of the Valley of Mexico. Allied with the Toltecs, the Putún brought many Mexican traits into the Maya regions they began to occupy.

Using large, seaworthy canoes, the Putún began to dominate trade in both the Usumacinta watershed and around the Yucatán Peninsula. J. Eric S. Thompson called them "the Phoenicians of the New World." They expanded up the Usumacinta to exert control at such sites as Altar de Sacrificios and Seibal; they appear, as well, to have extended into the Maya highlands. Some sites there were abruptly abandoned around A.D. 800 and replaced by fortified strongholds on hills or mountains bordered by steep ravines. In the Maya highlands, Mexicanized groups seem to have conquered the K'iche', Kaqchikel, and other Maya groups, though they adopted these highland languages as their own. The new foreign rulers may well have maintained cultural — and physical — ties to the new Putún rulers of the rising cities of Yucatán.[10]

The Putún also established new coastal trading centers, including ports on islands along the coast of Yucatán, and went on to establish their capital city at Chichén Itzá, a city that would reign over the northern Maya lowlands for the next two hundred years. Thus, in archaeology, the Putún came to be known in some regions as the Putún-Itzá and finally as simply the Itzá. Still, neither the Maya highlands nor the moist tropical forest of the southern lowlands were depopulated after the collapse of the Classic Maya. In the highlands, the Toltec-like groups blended with the traditional Maya. In the lowlands along the Usumacinta River, Putún-dominated cities such as Seibal faded and were abandoned after A.D. 900, perhaps in reaction to the gradual change from river-based to ocean-based trade routes.

But thousands of people continued to live in the southern lowlands, just as they did in the highlands and in the flourishing Yucatán Peninsula. Archaeological data even indicate that small groups of Maya reoccupied a few decaying cities in the southern lowlands, including Tikal, setting broken stelae back on their bases, and attempting to re-create some measure of Maya civilization's former glory. As well, some southern lowland cities with favorable locations — northern Belize, the Lake Peten Itzá region, and some cities along the western and southern borders of the southern lowlands — continued to flourish.[11]

As in the highlands, some of the Post-Classic Maya of the tropical lowlands established fortified villages, but they did so on islands in large lakes and rivers. These villages were built mostly of perishable materials that disappeared over time, but the inhabitants constructed some stone buildings that survive as ruins today. Among the known sites are Lacantún (Lake Miramar, Chiapas), Topiltepec (in the Jataté River, Chiapas), Pochutla (Lake Ocotal Grande, Chia-

pas), Tayasal (now the island city of Flores, Peten), and still unexplored and unnamed ruins on islands in Lake Puerto Arturo and Laguna Mendoza in the Guatemalan Peten.

These ruins have been largely neglected by archaeologists. Some sites — Laguna Mendoza and Puerto Arturo, for example — are known only from tales of local farmers, who have found stone walls and broken pottery on the surface of the islands. Frans Blom's 1953 archaeological map of the Selva Lacandona, Chiapas, indicates that he explored and mapped the ruins of Lacantún, the island in Lake Miramar, Chiapas, but the notes from this exploration lie unpublished in the library of Na Balom museum, in San Cristóbal de las Casas.

Finally, one of these fortified, Post-Classic sites, that of Tayasal, known now as Flores, Peten, has been continuously occupied at least since Classic Maya times. As the capital of Guatemala's Department of Peten, Flores is today home to 2,500 people and the focus of a thriving tourist industry.

But it was on the flat, dry plains of the Yucatán Peninsula where the Post-Classic Maya continued to develop and expand after the Classic Maya collapse. The first three hundred years of the Post-Classic period were dominated by the city of Chichén Itzá, located in the center of the modern Mexican state of Yucatán. These first three centuries are viewed as a period of Mexicanization of the Maya of Yucatán, meaning that the Putún-Itzá, who were heavily influenced by populations from the Valley of Mexico, came to dominate developments in the Yucatán. Archaeologist Robert J. Sharer points out that the expansion of Putún-Itzá influence throughout Yucatán and into the highlands "brought the heartland Maya into contact with new political ideas, military tactics, and religious practices."[12]

Around A.D. 1221, Chichén Itzá was attacked and sacked, apparently by warriors from a rival city, Mayapán, located some one hundred kilometers to the west. Although it thrived for more than two hundred years after the fall of Chichén Itzá, Mayapán too was sacked and abandoned around 1441. This warfare was part of an ongoing process of internal Maya struggles, during which all the larger cities of Yucatán began a period of decline. Maya leadership broke into separate states headed by rival noble lineages at small cities.

Just as the Putún Maya of the Tabasco lowlands spread their dominance over the northern lowlands of Yucatán during the Post-Classic era, so also did Mexicanized groups come to dominate the highlands to the south. The Putún appear to have extended their influence into the southern highlands by following the Usumacinta River southward up its tributaries, which flow out of the highlands, and by extending their coastal trading routes around Yucatán up the Motagua River into the heart of today's Guatemala.

As Mexicanized groups came to dominate the Maya highlands, Post-Classic settlement patterns changed in reaction. The open-valley sites of the highlands were abandoned and replaced by fortified communities constructed on hilltops bordered by ravines. The conquering warriors who wrought these changes adopted local Maya languages and married into local Maya lineages, but came to establish political dominance over these populations.

Groups such as the K'iche' and Kaqchikel Maya competed for control of Maya communities that lay between their fortified cities. Some of these cities can be identified with Maya linguistic groups that survive in the highlands today — among them Utatlán (K'iche' Maya), Mixco Viejo (Poqomam Maya), Atitlán

(Tz'utujil Maya), Zaculeu (Mam Maya), and Iximché (Kaqchikel Maya).

The basin of Lake Atitlán, in highland Guatemala, was occupied by at least two other Maya groups in addition to the Tz'utujil of the city called Atitlán. The Kaqchikel controlled the north and east sides of the basin, and the K'iche' the northwest side. The groups created a mosaic of agricultural landscapes, including irrigated fields, sophisticated terracing systems, and drained cultivation fields on the deltas of rivers leading into the lake.[13]

Such was the scene among the Maya when the first Spaniards arrived in the New World, bringing upheaval and an entirely new future to the land of the Maya.

FIRST ENCOUNTERS

The first known encounter between Maya and Europeans came in 1502, on Christopher Columbus's fourth and final voyage to the Western hemisphere. As his ships lay off Guanaja, one of the Bay Islands near the north coast of Honduras, Columbus sighted and halted an eight-foot-wide dugout canoe filled with Maya traders. In the canoe were two dozen men plus a captain, and an unnamed number of women and children, who rode in a palm-covered structure amidship. The bewildered Maya told the Spaniards that they came from a province called *Maia*, the word from which the term Maya eventually developed.

According to Columbus's son Ferdinand, who accompanied Columbus and later wrote about the encounter, his father ordered that "there should be taken from the canoe whatever appeared to be most attractive and valuable, such as cloths and sleeveless shirts of cotton that had been worked and dyed in different colors and designs, also pantaloons of the same work-

manship with which they cover their private parts, also cloth in which the Indian women of the canoe were dressed."[14]

Columbus seized what he wanted of the Maya's cargo of pottery, cacao, wooden swords set with obsidian blades, and copper bells and axes. He also captured the Maya captain to serve as his guide, renaming him Juan Pérez. While the traders continued on their way to an unknown port, Columbus and Juan Pérez sailed on into history.

Fifteen years later, three Spanish ships commanded by Francisco Hernández de Córdova were blown off course to flounder against the northeastern tip of Yucatán. Most of those who survived this shipwreck made it back to Cuba, where they told stories of fierce battles with Maya warriors. Some of the Spaniards managed to loot some Maya temples before their escape, and the small gold trinkets they brought back to Cuba fueled a Spanish rush to find more gold.

The governor of Cuba organized an expedition under Juan de Grijalva, who sailed off in April 1518, to travel around the northern coast of Yucatán, reaching the Laguna de Términos. Enticed by gold he found near the mouth of the Grijalva River, Juan de Grijalva headed in the direction the Maya pointed — toward Mexico and the Aztec empire. Near the present-day city of Veracruz, Grijalva met Aztec emissaries sent by Montezuma and received their gifts of large quantities of gold.

Those initial gifts would prompt Hernán Cortés to march into the heart of the Aztec empire in 1519, setting off a series of historic events that would forever alter the history of the New World's indigenous peoples. Four years later, the Aztec world conquered and its leaders deposed or killed, Cortés sent Pedro de

Alvarado to conquer Guatemala and El Salvador, an assignment that Alvarado "carried out with relentless brutality," as Gallencamp has noted.[15] Alvarado marched along the Pacific coast of Mexico to today's Guatemalan coast, then turned northward toward the fortified cities of the highland Maya. Following Cortés's example in the conquest of Mexico, Alvarado marched at the head of a column of thousands of indigenous warriors — in this case the previously conquered Aztecs and Tlaxcalans — who fought the highland Maya in a series of heinous battles.

In 1524, Cortés sent Cristóbal de Olid to conquer and colonize Honduras, an event that led to Spanish dominance of that region of the Maya world as well, although Olid himself was killed in a rebellion against Cortés — the same rebellion that prompted Cortés to tramp across the Maya world. Two years later, in 1526, Francisco de Montego was authorized by the king of Spain to conquer and subdue Yucatán, a process that would take a series of Spanish leaders two decades to accomplish.

A MYSTERIOUS POISON

Within fifty years of Columbus's sighting of the hapless Maya trade canoe, Spanish hegemony over the Maya world — and over Mexico and the Caribbean — was complete. But it was not Spanish firepower alone that wrought this victory.

Despite the advantage the Spaniards carried over the Maya in the form of horses, metal weapons, firearms, and dogs trained to attack and kill, it was something the Spaniards carried unwittingly in their bodies that allowed them to vanquish the highland and lowland Maya. The native populations of the New World had lived for millennia without contact

with Old World diseases such as smallpox, influenza, measles, and pulmonary plague. When Spanish soldiers unknowingly brought such diseases into Mexico and Central America, these disorders ran rampant among the indigenous populations. Even relatively benign diseases of Europe turned killer among the Maya.

The first and best documented of the epidemics to ravage the Maya region was a complex of diseases of which the most destructive was smallpox. Beginning in the Greater Antilles in 1519, this pandemic spread over Mexico and Central America, killing "a third or a half of the Indian population," according to historian Murdo MacLeod.[16] This epidemic entered Guatemala four or five years before Pedro de Alvarado set out to conquer the highlands, prompting MacLeod to call disease "the shock troops of the conquest."[17]

The historical records report plagues that swept off large numbers of indigenous people throughout the sixteenth century. Half the Indians of Honduras succumbed to measles in the 1530s. Ninety percent of the Indians of Tabasco died between first contact and 1579 of "measles, smallpox, catarrhs, coughs, nasal catarrhs, hemorrhages, bloody stools and high fevers," according to one of the early chroniclers. A few years later, during the seventeenth century, a new scourge — yellow fever — took a heavy toll among those women and men who had survived. Beginning in 1638 in the Leeward Islands, the disease spread to Campeche and Mérida, then south through the Maya area. Historians Frances Scholes and Ralph Roys wrote that in some towns probably half the population died in seventeenth-century yellow fever epidemics.[18]

Epidemic diseases were followed by endemic disorders such as tuberculosis, malaria, pneumonia, and the Old World varieties of hookworm and amoebic

dysentery. Overall, the tropical lowlands lost 95 percent of their population, and the highlands lost 85 percent, according to geographer Karl Butzer.[19] Butzer goes on to state that without the population loss wrought by European diseases, the Spaniards never would have been able to subdue and control the peoples of Middle America.

So great was the devastation of consecutive rounds of disease that, even decades later, some Europeans could not believe that the depopulation of the New World was caused by foreign pathogens. Thus, Sir Basil Thompson could declare in 1894 that "apart from bacilli of foreign diseases, there is now no doubt that the different races of man are themselves uncongenial, and that their first meeting generates a mysterious poison fatal to the weaker race."[20]

If the historical demographers are correct that approximately five million people lived in the Maya region at the time of Spanish contact, more than four million of these men, women, and children died of disease in the first hundred years after contact.[21] In the face of this information, the surprising fact is that any Maya traditions survived at all to reverberate in the modern world.

But disease and war were not the only factors that decimated the Maya. Traveling behind these came other predators to feed upon the native population — the Spanish colonists themselves.

The conquest affected every facet of the Maya world, not the least of which was alterations on the face of the land itself. The Spanish conquest altered this landscape in two profound ways. First, the intensive agricultural systems of the Maya — terraces, irrigation, and raised fields — could not be sustained after such phenomenal losses in human numbers. Lack

of upkeep eventually led to abandonment, which weakened Indian claims on the land and allowed the Spaniards to occupy territory for themselves. Second, the introduction of Old World species — especially cattle and sheep — led to dramatic changes in land use, as formerly cultivated fields, tropical forests, and savannas were burned and turned into pastures. Wheat for Spaniards' bread spread over the highlands, and sugar cane sprouted on Spanish estates in the lowlands.

Disappointed not to find the wealth of gold and silver they had hoped for, the Spaniards set about to exploit the land and labor of the region's indigenous people. By 1550, Spanish colonists in the Maya region had turned to the production of cotton and woven cotton cloth to produce the riches they desired. Both cotton cloth and cochineal — a scarlet dye produced by cactus-eating insects — "were simply demanded of Indian tributaries, who subsequently bore the risks and difficulties of cultivation," according to anthropologist Robert Wasserstrom.[22]

The conquering Spaniards soon found that their most lucrative enterprise was the exploitation of native labor. In this endeavor, religious and economic interests worked hand in hand. In return for title to territory in the New World, Spanish authorities were required by the papal donation of 1493 to Christianize the inhabitants of these domains. To fulfill this requirement, and more importantly to incorporate the Maya into the Spanish economic system, the Spaniards brought dispersed Indian communities together in programs of resettlement called *reducciones*. Once under firm Spanish control and nominally Christianized, the Maya were divided among Spanish landowners under the systems of *encomienda* and *repartimiento*. Through these systems, Indians labored for their Spanish patrons;

in exchange, the Spaniards provided for the religious well-being of their Indian wards.

Other groups of Maya became debt peons on Spanish haciendas. Under the hacienda system, the Spanish landowner paid the Indians' tribute requirements and protected them from further harassment in exchange for their labor. Still other groups provided a stable labor pool for the Spaniards as sharecroppers – often on lands they had formerly owned. And other Indians, seeking rest from exorbitant Spanish demands for tribute, "simply became attached to a hacienda or plantation by a multitude of interlocking arrangements."[23]

By 1626, when the English-born monk Thomas Gage described highland Chiapas, Spanish *encomenderos* and settlers were competing with royal governors for monopolies in Indian-produced cacao, cotton, and cochineal. He noted that merchants came from far and near to purchase cotton mantles "for the Indian's wearing" and exchanged them on the Pacific coast for cacao.[24] By 1760, *repartimientos* in Chiapas's Grijalva Valley were producing 100,000 pounds of finished cotton cloth per year.[25]

CONQUEST OF THE LOWLAND MAYA

Not all the Maya were forced into such direct and relentless contact with the colonial Spaniards. The Spanish colonists were drawn more to the highlands than to the lowlands of the Maya region, which seemed disease-ridden, inhospitable to people and domestic animals alike, dark, and filled with death.

But as the highland Maya fell victim to the effects of relocation and work demands, Spanish officials were forced to search for additional laborers and slaves. In answer, throughout the sixteenth and seventeenth

centuries, they sought to subdue the Maya of the tropical southern lowlands and incorporate them into the colonial economy. Between 1559 and 1697, the Maya of the lowland tropical forest were either killed, enslaved, or relocated by Spanish authorities and soldiers in a series of military and religious *entradas*. In Chiapas, Spanish soldiers attacked an island fortress in Lake Miramar. From the name of the island fortress, Lacantún or Lacam Tun ("fallen stones"), the Spaniards adopted the name of the people they sought to subdue – Lacandones. Spanish authorities eventually would go on to apply this term to all apostate and non-Christian Maya in the region.

The Spaniards marched to a second fortified village called Topiltepec, probably on an island in the Jatate River in southern Chiapas, which they also attacked and destroyed. Then they pushed on to the Chol Maya fortress of Pochutla, situated on an island in the lake known today as Lake Ocotal Grande, near the present-day Tzeltal Maya town of Palestina.

Over the course of the following century, Spanish military and missionary expeditions sought out the lowland Maya to kill, capture, or relocate and Christianize them. As a result, the populations of Spanish-controlled towns on the fringes of the forest swelled with former pagans and provided new tributaries for Spanish authorities.

During the 1690s, Spanish authorities began an accelerated program of pacification and *reducción* that eliminated the last lowland Maya holdouts once and for all. Economics provided the impetus. During the seventeenth century, raids on Spanish shipping by French and English pirates threatened trade between Spanish towns in Guatemala and Yucatán. English pirates sailing out of Belize attacked as far inland as the town

of Palenque. The raids increased so drastically in the 1690s that Spanish authorities planned an overland trade road between Guatemala City and Mérida.

Between these two territories lay the provinces of the still-pagan Choltí-Lacandones of the southern Chiapas jungle and the Itzá Maya of the northern Guatemalan Peten. Until the two groups were subdued, no overland route was viable.

In 1695, military *entradas* with Spanish missionaries were launched against the Choltí-Lacandones and Itzá Maya to defeat the unconquered groups "once and for all and briefly and completely," as Spanish officials determined. On February 28, 1695, a group of soldiers under the command of Melchor Rodríguez Mazariegos marched north from Huehuetenango, while other forces marched east from Ocosingo and northwest from Alta Verapaz. Mazariegos arrived first at a Choltí-Lacandón settlement called Sac Balam (White Jaguar). Through the adroit work of an accompanying Spanish friar, Spanish troops were able to occupy the Choltí town peacefully. They renamed the settlement Nuestra Señora de los Dolores, erected a palisade, and constructed a wood fort, from which they undertook several futile attempts to reach Itzá territory. Exploring the surrounding forest of the Selva Lacandona, the Spaniards brought in an additional seven hundred lowland Maya from dispersed settlements they encountered.

Interest in the conquered Choltí Maya town of Los Dolores eventually waned. What happened to its Maya inhabitants, though, is a mystery left unrecorded in Spanish chronicles. Some reports indicate that the town remained a Spanish settlement until at least 1712, when the Choltí were resettled near Huehuetenango or Comitán, where they either died off or were absorbed

by highland Maya groups. Others state that half the people of Los Dolores died of disease and the rest slipped back into the jungle to take up Maya ways again. Only one thing is clear: by 1712, the Spanish-dominated village of Sac Balam–Los Dolores was abandoned to the tropical forest from which it had emerged, and its fate and even its precise location were buried beneath the jungle vegetation.

The fading, undiscovered traces of Sac Balam lie someplace within the Montes Azules Biosphere Reserve, a 3,312-square-kilometer rain forest area established by the Mexican government in 1978. One of the enticing clues to its whereabouts came in the 1980s, when Guatemalan Maya families fled into the rain forest of southern Chiapas to escape the violence of Guatemala's civil war. Weeks later, as they filtered back out of the jungle into Mexican communities along the Mexico-Guatemala border, they spoke of finding deep within the forest a cave where swords and metal armor were stored against the walls.

In pacifying the Choltí Maya of the southern Chiapas jungle, the Spaniards had finally wrenched control of the Selva Lacandona from its aboriginal inhabitants. But their occupation of lowland Chiapas, though prolonged and costly, proved in the end to be a Pyrrhic victory. Aside from a thousand or so new vassals, the conquest of the Chiapas jungle yielded little of immediate value to the Spaniards. The lowland Maya possessed no great wealth in precious metals, and few Spaniards were willing to establish haciendas in the jungle.

Though they managed almost to depopulate the Selva Lacandona, the Spaniards soon learned that the Maya they had missed in their jungle roundups were mixing with refugees from occupied territories in

Yucatán and Guatemala to reoccupy the population vacuum they had left behind. As these refugees moved across the Usumacinta River into the Selva Lacandona, they too became known as Lacandones. Escaping disease and disruption in other regions of the tropical lowlands, these new Lacandones managed to remain aloof from Spanish — and later, Mexican — dominance until the 1960s, when logging companies and immigrating colonists found Yucateko Maya–speaking Lacandones living in quiet settlements hidden in the forest. Known today simply as the Lacandón Maya, these families have managed to hold on to a surprising array of traditions — mythology, agriculture, ecology, and weaving among them. Today, their lives provide researchers with tantalizing clues to some of the secrets of the tropical forest Maya who have lived so long within the biological riches of lowland Mexico, Guatemala, and Belize.

TAYASAL AND THE ITZÁ MAYA

Their story is not unlike that of the Itzá. The Putún or Itzá Maya had come to dominate much of the Maya world during the Post-Classic era. Although of Maya stock, they bore Mexicanized cultural traits because their original location in the coastal lowlands of Tabasco lay between the Toltec region of the Valley of Mexico and the Maya region itself. As seafaring traders between the two groups, the Putún-Itzá introduced Mexican traits into Yucatán, later into the Maya highlands, and — known as the Itzá — eventually came to dominate Yucatán through such cities as Chichén Itzá. Driven from Chichén Itzá by the rise to power of the city of Mayapán, at least some of the Itzá escaped southward into the forest of the Guatemalan Peten, where they established themselves on an island fortress in the middle of Lake Peten Itzá, the island known today as Flores. The Itzá settlement lay precisely on the

route the Spaniards chose for their road between Guatemala City and Mérida. This economic impetus prompted the Spaniards to try to establish control over the resistant Itzá.

In 1696, a Spanish friar, Alonso Cano, would describe the Itzá as "well featured and of perfect stature," but frightening in appearance: "They have their faces cut and rubbed in with black . . . painting themselves or cutting on their faces the form of the animal which they have as a charm."

Friar Cano noted that the men tied up their hair with bands of woven cotton, "with many curious colors, with cords and tassels at the ends, made very beautifully. They clothe themselves with something like jackets with half sleeves, and all from top to bottom woven at intervals with stripes of various designs and incorporated in the same woof — very lovely to look at."[26]

"And with all these elegantly ornamented clothes," he wrote, "they always paint themselves red and black." The women, Cano stated, "wear only some skirts of cotton from their waist down, but from the waist up they go bare and uncovered, with their hair rolled up without as much care as the men." At night, Friar Cano went on, the women "muffle themselves up with sheets woven of various stripes and designs of different colors, like cloaks."[27]

The Itzá were no strangers to Spanish *conquistadores*. Hernán Cortés himself had passed through Tayasal on his route from Mexico to the Caribbean to put down the rebellion of Captain Olid in 1524–25. By all accounts, Cortés was kindly received by the Itzá on his arrival in 1525. The Itzá, though, were amazed by the Spaniards' beards, clothes, firearms, and horses. As Cortés camped on the northern shore of Lake Peten Itzá, the Itzá ruler, Canek, and thirty-two of his chiefs came in canoes to visit him. The Spaniards sang a

mass with all available Spanish instruments and decorations, and the music especially delighted Canek, who said that "such a thing had never been heard before." Cortés gave the Itzá leader a shirt, a black velvet cap, and metal scissors and knives and urged him to give up his traditional gods to become a Christian vassal of Emperor Charles V of Spain. Canek declined, but the Itzá told Cortés how to proceed toward his destination of Nito, bringing "great joy to Cortés and his men on account of the great desire they all had to find the Spaniards in search of whom they had undertaken this perilous journey."[28]

As Cortés and his troops left the Itzá to continue toward Nito, Cortés asked one last favor. His horse, Morzillo, had injured an ankle and had become a burden to the expedition. Cortés asked Canek to take care of Morzillo until he could send for the animal after the expedition arrived in Nito.

Perplexed by the wounded horse, the first such animal they had seen, the Itzá of Tayasal fed it flowers, fowl, and meat. The horse promptly died. Either out of respect for this mystery animal or fearful of Cortés's reaction, the Itzá carved a stone statue of Morzillo and erected it in one of their island temples. They preserved one of its thigh bones in a second temple. The Itzá named the horse-god Tzimin Chac, "Tapir Lightning" (tapir being the rain forest animal that most closely resembles the horse).

Ninety-three years passed before the Itzá saw another horse or another Spaniard in Tayasal. In 1614, the current Canek sent emissaries to Governor Antonio de Figueroa of Mérida to advise him that "he and all his vassals were desirous of the friendship of the Spaniards and had come to ask for peace." Figueroa asked two Franciscan friars, Bartolomé de Fuensalida and Juan de Orbita, both of whom spoke Yucatec, to

peaceably contact the Itzá and Christianize them. The two friars reached Tayasal in 1618 with an entourage of singers and sacrisands. Their songs and ceremonies pleased the Itzá, but Canek diplomatically declared that the time had not yet arrived for the Itzá to renounce their traditional religion.

Things might have been left there, but events soured when the missionaries happened upon the stone horse in the temple, with flowers and incense arrayed around it. Infuriated at finding a domestic animal transformed into a heathen god, Father Orbita attacked and smashed the idol. The Itzá immediately ran to overpower him, but Fuensalida, talking quickly, convinced them not to kill his brother friar. The two missionaries rather contritely headed back to Yucatán, and the Itzá built a replacement statue to the horse-god, Tzimin Chac.

Frustrated by the events, in 1622 the governor of Yucatán authorized Captain Francisco de Mirones to mount a military expedition against the Itzá. A Franciscan missionary, Father Diego Delgado, joined the forces and, slipping ahead of them, continued on alone with eighty converted Yucateko Indians and thirteen soldiers. Delgado, the soldiers, and the Christian Indians arrived on the island of Tayasal to an apparently peaceful reception, but the Itzá suddenly ambushed them, killed the entire group, cut off the soldiers' heads, and set them on stakes around the island. Then, they cut Father Diego Delgado into pieces and sacrificed the eighty Yucateko Indians to the gods.

Determined to prevent another *entrada*, the Itzá traveled north until they found the original military expedition of Captain Mirones, who was camped on the way to subdue Tayasal. The Itzá killed that group as well. Thus ended the Spanish attempts to conquer the Itzá, either militarily or peacefully, for another fifty-five years.

The final chapter came in 1697, when the planned

Guatemala-Mérida road was halted only twenty kilometers north of the lake, and the Itzá were still resisting all attempts at pacification. A military expedition of 235 Spanish soldiers, cavalry, and more than 100 Indian mule drivers and carriers pushed to the edge of Lake Peten Itzá and built two boats, which they fitted with artillery they had brought from Yucatán. From there, they boarded the galley to row across the lake to attack the Itzá stronghold of Tayasal.

As the floating battle lines converged, the Itzá tried to flank the Spaniards with two waves of canoes, while the Itzá on shore loosed a hail of arrows. According to an official Spanish report, as the ship neared the island, an interpreter called out that the Spaniards had come in peace and friendship. The Itzá answered with another shower of arrows, wounding two Spaniards. At this, the Spanish soldiers began firing at will and leaping into the water to attack the Itzá island. Using firearms and swords, the Spaniards overran the shore defenses and put the Itzá to flight. As the galley rowed back and forth before the island with men firing from its deck, Ursua and his troops pushed up the hill to the top of Tayasal.

The surviving Itzá leapt into the lake and swam for the mainland, while Ursua struggled to plant the Spanish flag. The battle was over by eight A.M. Not a single Spaniard had been killed.

The Spaniards scourged the island's temples and smashed the Itzá idols, including, presumably, the stone horse. One chronicler wrote that "So vast was the number of idols that their destruction took the entire Spanish force from nine in the morning to half past five in the afternoon."[29] Ursua selected the site of the principal Itzá temple for the construction of a Christian church. The Church of Flores still stands on this site today.

"Thus," wrote Brainard and Morley, "in the morning of a single day the power of the Itzá was crushed, and the last independent Maya political entity was brought under the domination of the Spanish Crown."[30]

But the Itzá Maya hardly disappeared. Numbering 150,000 at the time of their conquest, the Itzá have diminished in number, but several hundred Itzá Maya still live today in the town of San José on the northern shore of Lake Peten Itzá.[31] Aware that their cultural traditions, agricultural systems, and language were disappearing, however, in 1991, the Itzá Maya established the Bio-Itzá, a thirty-six-square-kilometer tropical forest reserve dedicated to Itzá survival. The Bio-Itzá has become the focal point of a movement to revitalize the Itzá language and of an impressive agroforestry system based on traditional forest management and Itzá oral history.

The Bio-Itzá forms part of the southern buffer zone of the 1.6 million-hectare Maya Biosphere Reserve, created in 1990 to protect the tropical forest, wetlands, and Maya archaeological ruins of Guatemala's Department of the Peten. The largest tropical forest protected area north of the Amazon Basin, the Maya Biosphere Reserve simultaneously protects the largest collection of Pre-Classic, Classic, and Post-Classic Maya ruins anywhere in the Maya world. As the only aboriginal inhabitants of the Maya Biosphere Reserve or its buffer zone, the Itzá Maya carry on traditions that originated in the pre-conquest history of the Maya world.

THE RISE OF THE WESTERN WORLD
After the Spaniards had finally come to dominate — at least politically — the entire Maya world, history took a decidedly Western tack. Forces both regional and international gradually led the Maya and non-Maya

inhabitants to join with the rest of Mexico and Central America in declaring independence from Spain in 1821. The Maya of Chiapas learned in 1824 that they were no longer part of Guatemala, but were now Mexican. Guatemala's Maya became part of the Mexican empire for a few years, then were told that Guatemala had reasserted its independence to join the United Provinces of Central America. Later, Guatemala became a separate republic, which it remains today. The Yucateko, Q'eqchi', and Mopán Maya of Belize became part of the British empire and eventually became citizens of an independent Belize in 1981.

Despite these political maneuverings through the decades, Maya village life changed slowly. Viewed as second-class citizens during the Colonial and well into the Modern periods of history, the Maya held tight to tradition where they could and adapted to change where survival required it. As centuries of oppression began to slowly lift, Maya traits began to reassert themselves. In several places, this reemergence boiled into outright revolt — as in the Yucateko Maya Caste War of 1847. Inspired by a talking cross, the Yucateko Maya rose up against their Spanish overlords and pushed them to seek refuge in the capital city of Mérida by 1848. Guerrilla warfare between the two sides occurred for another fifty years, until the Spaniards unilaterally declared that peace had come in 1901. During the decades in between, however, the Maya had once again created a Yucatán ruled by Maya warriors and religious leaders.

Other rebellions punctuated the late nineteenth and early twentieth centuries in Chiapas, Guatemala, and the Yucatán Peninsula. Guatemala's civil strife took on a Maya face during the 1970s through 1990s as highland Maya farmers were transformed into warriors fighting against the Guatemalan army. In an ironic twist, Maya farmers have frequently found themselves shooting at Maya cousins drafted into the army by the Guatemalan government.

As recently as 1994, Tzeltal, Tzotzil, and Tojolobal Maya — united as the Zapatista National Liberation Army — rose in armed rebellion against Spanish-speaking landowners and soldiers in Chiapas, demanding justice, democracy, and land. Modern politics have so far prevented a full military assault on these historical and linguistic cousins of the Choltí, Itzá, and Yucateko warriors of previous centuries.

These continuing struggles remind the non-Maya citizens of Mexico and Central America that the Maya are far more than an archaeological memory. More than thirty Maya languages are still spoken in the region. Almost half of modern Guatemala's ten million people are of Maya descent, and more than a million Maya live today in Mexico, Honduras, and Belize. The Maya are the second-largest group of indigenous people in the Western hemisphere, after the Quechua speakers of the Andean republics of South America.

Far from being an echo of a jungle-covered past, modern Maya communities are a blend of survival skills learned during centuries of conflict with the outside world and traditions that reach back to the Pre-Classic past. Adaptability, ethnic cohesion, and deep cultural roots have allowed the Maya to weave ancient views and technological advances into the fabric of the future.

The story of the people and textile tradition of the Maya world is one of change, resilience, and determination. That the Maya and their traditions have been so adaptable is nothing short of miraculous. That so much has survived is a joyous relief.

History and Ecology

The winding road to Todos Santos Cuchumatán climbs above the clouds, and the vista gives a sense of cosmic connection. At approximately 3,500 meters there is a dry altiplano of fields separated by cactus. Guatemala

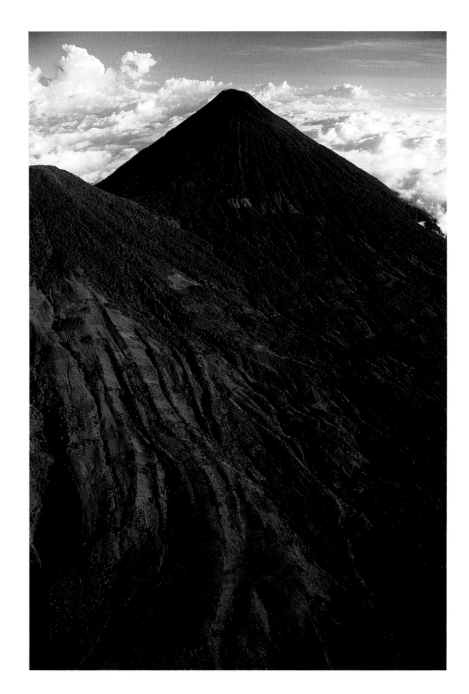

Seen through the window
of a small airplane on a steep
bank are the fields of rich
volcanic soil cultivated as
high as strong legs and the
laws of nature will allow.
Volcano Atitlán on the
south side of Lake Atitlán.
Guatemala

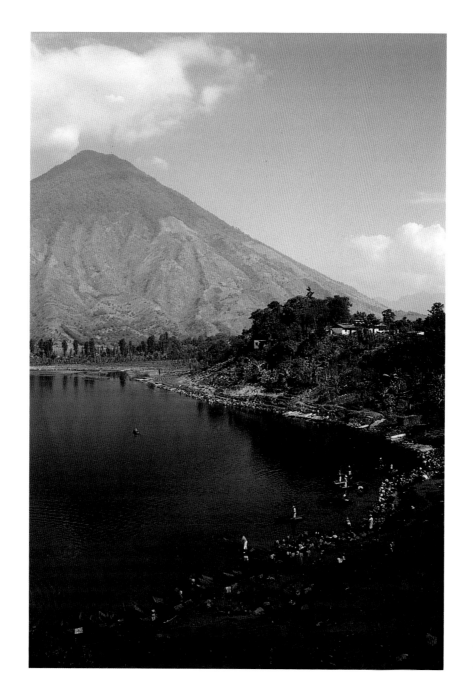

Morning in Santiago
Atitlán shows work and
social interaction taking
place on the lake across the
bay from Volcano San
Pedro. Fishermen stand in
small boats and speak
with the women doing their
wash. Guatemala

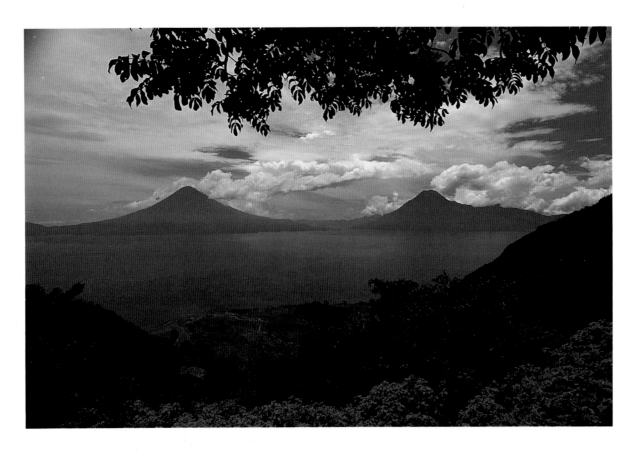

On the face of the Earth there are few places more beautiful than Lake Atitlán. It has many faces and moods, light and cloud cover . . . in fact it is mentioned in the *Popul Vuh,* the sacred text of the ancient Maya that describes the beginning of the world and the glories of Maya gods and kings. Volcano Atitlán (left) and Volcano San Pedro. Guatemala

It is easy to be overwhelmed by the carefully excavated temples at Tikal. The mysteries that tickle the imagination are the ruins as yet unrestored. Through the jungle foliage mounds appear covered by a net of roots and vines, all of them part of the history of the ancient Maya. Guatemala

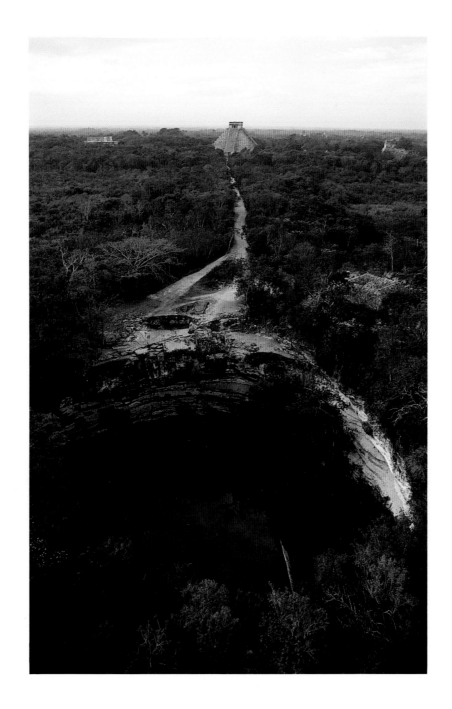

The pyramid El Castillo is connected to the Sacred Cenote, a collapsed cave, in the foreground, by a highway, called a *sacbe*, which extended for hundreds of miles. Caves and cenotes are access points to the underworld believed to be the abode of the dead to the ancient Maya. Chichén Itzá, Yucatán, Mexico

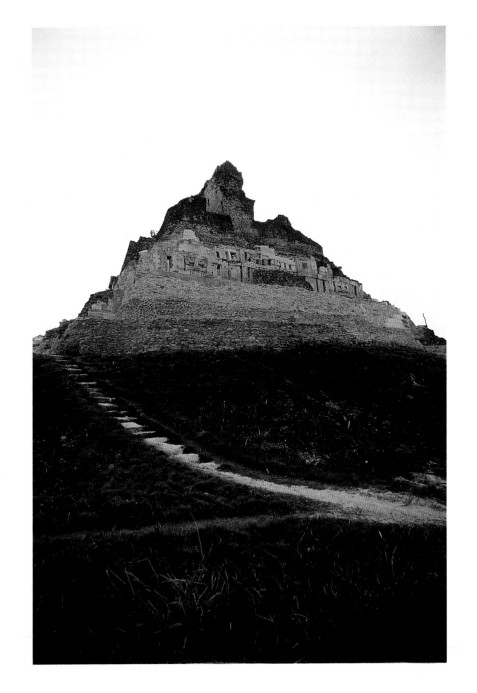

Xunantunich is the biggest ceremonial center in the Belize River Valley and part of a cluster of historic sites along the political border of Belize and Guatemala. In ancient times there were trade and wars among Xunantunich, Tikal, and Caracol. Belize

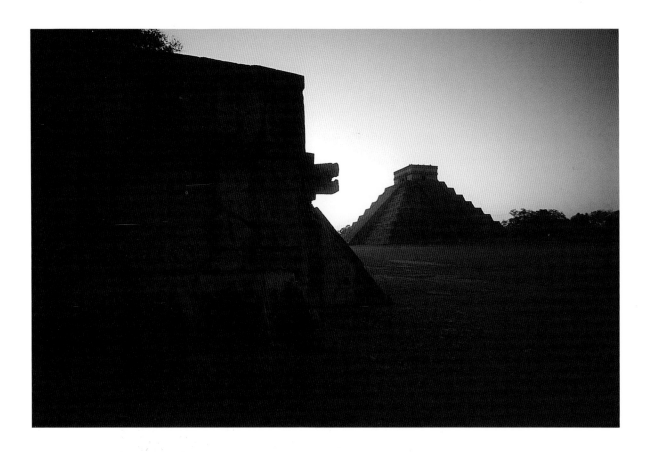

Looking past the stone silhouette of a feathered serpent (a Toltec deity adopted by the Maya) is the pyramid El Castillo, at Chichén Itzá. Yucatán, Mexico

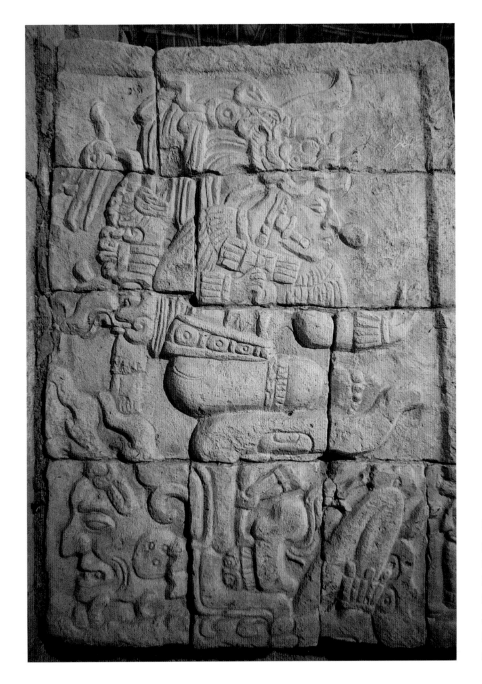

Fallen stones carefully pieced back together hold the secrets of the ancient Maya at Copán. The puzzle has been worked on by Mayanists for more than a hundred years, but many mysteries remain. Honduras

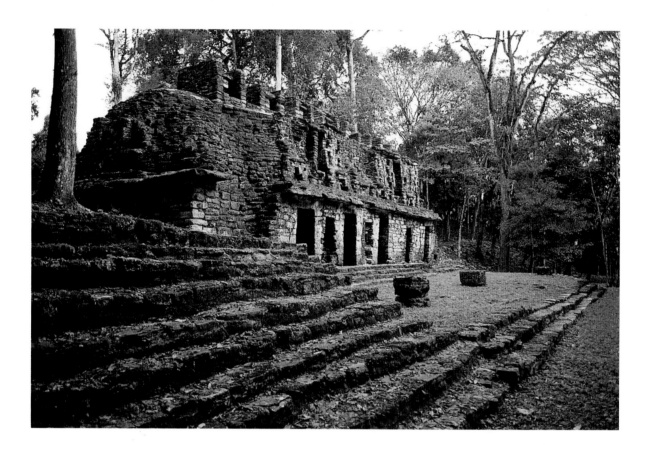

Yaxchilán was considered to be the most sacred ceremonial center of the Maya. It is set in the Lacandon Jungle, inside a bell-shaped curve on the Mexican side of the Usumacinta River, which also is the boundary with Guatemala.

The passage of time has made the rows of stones crooked. Huge trees and the human form are a testimony to these great builders of the past and to time itself. Copán, Honduras

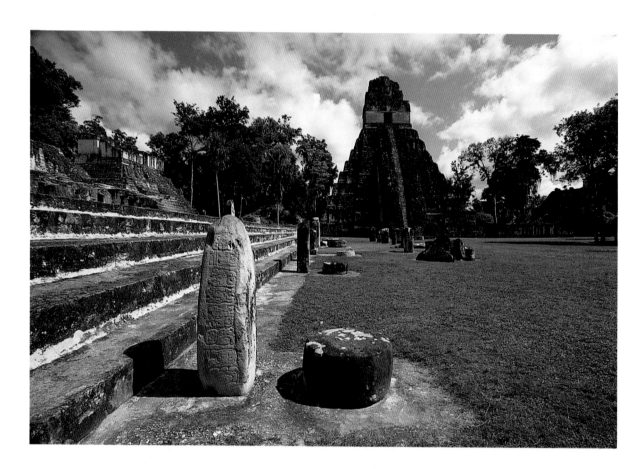

The Great Plaza at Tikal has the tallest of all structures created by the Maya, 212 feet. From the top there is a commanding view of the jungle in all directions. Temple I, seen here, also called Great Jaguar, is 145 feet tall. Guatemala

The original colors show
on a shallow relief of a
soldier deep within the
structure of the Temple of
the Warriors, which has
not seen the light of day
for centuries. Chichén Itzá,
Yucatán, Mexico

A timeless gesture suggestive
of the success of the Maya –
one of the longest continuing
civilizations in this hemi-
sphere. Here, Tenique Tulán
of Navenchauc, Zinacantán,
Chiapas, travels to a lower
altitude in the highlands to
find proper sticks to be used
in constructing her loom.
Mexico

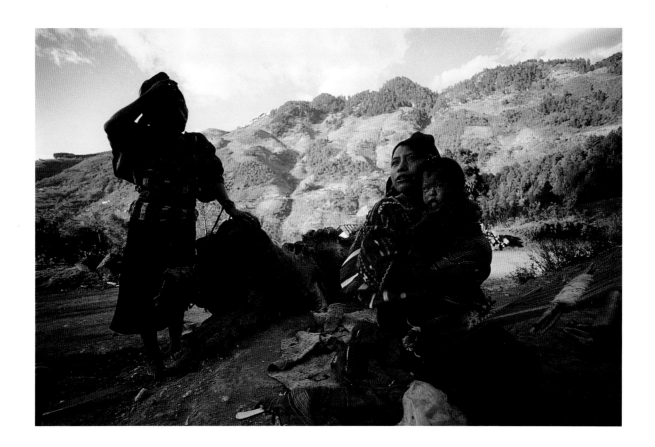

A weaver working near the
lightly traveled main road
near San Juan Atitán, high
in the Cuchumatanes
Mountains, takes a break to
take care of her children.
Guatemala

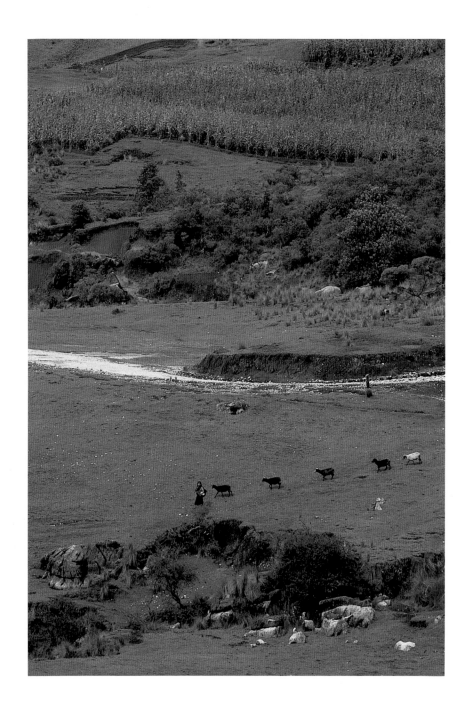

Sheep, creatures of habit, follow the young Chamula shepherdess in their daily ritual of grazing, not stopping to eat en route because each one wears a muzzle made of rope. On the road to San Andrés Larrainzar, Chiapas, Mexico

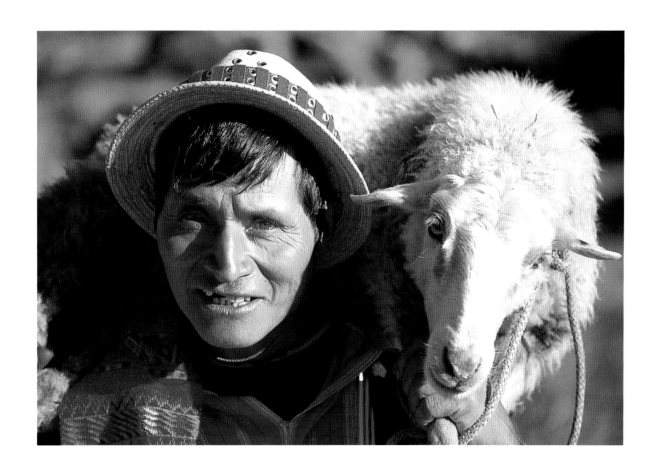

Sheep and man, both bound
for the market in Todos
Santos, pause for a portrait.
Guatemala

Young boys perform their
chores along the Pan Ameri-
can Highway where it crosses
the Continental Divide
between Antigua and Lake
Atitlán. Guatemala

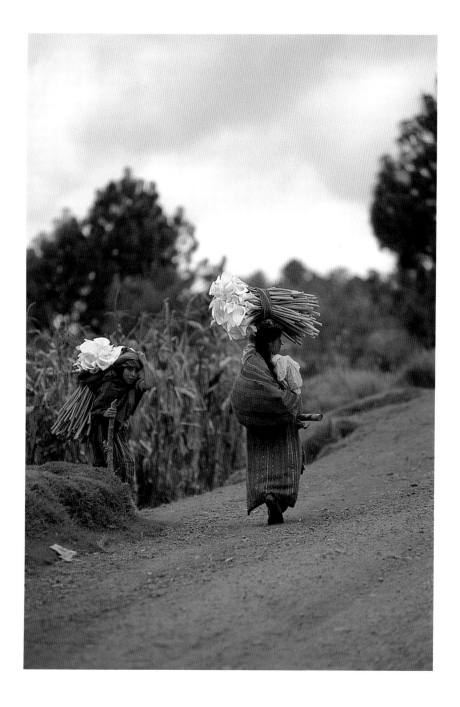

Flowers bound for the
market at Sacapulas
are transported in the tradi-
tional way. Guatemala

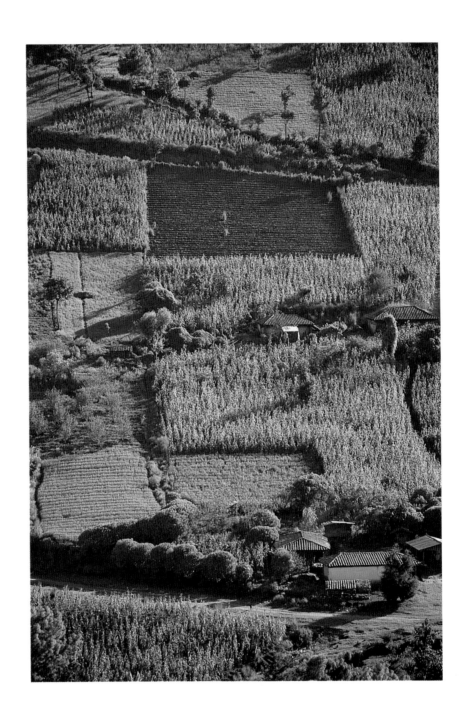

This vista of a cultivated mountainside and typical homes is seen from across the valley on the road entering Todos Santos high in the Cuchumatanes Mountains. Guatemala

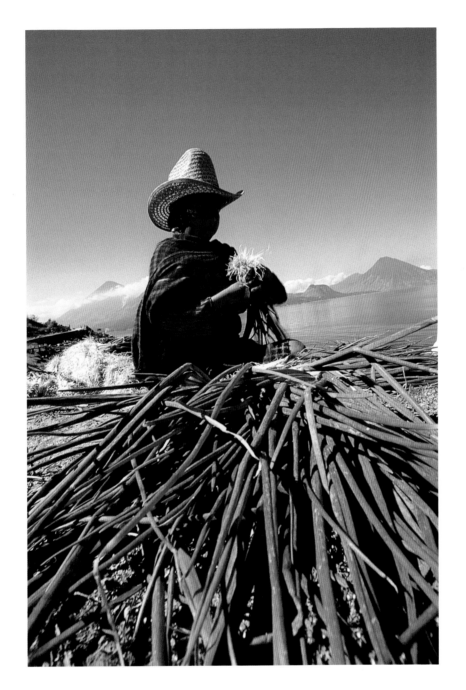

At the side of Lake Atitlán in San Antonio Palopó, a young boy cleans onions and ties them in bundles to be sold in the market at Panajachel. He works in the company of friends doing the same chore. Guatemala

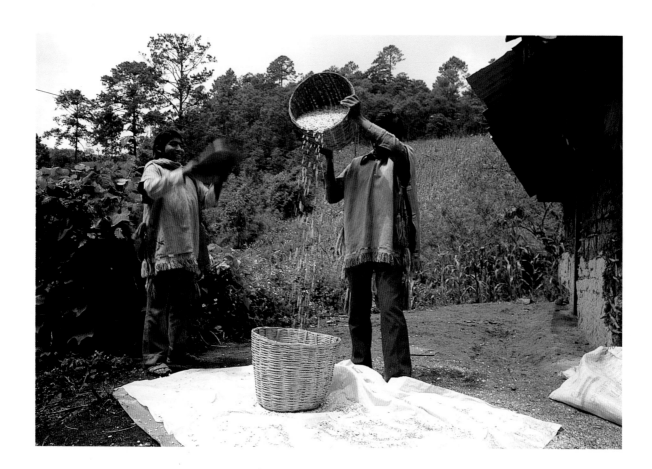

The man on the left creates
a breeze with his hat, which
blows away chaff from the
corn being poured from
one bamboo basket to the
next. Zinacantán, Chiapas,
Mexico

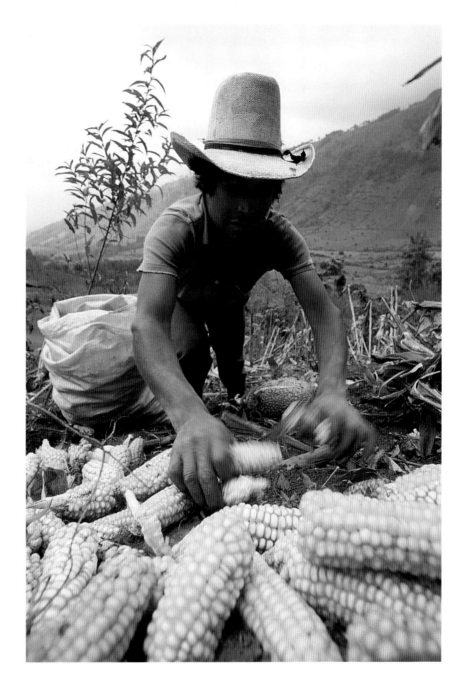

The corn stalks are dry and the harvest has been taken, but out of respect for each kernel of corn this farmer near San Antonio Aguas Calientes has returned to his *milpa*, or farm plot, to gather the very last ears of corn. Guatemala

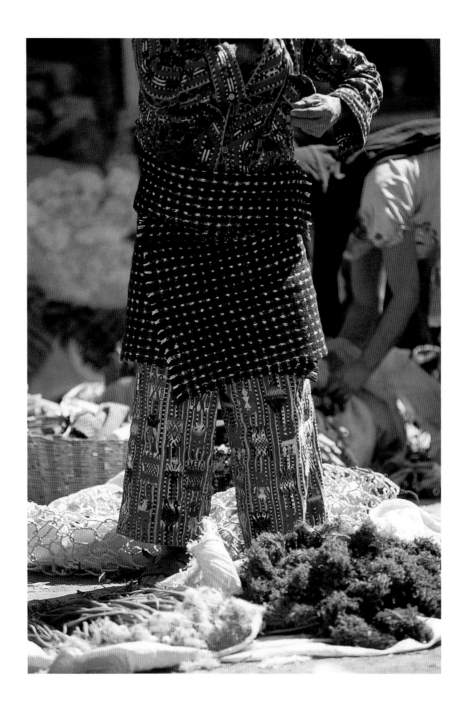

Men from Sololá continue to wear traditional clothing: shirts and pants of ikat or tie-dyed and brocaded backstrap-loomed cloth and a woolen cloth, or *rodillera*, wrapped around their hips. Guatemala

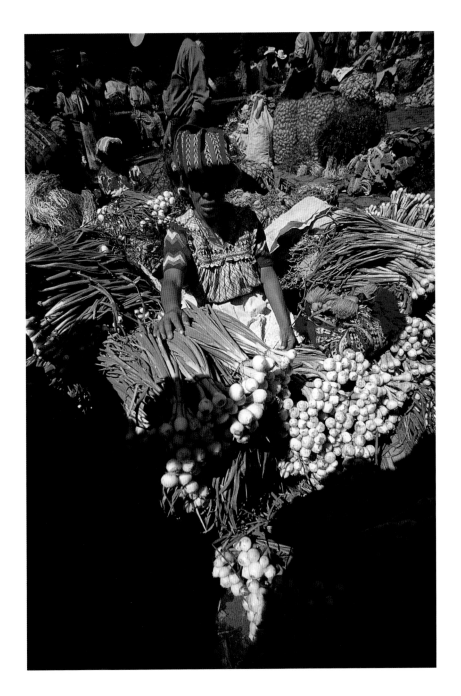

Selling onions at the Sololá market, a woman shades her head with the same cloth, or *tzute*, she would wear over her shoulders if the sun went behind the clouds. Guatemala

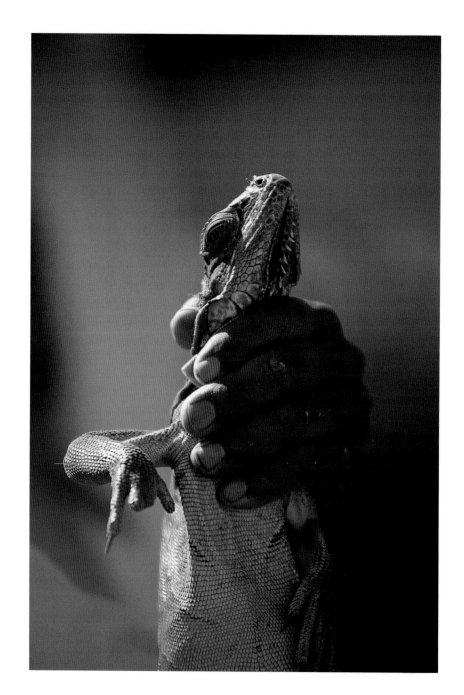

An unhappy iguana in the market at San Lucas Tolimán is part of a new government program that encourages people to raise them for food. Guatemala

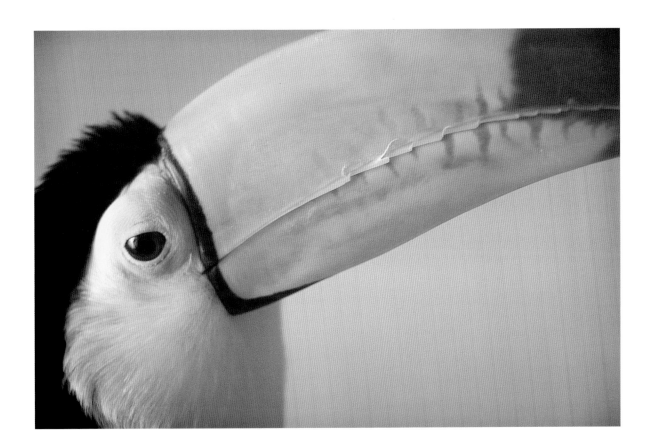

Toucans have always been
plentiful in the wild of the
Maya lowlands; this one,
Pinnochio, was a caged pet
in Guatemala City.

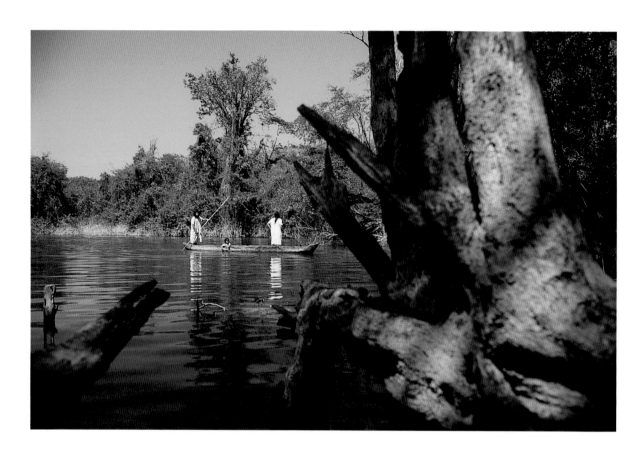

A traditional dugout canoe
carries two Lacandon
hunters and a boy on Lake
Nahá, Chiapas, Mexico.

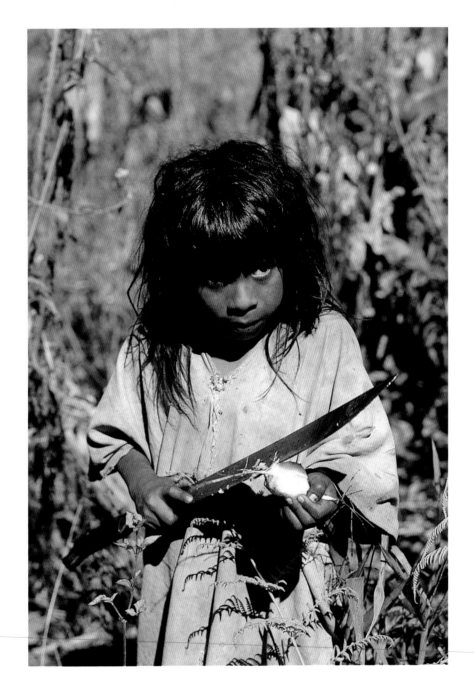

A young Lacandon boy
pauses for some fast food in
the form of a root, which
he peels with his machete.
Metzabok, Chiapas, Mexico

Trees (cedra odorata) with root systems you could sit on like a park bench are the kind that typically grow over Maya ceremonial architecture at Tikal and creep like serpents on the jungle floor. Guatemala

Over centuries of occupation of this jungle the Lacandon people developed a "slash and burn" agriculture, slashing the weeds and burning them to return nutrients to the soil, then allowing the trees to regrow. These days with advances in intensive farming and the growing population, the pressure on the jungle is too great to sustain this kind of farming. Mexico

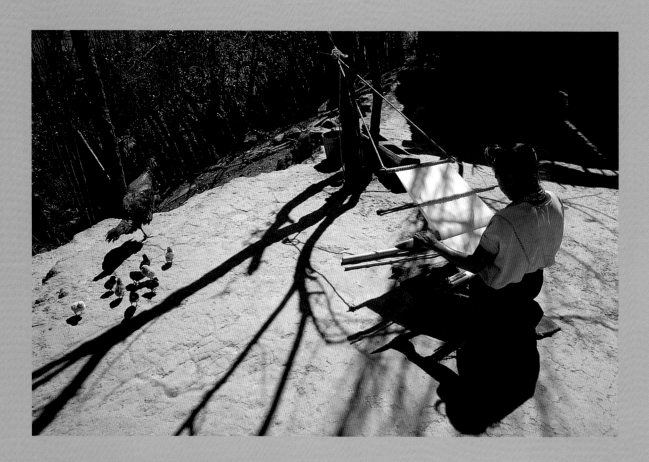

Warmed by the late winter
sun, and sitting in the
shadows of the peach tree
with back-lit pink blossoms,
Tenique Tulán weaves on
her family's patio. In her
view is the Zinacantec town
of Navenchauc below, and
across the valley is the Pan
American Highway. Mexico

LINDA ASTURIAS DE BARRIOS

Weaving and Daily Life

Long ago, the people of the rainy, mountainous region of Verapaz were trembling from the cold because they did not have clothes. From the heavens, the goddess Itzam saw their suffering and came down to Earth. She visited a woman in her house and tried to teach her how to weave, but the woman simply did not understand. Just as the goddess was about to give up, she saw a spider weaving its web. The deity told the woman to watch how the spider worked, and thanks to this demonstration the woman captured the essence of weaving. Today, some of the *huipiles* or blouses from Cobán have a brocaded design in the form of a *rukem la am*[1] or spider's web, a reminder of this myth on the origin of backstrap-loom weaving.[2] In other Maya communities different versions of how this thousand-year-old tradition emerged are passed on from generation to generation. In Magdalenas, Chiapas, according to oral tradition, the first act of the community's founder, Mary Magadalen, was to weave a *huipil*.[3]

Weaving on the backstrap loom has long been a pillar of Maya culture. From its roots in the pre-conquest era,[4] it has been preserved up to the present in hundreds of towns and hamlets where it is an important part of daily life. During the pre-conquest period, weavings not only provided clothing but also served as a means of exchange, tribute payment, and honorary gifts.[5] Textiles were made of cotton or agave fibers, depending on the wearer's social stratum. During the Colonial period, use of the agave fiber declined as cotton became widespread among Maya backstrap-loom weavers. The Spaniards introduced the treadle loom, sheep, and the process of spinning and weaving wool. The Maya incorporated wool and this new textile technology in some areas of the highlands where warm garments for men influenced by European styles emerged.[6] In some communities wool also was used to weave several male and female garments on the backstrap loom. Such is the case in Chamula, Chiapas, where women still weave their wraparound skirts with handspun wool. This animal fiber, however, did not replace cotton as the basic material for weaving. In the Colonial and Post-Colonial eras the treadle loom displaced the backstrap loom for making skirts in most communities; Colotenango, San Rafael Petzal, and San Idelfonso Ixtahuacán, Guatemala, and Chamula, Mexico, among others, were

notable exceptions.[7] Today, treadle and backstrap looms coexist in several towns fulfilling different functions. In Nahualá, for example, women weave garments for their own use and for sale on their backstrap looms, while male weavers make cotton yardage for export products on the treadle looms. Few male weavers continue to produce traditional woolen cloth such as the brown-and-white checkered one worn as a kilt by older men.[8] A different situation exists in Comalapa, where women have crossed gender boundaries in textile production by weaving on treadle looms, which were once strongly associated with men.[9] In other communities of the Maya area, either the backstrap or the treadle loom is used.

At present the Maya are participating in the global economy by producing not only textiles[10] but also vegetables, fruits, and other commodities for export. In this contemporary context weaving has both preserved and re-created the Maya's ethnic identity. Weaving and ethnicity have been historically interlaced as the warp and weft of a social web.

THE HOME: A SCENARIO OF FAMILY LIFE
Maya live in villages and hamlets belonging to municipal administrative units similar to counties. The inhabitants of the municipal capitals, called *chi jay*, or place of houses,[11] usually have small plots of land for cultivation outside of town. For this reason a distinction is made between *xoral*, land where the house is, and *ulew*, land for planting. People residing in hamlets may have one plot of land serving both purposes. However, given the scarcity of land, demographic pressures, and inheritance patterns, many families have their land dispersed over a wide area. The lack of land

or insufficient cultivable land for supporting a household is a hardship that faces many families. Sharecropping and renting plots from larger landholders are two of the strategies used to secure the land needed to plant corn, a dietary staple and a key cultural symbol. When landless Maya from the highlands are unable to rent land near their home, they may have to go as far away as the coastal lowlands.

Maya practice a virilocal form of residence, which means that a new couple begins its conjugal life living with the husband's family. After a period, which may vary from a few months to several years, the couple will build its own house on the same plot or on a different one. Therefore, an extended family including parents, their single children, and their married sons with their own wives and children may live in a single compound. Fenced in by stalks of corn, bricks, or stones, a compound may have two or more houses each with its own patio (*ruwa jay*), garden, and corn storage (*k'ujay*). A single steam bath (*tuj*) may be shared by all the members of the compound.

In Maya gender ideology women are clearly associated with the domestic space and men with the nondomestic one. The former is the house, including its immediate surroundings, while the latter encompasses the fields, mountains, forests, and streets. In San Andrés, Chiapas, this ideology is expressed by referring to the woman as "the lord of the house" and the man as "the lord of the cornfields."[12] Mothers in Comalapa advise their daughters not to spend more time than necessary in the town's streets because "a woman's place is in the house and a man's is in the field."[13] In practice, though, women do perform agricultural chores, raise sheep, run errands, and market

products away from the home. And although full-time male farmers spend most of their time in agricultural activities, other men, part-time male artisans such as tailors, treadle-loom weavers, and carpenters, usually work at home or in workshops located in other homes.

Work and other activities, as well as the tools used for performing these tasks, are the building blocks of the social construction of Maya gender roles. The man is responsible for growing the family's staple foods and the products to be sold at market, cutting and carrying firewood, repairing the house, and calling the midwife when his wife goes into labor. Meal preparation, cleaning, washing clothes and dishes, shopping for food at the market, taking care of the children, feeding poultry and pigs, hand-spinning cotton, weaving on the backstrap loom, making pottery, fetching water, and preparing the steam bath are tasks perfomed by women as part of the gender division of labor in the home. Women participate in specific agricultural tasks such as spreading fertilizers, picking beans and ears of corn, as well as most of the post-harvest chores. In the central highlands, where nontraditional export products such as snow peas, broccoli, and baby vegetables have been cultivated since the 1980s, women's involvement in agriculture has increased.

Crossing gender boundaries has provoked conflicts and ostracism. In Comalapa, for instance, folk painting was strictly a male occupation from the 1930s until the 1970s.[14] One of the first women to cross this gender boundary in the early 1980s could not tolerate the social pressure and felt compelled to move.

The patio of a Maya home is a working place and a playground shared by the members of a household and their animals. There, women dry ears of corn in the sun and separate *frijol*, or black beans, from their pods by pommeling them with sticks. Sitting on reed mats, women spend many hours weaving or embroidering, while their children play and cats, dogs, chickens, and turkeys wander about. The sunlight, weavers and embroiderers say, makes the colors and the intensity of the yarns' hues more beautifully vivid. *Huipiles*, skirts, and other washing compete for sun and wind. Women potters model earthen jars and other pieces in the patio, while men chop firewood or perform artisanal tasks, as is the case with tailors, in the same area.

Around the outside of the house one finds fruit trees, flowers, and *chayote* vines. After the harvest, which in the highlands takes place between October and February depending on seed types and climate, the storage area is filled with the dried ears of corn. If the harvest is abundant, some of the corn is sold and the money received spent to buy clothing, home utensils, and other needs. In some communities January is traditionally the month for weddings, since cash and corn are readily available to cover the large expenses of the fiesta: hundreds of pounds of meat and corn for traditional festive dishes, new clothes for the bride and the groom, liquor, firecrackers, decorations, and music.[15] If the corn supply is depleted before expected, families may say that the rituals believed to ensure that the corn would last were not performed. One of these rituals involves sacrificing a rooster before the corn is stored.

Steam baths, like those found in Nahualá, are domed adobe structures large enough for three people. Called *tuj* in Kaqchikel and *temascal* in Spanish, this bath has preserved its pre-conquest cleaning, ritual, and curing functions. Steam rises from a large pot of

water heated over a wood fire. Several members of the household may take a steam bath together. When a baby is born, the midwife takes the mother and her child into the steam bath. The new mother is rubbed with special herbs in order to speed her recovery and to stimulate milk production. The mother then stays at home without going out for several days. Throughout this period of time female relatives, neighbors, and her children's godmothers come to help with domestic chores. They bring chocolate, eggs, and other foods wrapped in woven napkins called *tzutes* (from the Maya *sut'*).

The structure of Maya houses varies in materials, size, and layout depending on the geographic region in which they are located, local traditions, and the family's economic resources. Walls are made of corn stalks, wooden boards, adobe bricks, or cement blocks. Straw, clay tiles, and sheets of corrugated metal are used for the roofs. Corn stalks and straw, used since the pre-conquest era; adobe bricks and clay tiles introduced by the Spanish colonists; cement blocks and metal sheets, often seen today, are all common combinations. Adobe bricks and roof tiles disappeared as building materials in several communities of Guatemala as a consequence of the devastating earthquake in 1976. The old way of building adobe houses, in which dozens of neighbors would help a family to construct a house and then expect reciprocal collaboration when it came their turn to build, was also lost.

Houses may have a living room, a bedroom, and a kitchen–dining room or may consist of only a single room with spaces set aside for each of these functions. In Kaqchikel houses the living room, called *nimajay*, or large room, and the kitchen are often separated. In Catholic homes, the rectangular living room is dominated by an altar. Covered with a colorful textile or with a store-bought tablecloth with flower designs, the altar table displays various-sized images and pictures of saints alongside offerings of flowers, candles, and incense. When a couple accepts the highest position in a *cofradía*, or religious confraternity,[16] its saints and paraphernalia are housed in their *nimajay* for one year or more. During this time, their living room is transformed into a *cofradía* shrine, and any person wanting to pray to the *cofradía's* patron saint is welcome.[17]

A family's history is also visually recorded in the *nimajay*. Photographs of memorable events — baptisms, weddings, graduations, trips to faraway places — hang from the walls, along with portraits of dead relatives and diplomas awarded to members of the household. It is here that rites of passage are witnessed by the community. Baptismal godparents pray at the family altar for their godchild's well-being. The day before a wedding, the parents of the groom send the bride's parents a large basket filled with bread, chocolate, and plantains covered with a magnificent white *tzute*, a multipurpose rectangular or square cloth specially woven for the occasion. The gift basket is set before the altar and incensed. After the religious ceremony in the church, the guests gather at the groom's house where the men sit on benches and the women on reed mats in the living room. A traditional ceremony, led by representatives of the groom's, bride's, and god-parents' families, is carried out, which includes blessing the bride's gifts and thanking the guests.[18] Wakes also take place in the *nimajay*. When people come to express their condolences, they leave a small amount of money on the family altar to contribute to unexpected expenses.

The kitchen, *rute' q'aq'* in Kaqchikel, which literally means mother of fire or principal fire, is the center of the home.[19] It is here that food is prepared and eaten, and where conversations are held around the fire. The traditional hearth is composed of three stones supporting a clay cooking surface, called a *xot*, over a wood fire. The clay *xot* has been replaced in many homes by a metal one. In some communities the more well-off families have a wood-burning stove made of bricks and decorated with tiles. Tortillas, the principal food, can be made on any one of these surfaces. In Guatemala the tortillas are patted by hand while the Yucatec Maya in Mexico shape the dough on a table using a small sheet of plastic.

A fundamental part of the woman's role is to process food and to feed the family. This task absorbs several hours of each day. Usually the woman is the first to wake up, arising very early in the morning. She starts the fire to heat coffee, tortillas, and beans for her husband, who eats breakfast and then departs to work in the fields; sometimes she will also prepare a lunch for him to take. Later she serves breakfast to her children and sees to it that they get ready for school. By midmorning, the woman has already swept, dusted, and cleaned the house; taken care of the younger children; fed the chickens and pigs; and prepared the *nixtamal* (grains of corn cooked with lime). She then takes the *nixtamal* to a mill where it is ground. If there is no grinder available near where she lives, she will grind the *nixtamal* on a grinding stone. Back at home, the woman kneads the dough again and starts to make the tortillas. If she has a large family, of eight members or so, she may make more than 140 tortillas a day, which are consumed during the three meals.[20] When her daughters come home from school or work at noon, they will help her fix lunch.

The Maya's meal components differ from those of the West. For the K'iche', for example, a meal has four components: *wa*, tortilla or main food; *rikil*, chili or the companion of the main food; *rachil ri rikil*, companion of the chili; and *uk'ya'*, which means beverage. Specific foodstuffs meet the criteria for each component. Tortillas or *tamales* are appropriate for the main food; meat, eggs, rice, cheese, herbs, avocados, or vegetables qualify as companions of the main food; chilies, tomatoes, noodles, and rice may make up the third group; and coffee or *atol*, a hot drink, are the most common beverages.[21]

As part of their upbringing, children learn fundamental values and are initiated into gender socialization while they are young. In the K'iche' and Q'eqchi' areas, the goal of family education is to develop individuals who are hardworking in both work and studies, respectful, bilingual (Maya-Spanish), religious, loyal, cooperative, and responsible. Boys and girls between four and six years of age learn basic manners and behavioral norms and begin to play gender roles. Little boys play at cutting firewood, while girls pretend to make tortillas with mud and weave with small sticks and scraps of yarn. From the ages of seven to fourteen, boys and girls gradually acquire gender-defined responsibilities in domestic, agricultural, artisanal, and commercial areas. Children of these ages help their parents with both housework and chores related to the family's productivity. At the same time they attend elementary school and acquire the language skills necessary to become bilingual.[22] Although it is a goal of many parents to send their children to school, not

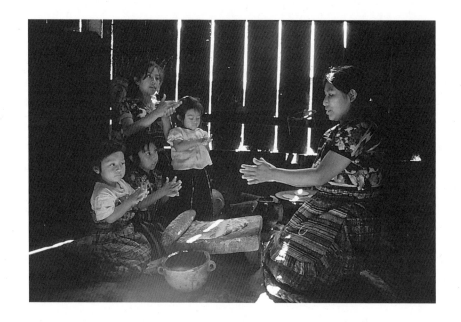

Young girls learning to make tortillas. Top: San Antonio Aguas Calientes, Guatemala. Bottom: Zinacantán, Chiapas, Mexico

all Maya children have access to formal education. National statistics indicate that 21.2 percent of the children in the department of Guatemala and 62 percent of those living in the northern regions of Alta and Baja Verapaz have never attended school.[23]

IN THE WORLD OF BACKSTRAP-LOOM WEAVING
The backstrap loom may be set up and worked on in any part of the house. On a sunny day, a woman might weave outside in the patio; when it is cold or rainy, she works inside in the living room or in the kitchen. Like the wood-burning fire, the backstrap loom is an integral part of life in the Maya home. The weavings brought to life on this ancient loom provide not only clothing and warmth but a means of creative expression and a link with the past.

Isabel and her daughter-in-law, Maria, live in the same compound but in different houses in Comalapa.[24] For them, as for many Maya women, weaving is a peaceful, enjoyable, and aesthetic experience that expresses their ethnic, community, gender, and individual identities. At sixty-five, Isabel probably belongs to the last generation of women who were taught to spin cotton as part of their upbringing. She owns the basic equipment for transforming cotton into yarn: a goatskin, two forked sticks, a spindle, and a gourd. After removing the seeds from the cotton, Isabel places a large net full of dried corn husks on the floor to make a cushion. After spreading the goatskin over the cushion, she then beats the cotton with the forked sticks. The rhythmic sounds of the cotton being beaten remind her of the music at *cofradía fiestas*.

Meanwhile, Maria and her adolescent daughters weave the *huipiles* they will wear for the first time on the day commemorating the patron saint of their community, St. John the Baptist. A few hours remain before the sun begins its journey through the underworld and the sunlight is still good for working in the patio. Isabel has finished beating the cotton, and she begins the task of spinning with a simple spindle made of a stick and a clay whorl. She will have to work several days before the yarn is ready for weaving. After the cotton is spun, two more steps must be completed: she has to twist the yarn again with the spindle and then combine two threads into one to make two-ply yarn. This stronger yarn is used today in the warp and the weft of only a few overblouses.[25]

The days when Isabel's father and other men would go on foot to the Pacific coast to buy white and brown cotton are gone. Today, Isabel must ask a trader to buy a few pounds of natural brown cotton at the market in Sololá, a Kaqchikel town in the region around Lake Atitlán, where it is still possible to find some brought in from the coastal region of Patulul.

At the end of the twentieth century, hand-spun cotton has almost disappeared. Some natural white cotton is still spun by hand in Santiago Atitlán, due in large part to its relationship with traditional religious beliefs and tourism.[26] In Comalapa and Tecpán some of the older weavers continue to spin natural brown cotton, considering it a highly prized material for the background of their overblouses. Textile connoisseurs also are willing to pay higher prices for pieces woven with this now-scarce handspun natural fiber, thereby motivating a few weavers to spend the long hours spinning.[27]

The Maya revitalization movement may motivate younger generations to revive the beliefs, values, and

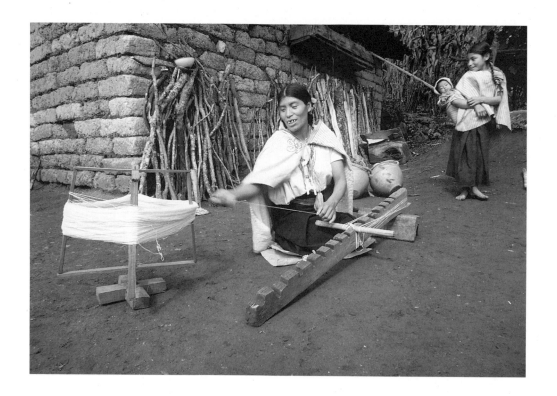

Women's work includes
setting up the warp of the
loom and child rearing,
in Chaktoh, Zinacantán,
Chiapas, Mexico

WEAVING AND DAILY LIFE

uses of natural brown cotton. In Tecpán, brown cotton, in addition to being used for the ceremonial overblouses, also was employed to cure physical ailments associated with the "evil eye" and to heal the umbilical cord of newborns. Its curative powers come from being *nim ruq'ij*, translated as full of strength or having a big sun, and from being *ruwachulew*, which means coming from the face of the earth or being natural. Possessing *ruqanil*, a word that means semen, creative force, and vigor, natural brown cotton was the foundation material of the *tioxb'al po't*, the overblouse worn in ceremonies by women captains of *cofradías*. The religious and cultural significance of this garment is reflected in its Kaqchikel name, which means *huipil* of gratitude.[28]

Maria, Isabel's daughter-in-law, is thirty-five years old. She did not learn to spin cotton but has been weaving on a backstrap loom since she was seven, when her mother prepared a small loom for her and taught her the basics: plain weaving and a very simple brocade design. Like many beginners, Maria got her yarns tangled up as she first tried to weave. They looked like a cat's whiskers, she recalls. Her grandmother took over the weaving lessons when her mother lost patience. Together they went to church to visit St. Lucía, the patron saint of weavers, taking colored yarns as offerings, leaving them draped over the saint's hands, and exchanging them for ones that had already been blessed. Grandmother also tapped Maria's hands with branches from a quince tree that had been blessed by the Christ Child. Every year at the end of December, the Christ Child is taken in procession through the streets of Comalapa. At each home He blesses the corn and bean seeds that will be planted the following

year and the water to be used for curing the sick. He also blesses quince-tree sticks used to tap the hands of children who have problems learning.[29]

Maria learned to warp the yarns on a warping board. Her grandmother taught her to count the yarns using two units, *kulaj* and *ximal*. The *kulaj* literally means a couple and is applied to a pair of warp threads. Weavers say, "Threads, like people, go in pairs, for a man or a woman cannot live alone." A *ximal* is equal to ten *kulaj* or twenty threads and is one of the units of measure derived from the vigesimal numeric system of the ancient Maya. In Maya languages, *jun winak* literally means one person and is how the number twenty is expressed. In rural bilingual elementary schools, Maya teachers explain that some aspects of this preconquest system based on the number twenty and related to a person's total number of fingers and toes are employed today by backstrap-loom weavers.

Setting up the loom, one of the last tasks Maria learned as a child, is a complex process lasting at least two days. On the first day, the warp yarns are soaked in corn gruel to strengthen them, and then dried in the sun. During the second day, the weaver transforms the sticks, a simple strap, the grueled warp, and the weft into a loom. In addition to the eight basic sticks – front bar, back bar, heddle rod, shed rod, shuttle, batten, tenter, lease stick – more may be used in some communities to execute certain techniques. In Comalapa two heddles allow the women to make a red band in the *huipil* with a weft-faced plain weave called *ka'i' ruchokoyil*, which literally means two heddles.[30] Ten or even more heddles are used in Santiago Atitlán to repeat brocade designs several times along the panel.[31] The hours invested in "programming" a particular design

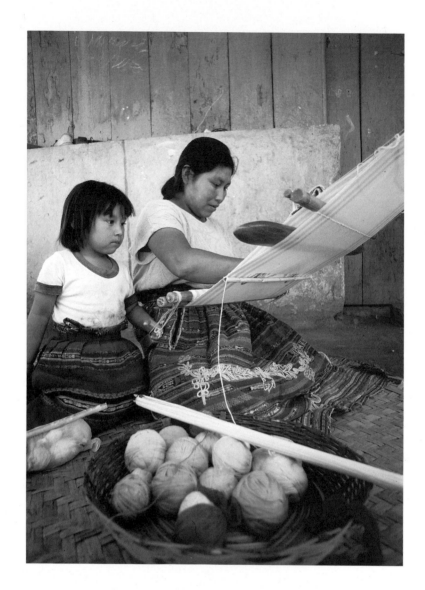

Young girls become weavers
by watching their mothers.
San Antonio Aguas Calientes,
Guatemala

with the heddles speeds up the task of brocading, since the weaver does not have to select the warps again and again to repeat the same pattern. Weavers from San Martín Jilotepeque use several small pattern sticks, akin to the batten, to select warps from selvedge to selvedge.

Molaj che, or set of sticks, is the Kaqchikel name for the backstrap loom. The set of sticks may be passed on from mother to daughter, bought in a marketplace, or made by a member of the household. During a trip to the woods, the weaver's husband may collect several sticks and afterward, at home, remove the bark and shape them with a machete. This scenario is common in Comalapa. Whether inherited, bought, or made at home, the sticks used to set up the loom acquire a certain patina after prolonged use, making them personal favorites of each weaver.

The aspect of weaving that Maya backstrap-loom weavers enjoy most is brocading. This is the technique by which supplementary wefts are interlaced with the warps to create designs. It is the art of painting with a rainbow of yarns. Maria, the weaver from Comalapa, refers to the local repertory of brocading techniques by their Kaqchikel names. These names are related to an action or to a tool associated with the technique. For example, *pajon*, which means to choose, is done by picking up certain warps with a pattern stick and then passing the supplementary weft from selvedge to selvedge. *Chi xik'a'y*, or with sticks, is a technique that allows the weaver to repeat a design that has continuous supplementary wefts, that is, one that goes from selvedge to selvedge. She uses one stick to separate the warps of each row of the designs. Some designs are done with ten sticks, others with more or fewer sticks. *Chi b'aq*, or with a needle, is a very time-consuming

technique. The woman "plants" (inserts in the background weave) several supplementary wefts in a row and then interlaces them with the warps using a bone pick. *Marcador*, a Spanish word used by Kaqchikel speakers, denotes a modern and prestigious technique that was originally developed in San Antonio Aguas Calientes and has spread to other Kaqchikel communities.[32] This technique, named after the sampler or marker, allows the weaver to copy designs from cross-stitch magazines and booklets and is completely reversible. Thus the designs woven with this technique are identical on both the right and wrong sides of a garment. For this reason it is called double-faced supplementary weft weaving in textile literature.

Many weaving techniques vary from one region to another and in some cases even between neighboring communities. The use of several other techniques, however, is far more generalized among the Maya. For example, warp-faced weaving is found from Chiapas, Mexico, to the Verapaz region in Guatemala. On the other hand, open plain weaving with single-ply white yarn is more restricted geographically, and is seen in Carranza, Mexico, and some communities of Alta Verapaz such as Cobán. Similarly gauze weaving, a technique in which warps are interlaced by means of a weft creating a texture akin to lace, is used in a few communities such as Cobán, San Pedro Carchá, and Santo Domingo Xenacoj.[33] While in the former two Q'eqchi' communities gauze weaving is used to create lightweight *huipiles*, in the latter Kaqchikel town women employ it to weave a band of the baby cap. Double-faced supplementary weft weaving is used in Jacaltenango, particularly in headbands, and in *huipiles* and *tzutes* from San Antonio Aguas Calientes.

The preferences in styles, colors, and designs of Maria, her daughters, and her mother-in-law vary according to generation and personal taste. Each one plans her weavings in advance and takes into consideration the norms that rule the design layout of each garment. For example, the Comalapan *huipil* has a red band at shoulder height. But each weaver decides the width of the band, the type of yarn, and technique to be used. The mother-in-law, Isabel, like most of her peers, likes a wide red band, while her granddaughters prefer a very narrow one. Similarly, each weaver chooses the design, technique, and combination of colors and yarns that will be used in the *ruxe runikajal*, or central band of the *huipil*, as well as in the other bands. Isabel enjoys having old animal figures in the central band of her *huipil*. Her daughter-in-law and her granddaughters are fascinated with the modern floral designs taken from cross-stitch patterns. This freedom of choice within a local design framework permits individual artistic expression to coexist alongside a community one. Through her *huipil* Maria communicates not only her social identities as Kaqchikel Maya and Comalapan but also her personal identity.[34] Not one of her *huipiles* is identical to the *huipil* of another woman. When Maria's favorite *huipil* dries on the grass near a public washing place, her acquaintances and friends can recognize it as her own creation.

Paula Nicho, one of Maria's friends, is not only a weaver but also a successful folk painter. Her works, like those of other Comalapan women painters who define themselves as surrealists, are characterized by the painted textiles that serve as the framework of the main scene or give texture to mountains, volcanoes, and other landscape elements.[35] One of her pictures,

The Weaver's Dream, illustrates how Maya women dream about garments with particular designs and colors. The painting depicts a gorgeous brown overblouse with multicolor geometric and zoomorphic brocaded designs. The neckline of the overblouse forms the profile of the weaver, and a landscape including clouds and a volcano can be seen in the distance through the neckhole.

Whether represented in detail on a canvas by a Kaqchikel woman painter or woven on a backstrap loom, fine *huipiles* and other garments meet a series of aesthetic criteria. Some of these are shared by Maya weavers in general, while others are more community-specific. General criteria include tight weaving, use of fine yarns, and good alignment of the two panels forming the *huipil*. Specific criteria may include covering even the smallest spaces with tiny brocaded figures and joining the two panels with brocaded zoomorphic designs, in such a way that the heads or the tails of the animals match up precisely.[36]

Weavers from each community learn the design layouts of different garments. Usually these layouts follow a bottom to top order, since that is the way women weave on the backstrap loom. For example, the layout of a blouse from Comalapa begins with a non-brocaded area that is tucked into the skirt and is called the *rachaq po't*, meaning the hips of the *huipil*. The first brocaded band, at the waist, is the *rukajin*, named after a simple design that is usually covered by the skirt. The next three bands, at chest level, form the main part of the design: the *ruxe runikajal*, or central drawing, and its accompanying *ruchi ruxe runikajal*, or borders. The symbolism of center is pivotal in the Maya world view; for example, the Tree of Life is thought of as

being in the center of the universe. In the context of textiles, the center usually has the most elaborate designs. There are three bands at the shoulder on the Comalapa *huipil*: two bands of multicolored stripes on either side of a solid red one. Once the weaver has reached this point, she has finished the back of the *huipil*. Now she weaves the front part following an inverse order. To brocade a bird, instead of weaving from the legs to the head, as she did with the back of the *huipil*, she starts with the head and finishes with the legs.

Designs usually are related to culturally significant domains. These relationships may be discovered through symbolic analyses, where Maya concepts and words for motifs and components of design layouts are crucial. The Kaqchikel name translated as "the hips of the *huipil*" illustrates the metaphoric use of the body as a spatial reference. This metaphor is also used in the context of the house, where the roof is literally the "head of the house." In Colotenango, a Mam community, the body and the family are used metaphorically in the textile domain. The central panel of a three-panel overblouse is called "mother of the *huipil*" and the lateral ones "arms of the *huipil*," while the basic units of warp design of both blouses and skirts are called "mother" and "children."[37] In Sololá the brocaded rows of the *huipil* are called "furrows," an example of an agricultural metaphor.

Individual brocaded motifs may be related to elements of everyday life, ceremonies, mythology, or cosmology. To an outside observer many designs are geometric, described as "rhomboids," "chevrons," or "zigzags." But Maya women refer to these motifs as "jars," "combs," "flags," and "seeds." In one of the ceremonial overblouses of San Pedro Sacatepéquez, department of Guatemala, an avian design of a turkey with a hanging head is often seen.[38] Called a "dead turkey," this motif is associated with the wedding ritual, in which a turkey is sent to the bride's parents as an offering from the groom's. In Chiapas, the universal design has four small diamonds indicating the cardinal directions and a line connecting east and west to show the path of the sun.[39] In Chajul, one of the three communities of the Ixil triangle, *huipiles* usually have human figures, four-legged animals, and avian forms. Several of these are related to the following myth:

The young lovers, Markao and Oyeb', had tried many things to stay together. Kub'aal, the father of the young girl, was opposed to their love affair. In desperation, they looked for a way to be together forever. They decided that Oyeb' should turn himself into a sparrow and come to taste the sap of a flower. Markao would then ask her father, who could not see very well, to kill the bird with his blowgun so that she could copy it and use it as a figure in her textiles. The old man shot at the bird but as expected missed. The sparrow fell to the ground, pretending the old man had good aim. Markao picked up the bird and placed it in her basket. At night the bird turned back into a man, this being the only way he could be with his beloved.

Kub'aal, however, soon began to hear his daughter talking at night. Intrigued, Kub'aal sent in a flea to slip under the door and find out what was going on. But the flea soon forgot about its mission and set about sucking the blood of Markao and Oyeb'. When it was full, it no longer fit under the door. Kub'aal, tired of waiting, sent in a louse, but the same thing happened. After two failed attempts, he decided to find out what was going on for himself. As he entered the room, he was surprised to see Oyeb'.

Kub'aal then decided to give his son-in-law several difficult tasks. The first task was to build a house, to demonstrate that he

was a man; but the house he asked for was large, with several doors, meaning several rooms, and he had only three days to build the house. Markao gave Oyeb' some strands of her hair and told him to bury them in a little valley so that the trees would grow rapidly. The next day they were ready to be cut down and worked on. On the third day, Oyeb' finished the house just as Kub'aal had asked and in the amount of time allowed. Strands of Markao's hair were used instead of vines to tie the beams together. Today, the vines still belong to her.

Kub'aal was dazzled by the construction, but suspected that his daughter's powers had something to do with it. He still did not accept Oyeb' as his son-in-law and decided to put him to more tests. This time he asked him to bring dry firewood for the steam bath when the rains were at their worst. Again, Markao gave Oyeb' some strands of her hair and told him to bury them at the bottom of a hill so the trees would dry more quickly. Pine and fir trees are nothing more than strands of Markao's hair.

The next day, Oyeb' took the dry firewood to his father-in-law. But fearing another task, the young lovers decided to run away while Kub'aal was taking a steam bath. Kub'aal found out about the escape and sent a lightning bolt to kill his son-in-law; but it reached Markao instead.

When Oyeb' discovered what had happened, he collected the scattered bones of his beloved, wrapped them in a cloth, and took them to his aunt's house. Hoping that by keeping all the bones together, Markao might somehow be revived, he placed them in a covered pot and ordered that nobody touch them. The aunt did not obey. She opened the pot, and bees, rabbits, squirrels, deer, and all sorts of little animals came out.

Realizing there was nothing he could do, the young man began to cry. A woodpecker came to Oyeb' and took him to a hollowed-out tree trunk where a bees' nest hung. "This is where your wife is, but she has turned into the bees and other little animals. From now on, she will feed the people."[40]

TEXTILES AND THE LIFE CYCLE

Among the Maya, as with numerous other ethnic groups, baptisms, weddings, and funerals are ceremonies related to the different stages of life. In Maya culture, textiles play an important role in these socially constructed dramas. When a baby girl is born, her umbilical cord is buried below the hearth or in any other place associated with the domestic domain and the female role. A baby boy's umbilical cord is buried in a field, under a tree, or tossed into a river. These places belong to the nondomestic domain associated with men. However, in many communities, from birth to baptism a baby boy is dressed similarly to a baby girl. At baptism the baby receives not only a name, but also a visual gender identification: either a male or a female costume. The godmother weaves or buys the corresponding garments for her godson or goddaughter: a huipil and a skirt for her or a shirt and trousers for him.

Later in life, when a wedding socially sanctions the union of a couple, textiles and garments contribute to marking changes in status or the creation of alliances between families. In Sololá, Santa Catarina Palopó, Todos Santos Cuchumatán, and other places where women continue to weave men's garments, a man may take into consideration the weaving abilities of a prospective wife. His friends will admire or criticize his garments depending on his wife's skill, and these observations will reflect either well or poorly on him.

In Comalapa and other Maya towns, once the bride's parents have accepted the wedding petition she has to start weaving her wedding attire, especially the huipil. Traditionally, the bride-to-be would also weave a present for her future husband: a shirt, a sash, or a handkerchief. Women from the groom's family may

Mixing traditions: a bride in
Patzún, Guatemala.

begin to weave certain ceremonial textiles, such as the large *tzute* that covers the gifts presented to the bride's parents before the wedding. Depending on the amount of time and money available for yarn, female friends and relatives of the bride may also weave garments and utility cloths for the wife-to-be. These, as well as other presents such as kitchen utensils, are blessed in front of the family altar of the groom's house as part of the traditional wedding rituals. Several days later, at the groom's house, the mother-in-law supervises her daughter-in-law's weaving. If the new bride is still in the process of learning, her mother-in-law will act as her teacher.

Beliefs and practices regarding weaving and fertility vary from one community to another, but they demonstrate how this relationship has endured since the pre-conquest period. Among the ancient Maya there were female deities associated with the moon, fertility, and weaving. For example, in the Trocortesiano Codex, Ixchel, a moon goddess, is depicted weaving on a backstrap loom. The goddess is holding an instrument in her left hand, which could be either a brocading pick or one of the sticks forming the loom. Martin Prechtel and Robert Carlsen have documented a contemporary case in Santiago Atitlán. There, the process of weaving is metaphorically related to the process of giving birth to a child and to the daily regeneration of the cosmos through the movement of the sun around the world and underworld. In the same community, when a baby is not in the correct head-down position, the midwife may pass the sticks of the backstrap loom over the mother's belly in order to rotate the baby's head toward the birth canal. As Prechtel and Carlsen have pointed out, this ritual is metaphorically related to the way

backstrap-loom weavers rotate a textile after they have finished setting up the loom.[41] Once they have woven about an inch on the lower end of the loom, they interchange the position of the end bars, placing the woven part at the upper end. Then they start to weave again from the lower band up.

The relationship between weaving and fertility also is illustrated by the advice given to pregnant weavers by older women in Comalapa and other Maya communities: "Finish your weaving before the baby is born. Otherwise the baby may be born with a problem." Another popular belief is that a pregnant woman should not step over the rope that suspends the loom in place. It is believed that if she does the child will be born with the umbilical cord wrapped around its neck. Here the parallel relationship between creating a textile and gestation is implicit.

As a weaver ages, her eyes begin to tire. Without proper glasses she may no longer be able to do the finer aspects of weaving such as certain types of brocading. Therefore, she relies on her daughters or daughters-in-law to weave garments for her. If she depends on weaving to make her living and does not have female help in her household, she will turn to weaving garments that do not need brocading. Finally, when a woman is old and she thinks her life is coming to a close, she prepares the clothing she wants her loved ones to dress her in when she departs for the afterlife. If she can still weave, she will make her *huipil* and other garments. If she does not weave anymore because of her age, she may commission the garments to a relative, a friend, or an acquaintance.

In the mid-1980s I visited an old woman in Colotenango, a Mam community in Guatemala's north-

western department of Huehuetenango. She was born in the 1890s and was about ninety years old. She showed us the new skirt she had ready for her burial. It was a blue wraparound skirt with small brocaded designs done in brightly colored acrylic yarns. This single garment captured two epochs she had witnessed: the beginning and the end of the twentieth century. The solid blue ground of her skirt was fashionable in her hometown at the turn of the century, while the bright colors of the acrylics used for brocading corresponded to a fashion trend of the 1970s and 1980s.[42]

Just as human life goes through cycles, so do textiles. Usually a weaver makes a textile with a specific purpose in mind. For example, she may weave herself a *huipil* to wear for the first time at her graduation, her wedding, her investiture as a *cofradía* member, the next town fair, Christmas, New Year's Eve, and so on. Once the big event is over the woman may wear it for other festive occasions, such as attending a wedding or a baptism. As the garment wears out it becomes an everyday item, to be worn for staying at home, working in the fields, or similar situations. When the woman's daughters grow enough to wear adult-size clothing, she may pass on her old *huipil* to them. Finally, after passing through these different stages of usefulness, the old *huipil* will be cut to make diapers.

WEAVING ON TREADLE AND BACKSTRAP LOOMS
The backstrap loom is a portable device. It may go everywhere the weaver wants: the cornfield, a river or lake shore, even to mother's house. The weaver rolls it up and wraps it in a *tzute*, and it is ready to go. In addition to its small size and portability, the backstrap loom is inexpensive. On the other hand, the treadle loom is large, has to be set up permanently in one place, and is relatively expensive. Some weavers who do not have enough room may ask friends or relatives to provide a place for their treadle loom. As production for national and international markets has increased, some weaving entrepreneurs have rented and even bought houses, converting them into textile workshops.

In order to set up a treadle loom, a significant amount of money must first be invested in a wooden structure, attachments, several pounds of yarn, and specialized labor. The total cost of setting up a treadle loom will depend on its size, the model, and the number of attachments. Generally speaking, the price will be the equivalent of the wages earned for anywhere between 35 and 170 days of work.[43] To collect the cash needed to make a down payment on a treadle loom, weavers must either save for quite some time, borrow money from a relative, or sell some of their own goods such as chickens or pigs.

Just as backstrap looms have been historically associated with women, so treadle looms have been with men. This gender division of labor in textile production, however, has not been static but rather subject to changes, particularly during the second half of the twentieth century. Although only a very small number of men have learned to weave on the backstrap loom in the context of childhood socialization, such as in San Antonio Aguas Calientes and Sumpango, others have had to do so under very special circumstances. Such was the case of Guatemalan Maya men living in refugee camps in Mexico during the 1980s. Mexican government policies at the time initially prohibited Guatemalan refugees from working in Mexico. Refugees began to produce textiles to be sold in United States

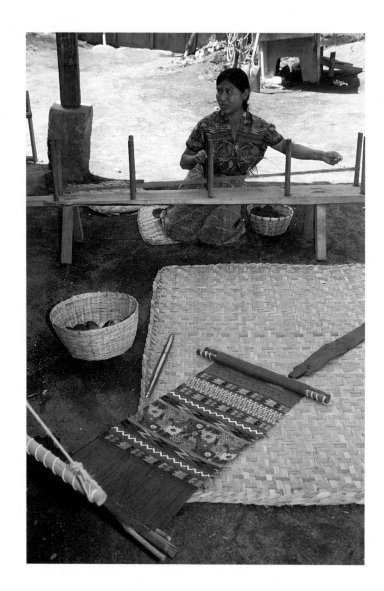

Backstrap loom in foreground; Mirsa Xicay setting up the warp in San Antonio Aguas Calientes, Guatemala.

markets, and some of the men learned to weave on backstrap looms. As a result of this unusual experience the men began to fully appreciate the skills involved in women's textile work.[44]

Women entering into treadle-loom production is more common. The case of Comalapa is a good example. In the 1940s and 1950s treadle-loom weaving was strictly part of the male domain. Only a few wives and daughters of male weavers knew how to operate a draw loom. A draw loom is a treadle loom with additional heddles allowing the weaver to repeat a pattern several times. In the 1960s, Peace Corps volunteers organized a weaving club for women that encouraged the use of both treadle and backstrap looms. These women produced textiles for both local and international markets.[45] According to a survey, by the early 1990s there were more women in Comalapa engaged in textile production on treadle looms than men.[46] Thus, in a period of only three decades treadle-loom weaving became locally defined as a field of work for both men and women.

In the tourist markets consumers rarely distinguish between textiles woven on backstrap looms and those woven on treadle looms. This distinction, however, is fundamental to many Maya, especially for those who live in communities where both types of loom exist. A weaver may spend less than eight hours on a draw loom to make a *huipil*, but she would need four to six weeks, working eight hours a day, six days a week, to make a *huipil* on a backstrap loom.[47] Clearly, there is more time and effort invested in making a *huipil* on a backstrap loom. Programming a pattern of eighty heddles on a draw loom, however, may require two or more weeks of intense work to make the heddles and then to install them correctly on the loom.

Just as backstrap-loom weaving requires a long, gradual learning process, so too does treadle-loom weaving. Children learn to weave early, often by the age of ten, by apprenticing in a textile shop. The progress to full weaver can take as long as ten years.

THE MARKETPLACE: SOURCE OF COLORS, THREADS, AND INSPIRATION

The markets of Guatemala's highlands are in transition between two different organizational systems. With its roots in the pre-conquest period, the indigenous system revolves around the *plaza* concept, an open space for commercial exchange located in the community *plaza* and its nearby streets. Until several decades ago, the municipal origin of the merchants, rather than the type of goods they offered, was the organizing criterion in the *plaza*. Most vendors would sit on *petates*, or mats, on the ground. Exchange focused on social interaction between the participants, and bargaining played an important part in the communicative pattern. The marketplace was an area used not only for commercial transactions but also for chatting and gossiping, keeping in touch with friends, and finding out about the world outside their own communities. The *uk' ux kayb'al*, or heart of the market, was located in the center of the town's *plaza*, around a fountain, a cross, or other monument.[48]

On the other hand, influenced by Western tradition, the Ladino system adheres to the concept that the *mercado* should be held in an enclosed space or building, where the organizing principle is the type of product being sold. Regardless of their geographic origin, sellers offering the same kinds of goods — meats, vegetables, grains, clothing — are placed together. The

spaces within each section of the market are rented on a long-term basis, and preference is given to local vendors. Contrasting the idea that "dirtiness" is associated with floors and streets, in the *mercado* system, the concept of "cleanliness" underlies the practice of placing goods up on tables and counters. Today, elements derived from both the *plaza* and *mercado* systems may be observed in many highland markets.[49]

Yarns and threads, sticks for backstrap looms, *huipiles*, *tzutes*, and all kinds of textiles converge in the highland marketplaces together with vegetables, fruits, grains, meats, chickens, pigs, and household appliances. These marketplaces attract people from many different hamlets, towns, regions, and, in some cases, even other countries. Chichicastenango's market, for example, is a popular attraction for many tourists visiting Guatemala. Held on Thursdays and Sundays, this sprawling marketplace covers the *plaza* and spills out into dozens of surrounding streets with countless stalls and booths. Visitors often climb the steps of the Santo Tomás Chichicastenango church where ancient rituals are performed by K'iche' religious leaders. From this vantage point there is an impressive view of this famous marketplace attended by thousands of Maya from Quiché, Sololá, and other departments of Guatemala.

Market days have a special social and economic meaning for Maya.[50] In Colotenango, the *plaza* market is held on Saturdays, but traders start coming in one day before. Idalma Mejía de Rodas's description of this market gives us a look at the many details making up this important event:

On Friday night *sanjuaneros from San Juan Atitán play cards to entertain themselves.* Todosanteros *from Todos Santos Cuchumatán wash potatoes in a public wash stand while other merchants set up their stalls. The market begins at dawn on Saturday and by nine o'clock in the morning it is hard to walk in the crowd. By this time middlemen, from the departmental capital of Huehuetenango, have purchased the small amounts of goods brought in by villagers from the surrounding hamlets. Vegetables come in from San Sebastián, Santa Bárbara, San Gaspar, Ixtahuacán, and Almolonga; rope and nets from Concepción Tutuapa; pottery from Ixtahuacán and Santa Bárbara. Merchants from San Juan Atitán bring clothing and sandals. The hamlets around Colotenango supply molasses, oranges, limes, lemons, tomatoes, and peanuts. Women from San Gaspar Ixchil bring* atoles *(hot beverages made of corn, rice, and other ingredients) and cooked cassava and sweet potatoes. Ladina women from Colotenango sell homemade cigarettes. Live animals including chickens, hens, roosters, turkeys, pigs, cows, and sheep are sold in a separate area.*[51]

Women from Colotenango and nearby towns dress up to go to the market. They wear their festive *huipiles* and arrange their hair in intricate styles using very long ribbons woven on small tape looms. In addition to buying salt, molasses, coffee, and other products for their kitchens, they take this opportunity to buy, or at least to look at, yarns. Since there is a good selection of materials in a wide range of colors, they have to think in terms of the function of each yarn. Some are used for the background, others for the weft of the background only. Fine cottons and acrylics are usually preferred for brocading. Informal units of measure such as the *brazada completa* (the distance between the hands when both arms are fully extended) are used to buy smaller quantities of yarn for brocading, while the larger amounts needed for the background are sold in skeins or by the pound.[52] In other, more well-off communities, the pearl cotton, rayon,

and silk used for brocading and embroidering may be purchased in the market in small skeins and spools. Vendors display colorful threads in large baskets, on tables, and even spread out on sheets of plastic on the floor. Weavers deliberately choose the threads they need, carefully combining colors and tones, all the while imagining how they will fit into each of the designs they are contemplating.

In Colotenango most of the women weave their own *huipiles*, skirts, and sashes. In the marketplaces of other regions, however, Maya women find not only yarns and weaving tools, but also ready-made woven garments. San Francisco El Alto, Quezaltenango, and Totonicapán are famous for the variety of ikat-patterned skirts and machine-embroidered *huipiles* available at their markets. Occasionally a bride and her family may make a trip to one of these communities to buy an outstanding skirt or a very special *huipil* for the wedding.

A Kaqchikel silversmith once told me that he had learned his craft by "stealing with the eyes."[53] This concept of learning and getting ideas by looking at another's designs and colors is part of every weaver's daily life. At the marketplace, a wedding, or any social gathering where women wear new or fine garments, a weaver's eyes are attracted to the motifs, colors, textures, and brightness. What impact will the foreign *huipil* have on these curious weavers? Will they try to weave one of the designs? Will they try new combinations of colors? Though there are no answers, the textile record of the last decades shows a diffusion of motifs and techniques throughout the Maya world.

At the marketplaces most often visited by tourists, such as those of Sololá, Panajachel, Antigua, and Chichicastenango, there are thousands of textile products designed specifically to be sold to tourists. Weavers and merchants easily distinguish textiles woven for tourists from those woven for Maya. The former are often made more economically taking into consideration Western tastes and styles. For example, today, some textiles are dyed in purple or ocher changing the original colors to appeal to foreign customers. Bedspreads, jackets, bags, and other products made with patchwork are fashionable among tourists. On the other hand, the textiles produced for Maya consumers follow ethnoaesthetic norms, that is, culturally defined aesthetic rules, which may be community-specific or regional.

The *tzute* is the most versatile and omnipresent textile seen throughout Maya markets. It is made from one or two pieces of cloth woven on either backstrap or treadle looms. In some communities such as Santa Bárbara and San Mateo Ixtatán, in the department of Huehuetenango, however, women use embroidered *tzutes* made of muslin and other industrially made cloth. Usually the colors and designs of these textiles are community-specific, ranging from plain solid colors, to many-colored stripes, to rich and colorful brocades. Some larger *tzutes*, called *tanateros*, are used by itinerant merchants throughout Guatemala. The Spanish name for these *tzutes*, which are characterized by multicolor plaid designs, comes from the word *tanate*, meaning bundle. Traveling merchants use them to carry a wide range of products, from fruits and vegetables to seafood and blankets. Carrying their loads, they travel to the different markets that take place every day of the week. Men carry *tanates* on their backs, holding them in place with a leather band, called a *mecapal*, stretched across the forehead, while women balance them on their heads.

Tzutes are often described as multipurpose textiles. But the uses a particular type of *tzute* may serve are ruled by community norms. One of the best documented examples comes from Sololá, the Kaqchikel town that inspired the appelation the "Balcony of Lake Atitlán"[54] due to its privileged geographical location. *Tzutes* from Sololá have solid-colored stripes alternating with ikat-patterned bands. Kaqchikel inhabitants distinguish several types of *tzutes* according to size, design, function, and the wearer's gender. Generally speaking, both men and women use *tzutes* and other textiles in a very creative and practical manner. All the *tzutes* used by women have white and brown stripes incorporated in the multicolor-warp design. The rectangular *kupraj tzute,* the largest one used in this community, is worn for warmth or to carry a baby on the back and is distinguished by a wide blue or black stripe. The carrying *tzute* is almost square and of medium size. Women use it in the market to make bundles, to cover baskets and merchandise, and when worn over the head, to provide shade. Its Kaqchikel name, *sub'al chi'ij,* literally cleaner of the mouth, may possibly refer to a ceremonial use of the past. The *pisb'al way tzute,* or *tzute* for wrapping tortillas, is much smaller. As its name suggests, it is used for wrapping up tortillas and other small items as well as for covering small baskets.[55]

Men's *tzutes,* on the other hand, have distinctive warp units with blue or green stripes. The *sutal,* or top, *tzute* is often worn on the head, but its use is intimately related to the political and religious hierarchy of Sololá, which is a combination of the Kaqchikel town council, the *cofradías,* and servants of the church. Depending on the wearer's charge, the *sutal tzute* is worn in differ-

ent ways: the *mayordomo* wears it twisted around the waist; the *mayor* and the *alguacil* around the neck; the *calpul* and the *alcalde auxiliar* wear theirs twisted and wrapped around a hat; and the highest authorities, such as the *alcalde,* the *cofrades,* and the *regidores,* wear the *tzute* tied around the head. The *numasu't,* or large, ceremonial *tzute,* is worn by the main *cofrade* and as a special privilege by the *texeles* or women captains of the *cofradía.*[56] On Fridays, market day in Sololá, religious and political officers may walk through the crowds on their way to the Kaqchikel town council or to the church, which are located around the central plaza. These important social leaders may be recognized by the rest of the community by the way they wear their *tzutes* and other ceremonial garments.

Every year on January 6, the day of the three kings, the Sololá market becomes an important part of the circuit run by the *regidores* paying homage to their patron San Gaspar. The *regidores* divide into two groups, each one accompanied by a *fiscal* from the church. Carrying an image of the Christ Child suspended from the neck in a *tzute* filled with rose petals, the *regidores* literally run through the town's streets visiting homes where the Christ Child blesses the families and in turn receives some token of gratitude. At the marketplace the Christ Child visits the various merchants spread out along the streets sitting on woven *petates* or colorful *tzutes,* blessing them and bringing them good fortune in their endeavors.[57]

The *atoleras* are women who sell *atoles,* the hot beverages made of corn, dough, lima beans, rice, plantains, and other items that make up the Maya diet. They are found in the markets throughout the Maya region and often in church entrances, and typically several

tzutes carry out different functions at their posts. Once made, the *atol* is poured into large clay jugs covered in plastic and then wrapped in several *tzutes* to keep it warm. The entire bundle is placed in a basket and balanced on the woman's head on top of another twisted *tzute* that forms a type of pad. In this fashion, the *atolera* carries her rich drink to and from the market. A child might be placed to rest in a box beside its mother while she works, cushioned and protected by several textiles. On chilly mornings and evenings the *atoleras* wrap themselves in their *tzutes* or shawls called *perrajes*.

Weaving represents one of the most deeply rooted continuities of the Maya culture. Within the context of contemporary political movements through which Maya are struggling to establish ethnic and political rights, weaving, clothing, and textiles function as powerful cultural symbols. The women leaders of the Maya revitalization movement wear clothing from different communities as a statement of pan-Mayanism. While most men have given up the use of their traditional clothing, many of today's male leaders express their ethnicity by wearing some garments made with patterned cloth woven on backstrap or treadle looms. Additionally, others are wearing their hair long as their pre-conquest ancestors did. Some Maya women exiled in the United States are weaving textiles on the backstrap loom in order to maintain a link with their roots, to earn income, and to promote political solidarity selling their textiles at activist events. A woman who won a seat as a representative to the Guatemalan Congress for the period from 1996 to 2000 wore throughout her campaign a hairband that alternated the initials of her political party with traditional designs, thus effectively using clothing to convey both political and ethnic messages. As the ancient art of weaving enters the twenty-first century, it functions both as an economic activity permitting Maya to provide clothing for the family and textiles for a global economy and as a means of expressing their world view and their social and political standing.

Weaving and Daily Life

High in the Cuchumatanes
Mountains a young Todos
Santos woman does her
wash in a fast-moving stream.
Guatemala

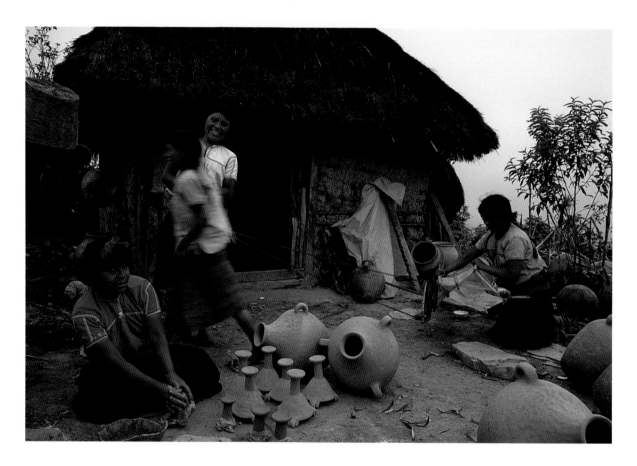

The Maya have made
ceramics for centuries. In
this rural Chamula setting,
the scene is one of intense
work at cottage industries
that produce goods to be
sold in the market – water
jugs, incense burners (placed
upside down), and textiles.
Mexico

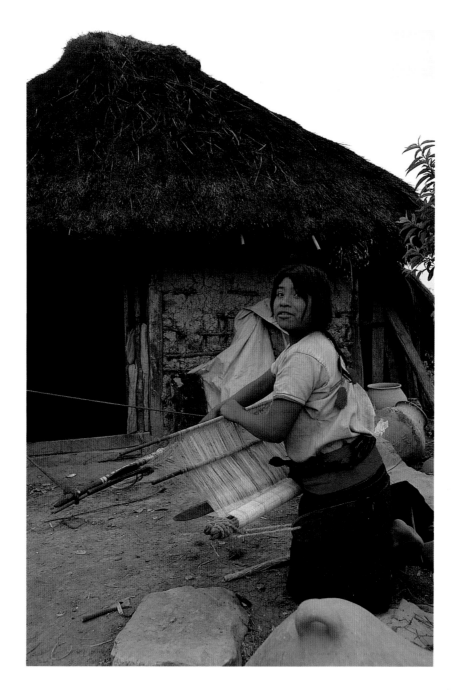

In front of her traditional-style house (a *jovel 'na*, or house with a thatch roof) of sticks covered with mud, a Chamula weaver raises the shed of her loom. Mexico

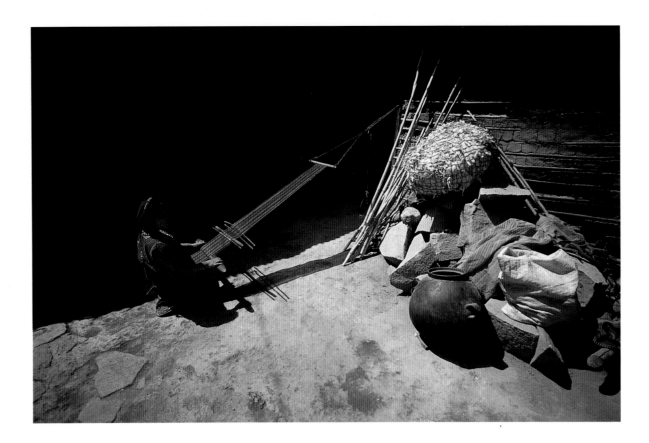

The sun in San Antonio
Palopó cuts shadows like a
razor. The backstrap-loom
weaver sits on the well-
groomed patio in the privacy
of her family home.
Guatemala

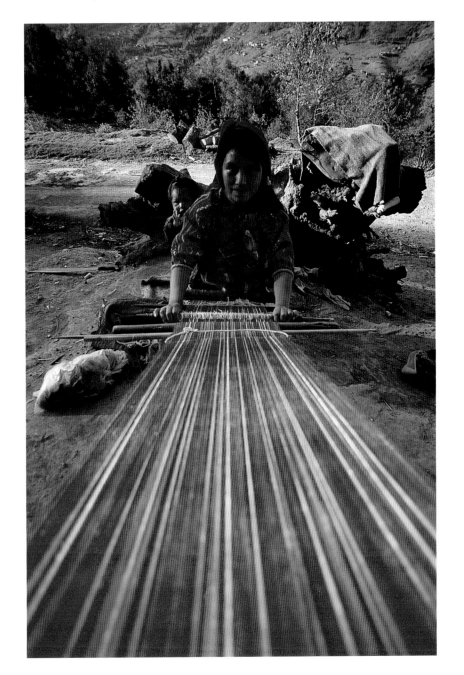

In San Juan Atitán, as in many other Maya communities, red is the dominant color of the textiles. All the warp threads are carefully counted before the weaving begins. The tension on the loom is controlled by the weaver's movement, back and forth, rocking the baby as sheds are opened and the batten is inserted. Guatemala

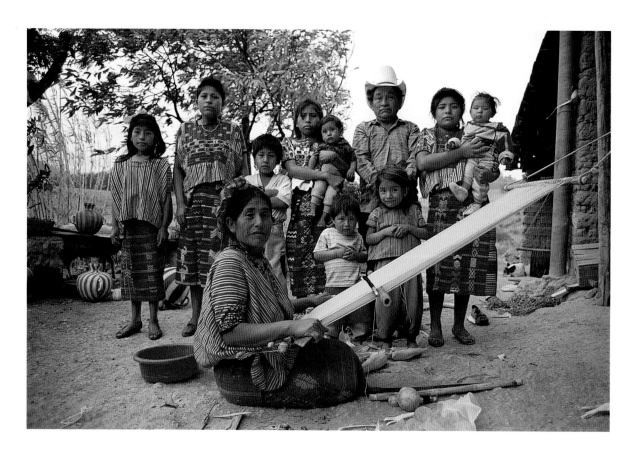

In the Colotenango area,
many different *huipil* and
skirt styles coexist depending
on the age and preference
of the wearer. Men, however,
no longer wear traditional
clothing except for special
occasions. Guatemala

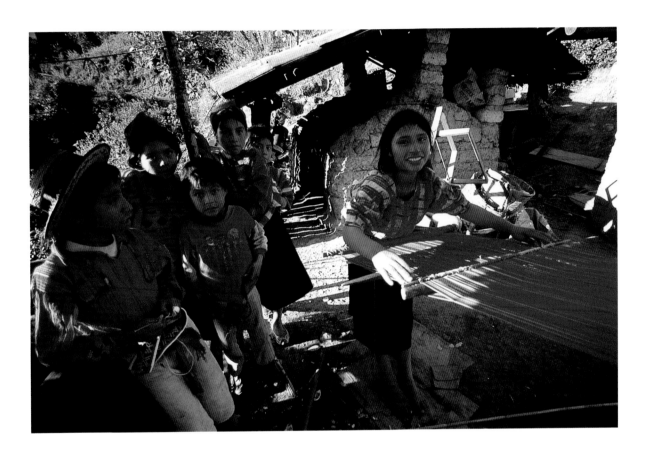

The young woman said she
weaves twelve hours a day.
Fortunately she is visited in
San Juan Atitán by her
friends who are younger and
do not work long hours.
Guatemala

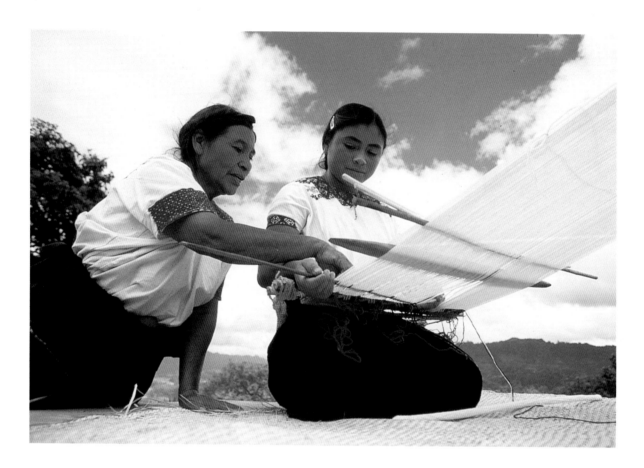

Rosha Hernandez, master weaver from San Andrés Larrainzar, instructs her niece on the subtleties of supplementary weft bro- cading, the most common method used by Maya weavers to create surface designs. Chiapas, Mexico

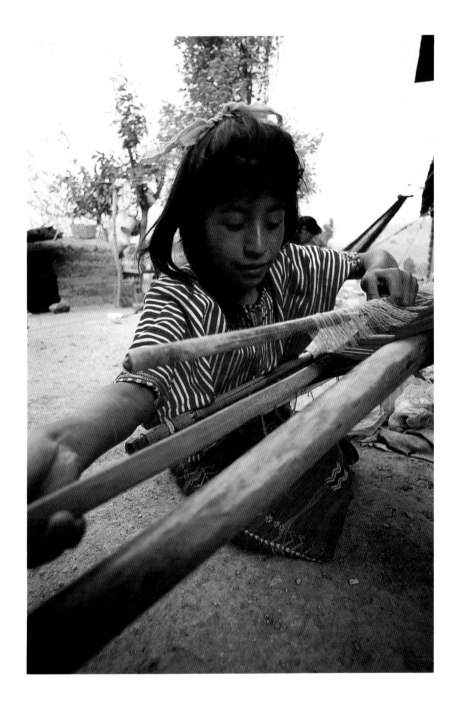

For young girls with short arms each row requires great concentration, a long reach, and lots of patience. Colotenango area of Guatemala

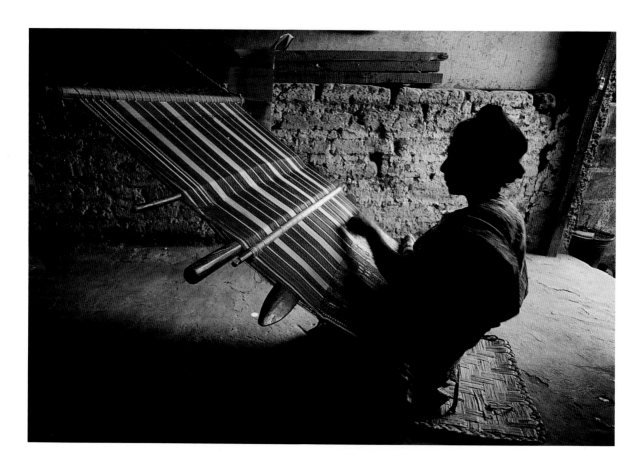

In the community of San
Juan Sacatepéquez, work
continues on a rainy day
with the loom set up near
the light of the doorway.
Guatemala

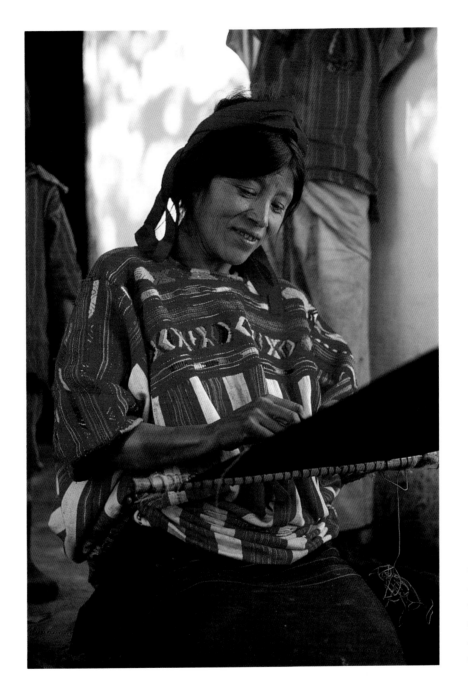

A white wall of a San Juan Atitán home reflects back the dappled light of late afternoon. Soon weaving will cease and dinner preparation will begin. Guatemala

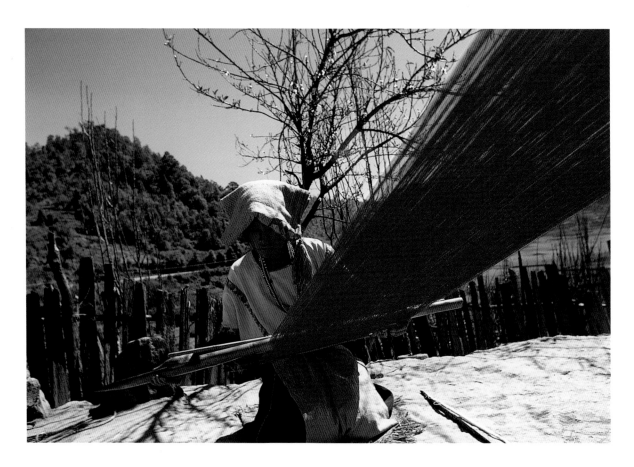

Maruch Tulán shades her head from the sun. The fashion this year in Navenchauc is more bold colors, and she happily uses them on a tunic she is weaving for her brother Antun. Zinacantán, Chiapas, Mexico

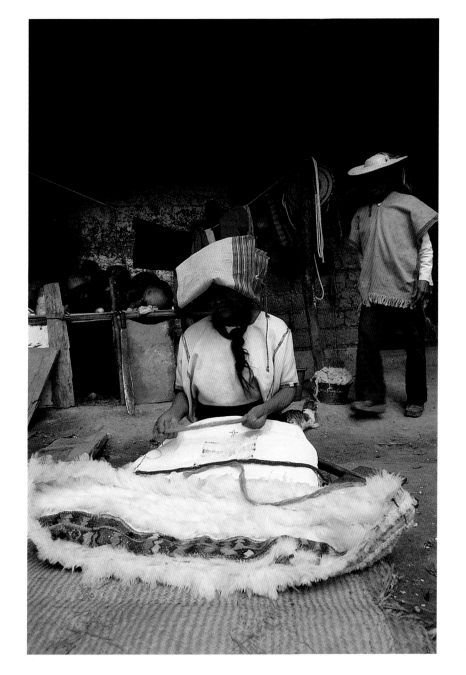

Maruch's mother, Xunka, is one of the best weavers in Zinacantán. Xunka is putting the final touches on a feathered wedding *huipil*. The feathered technique is an old tradition passed down through generations. In the background, Manuel Tulán wears a hat of fine straw he braided into long strips and sewed into the traditional Zinacantán style. Chiapas, Mexico

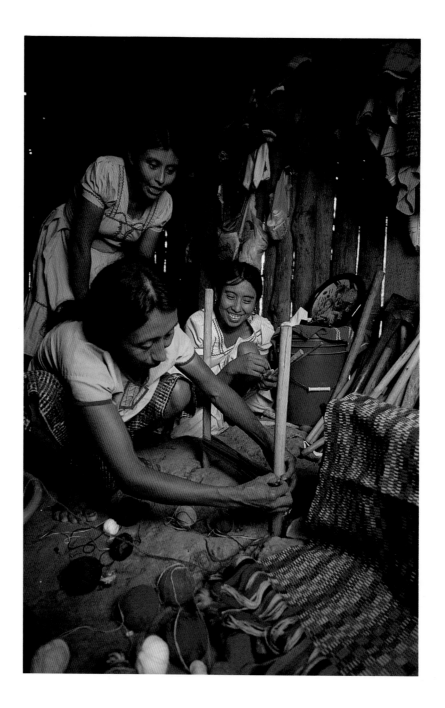

The weaving tradition
almost died out in Belize.
In the Toledo District near
the Maya Mountains at
Indian Creek, Petrona Chub
and her two daughters are
preparing a warp on the
floor of their house. Belize

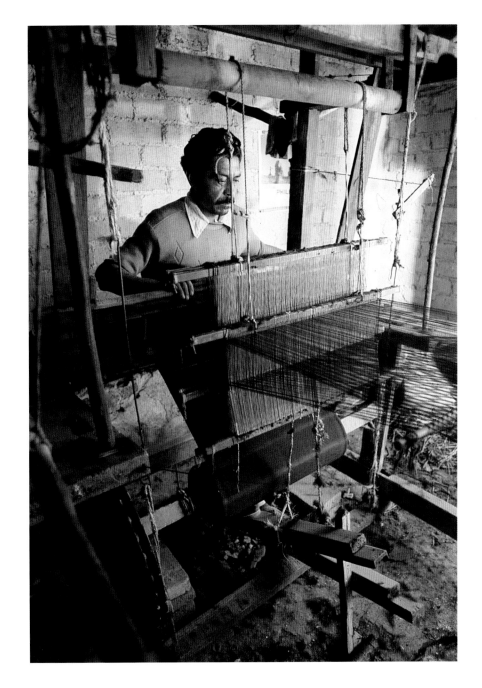

Whereas the backstrap
loom has been part of Maya
culture for millennia, the
foot or treadle loom is a
piece of Spanish technology
that is still in use, and
operated mostly by men.
Chiapas, Mexico

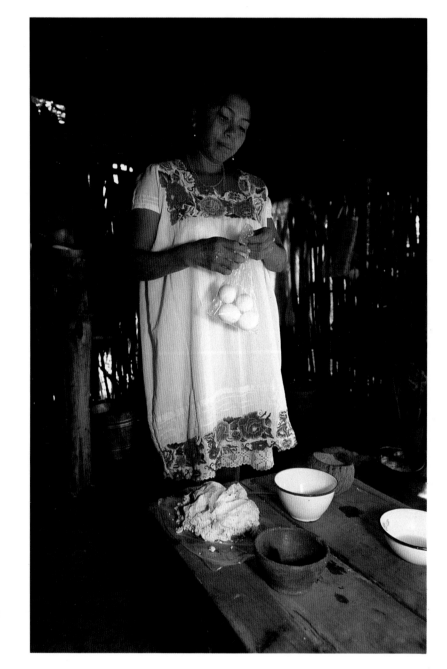

In the warmer climate of the Yucatán, women wear white dresses of commercial cloth, which they decorate with colorful embroidery. White underskirts complete the costume. Fashions may change from Chiapas to the Yucatán, but the tortilla remains a constant among the Maya. A community next to Chichén Itzá, Yucatán, Mexico

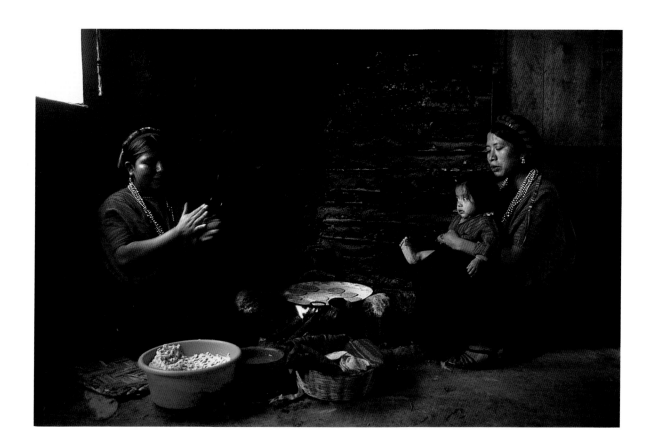

Two women chat as corn tortillas are fashioned by hand and placed on the hot griddle; this *comal* is not made of clay but from the top of a fifty-five-gallon drum and covered with a limestone paste to keep the tortillas from sticking. Maya staples also include squash, beans, and chilis. San Antonio Palopó, Guatemala

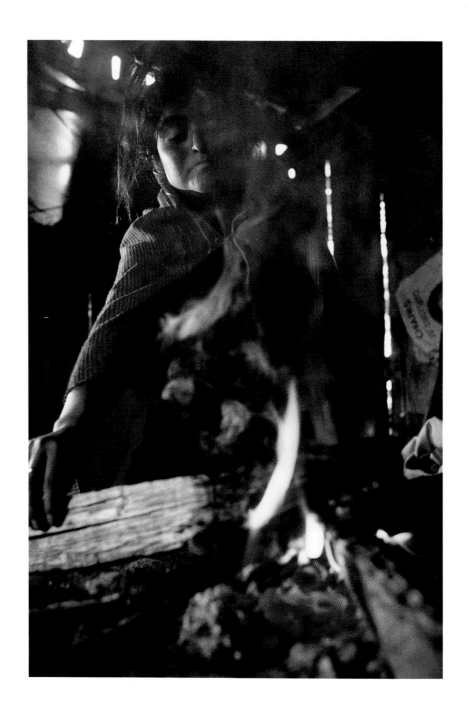

Petrona of Nachig, Zinacantán, adjusts the heat of her fire. Fires are left to smolder between meals and bringing it up to cooking temperature requires impressive skill. Mexico

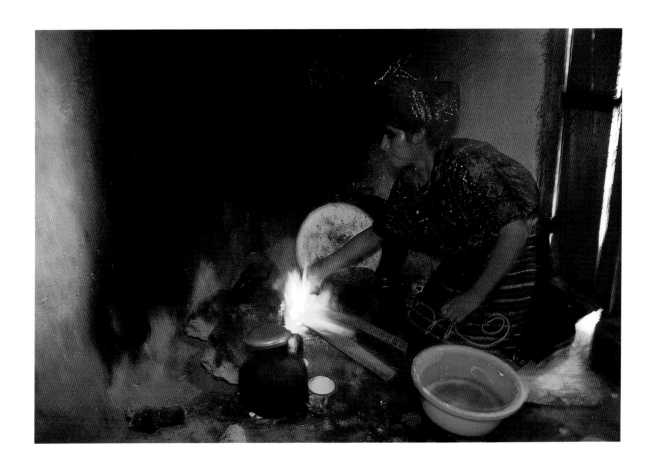

Cooking in Santa Catarina
Palopó, Guatemala

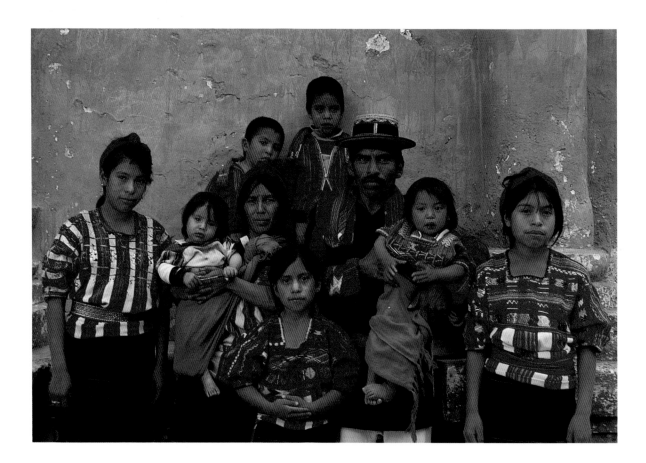

The sacristan and family
take care of the church in
San Juan Atitán. Families all
wearing traditional costumes
are more prevalent in rural
places. Guatemala

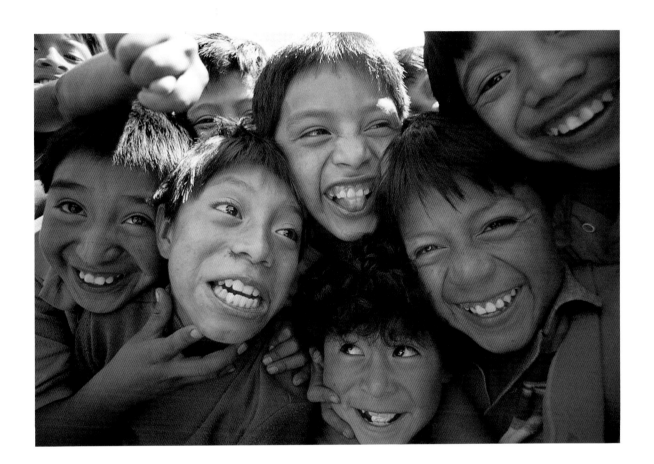

Young boys who work in
the market at Almolonga
carrying goods are happy to
show their silliest faces.
Guatemala

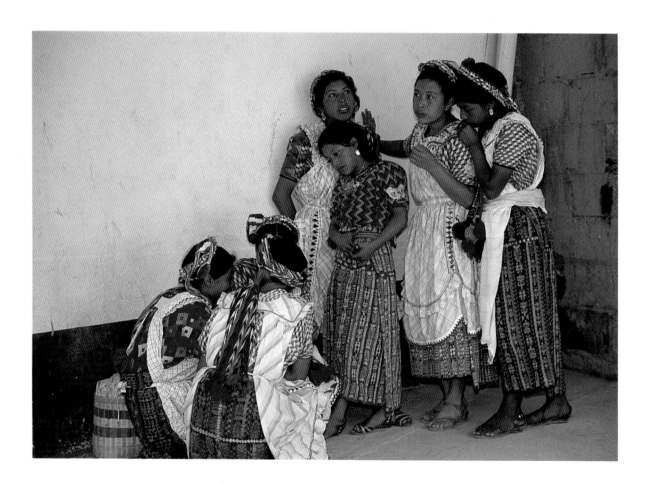

Waiting in anticipation of a wedding procession to emerge from a small church, these girls from Almolonga share an intimate closeness with each other, yet have no eye contact. Appropriate wedding clothing includes a fancy white apron or *gavacha* that covers the *huipil* as well as the skirt. Guatemala

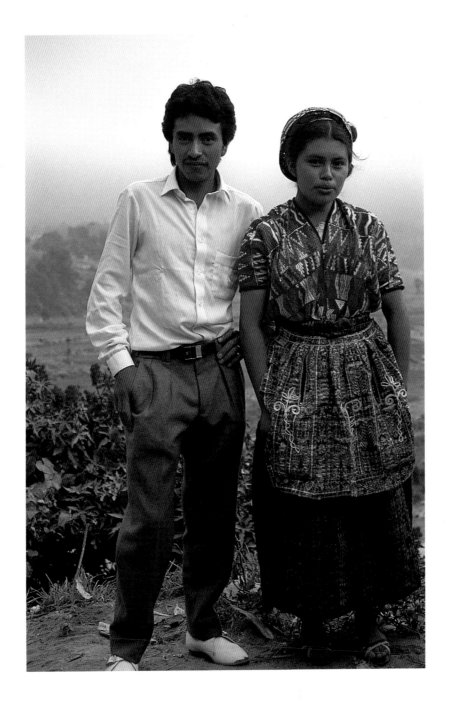

The wedding couple, Cile and José, relaxed and posing for pictures after the ceremony in Almolonga, Guatemala

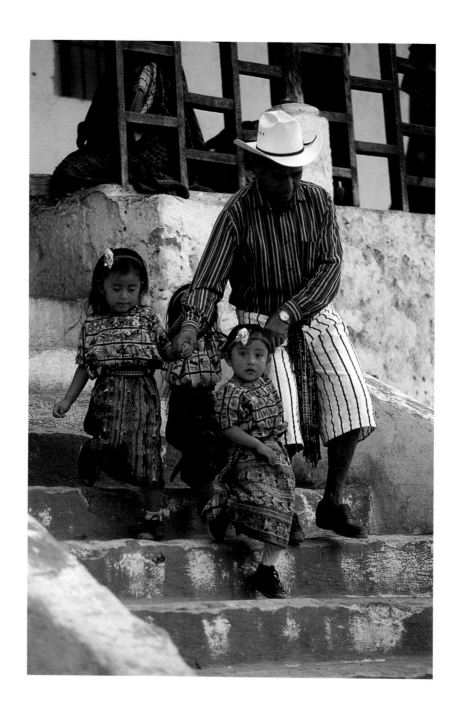

The children are dressed in their best clothing so as to please the Sun, "Our Father," at a fiesta. Diego Ratsan of Santiago Atitlán takes over the child care responsibilities. Guatemala

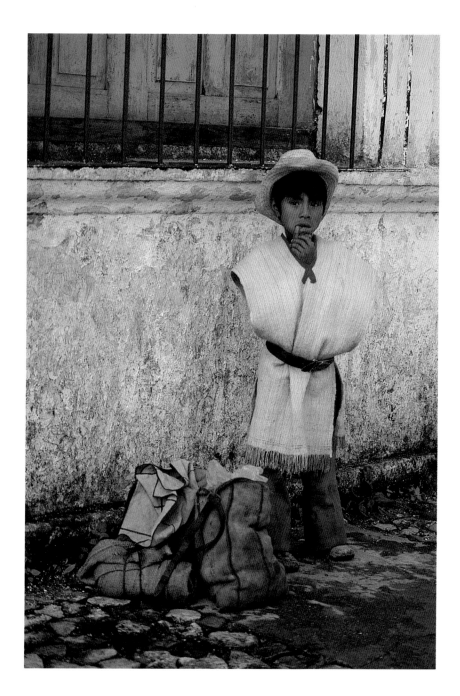

At the edge of the market
in San Cristóbal de las
Casas, a boy from Chamula
watches over the market
purchases while he waits
for his family to return. To
protect himself from the
chill of the high mountain
air, he pulls his arms into
his backstrap-loomed woolen
tunic. Mexico

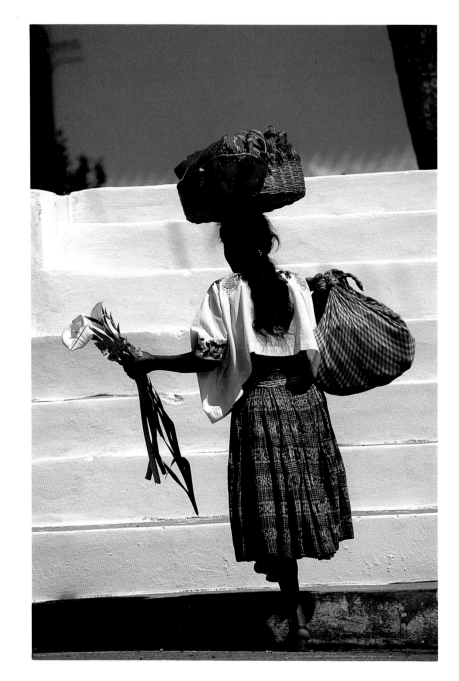

In the city of Cobán, a Maya woman makes her way to the market to sell her goods. Cobán has been strongly influenced by German farmers who began to arrive in the late nineteenth century to cultivate coffee. *Cobañeras* wear a gathered instead of a wraparound skirt and a short *huipil* not tucked in. Guatemala

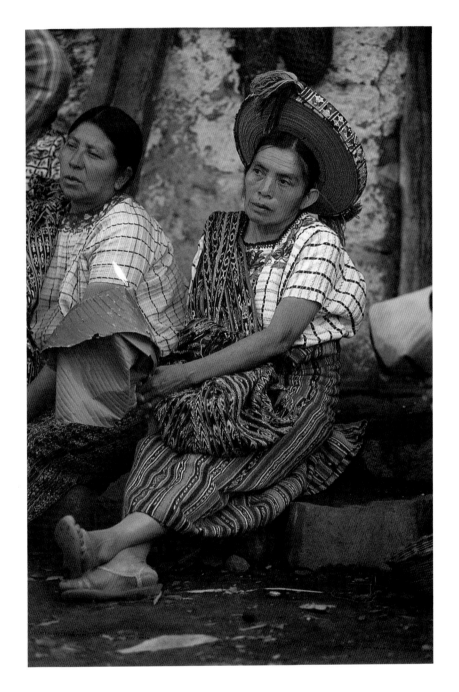

Dressed in the traditional costume of Santiago Atitlán, a woman participates in a ritual procession that has stopped to rest as it moves around the town. Her candle is protected from the breeze by a folded banana leaf. Guatemala

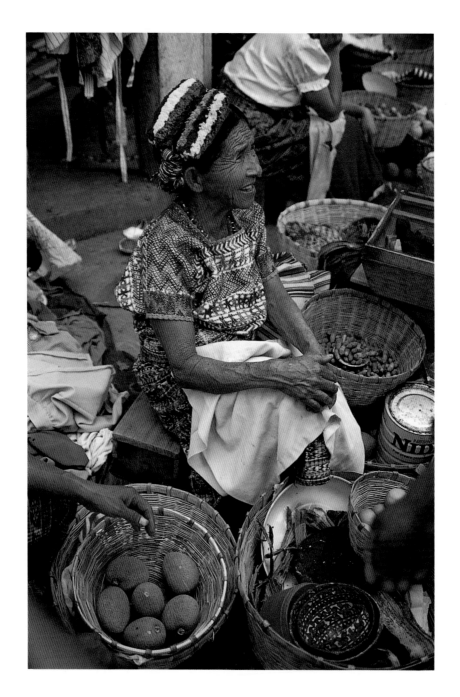

Vendors in the market at Rabinal sit in organized rows and offer everything from prepared foods to produce, household goods like *mano* and *metate* (for grinding corn and other things), to a glass of fresh warm milk taken right from the goat's udder. Guatemala

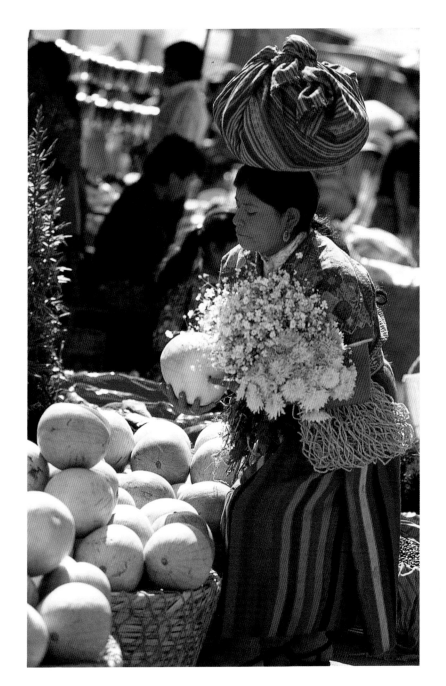

From childhood, women
from San Antonio Aguas
Calientes practice the skill
of carrying loads in the
Maya style. In a mountainous
country like Guatemala,
where climates vary within
a short distance, there is
a wide variety of fresh fruit
available year round.
Guatemala

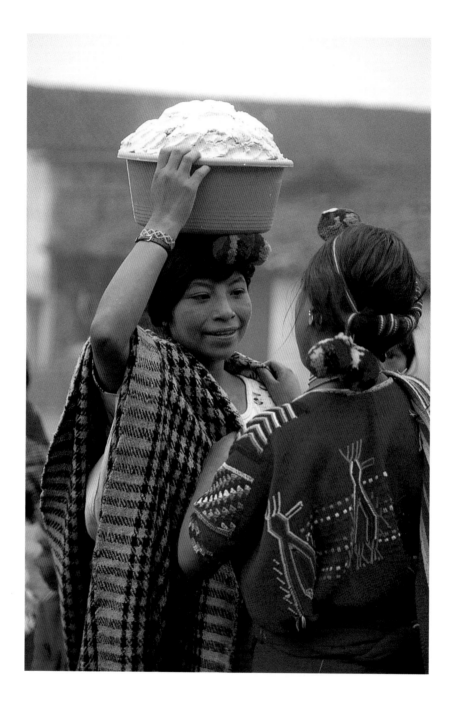

Friends pause for an intimate exchange in the market at Chajul, a part of the remote Ixil Triangle and located high in the Cuchumatanes Mountains. The new *huipil* motifs are much larger than earlier styles. Their head-dresses are another indicator of where they live. Guatemala

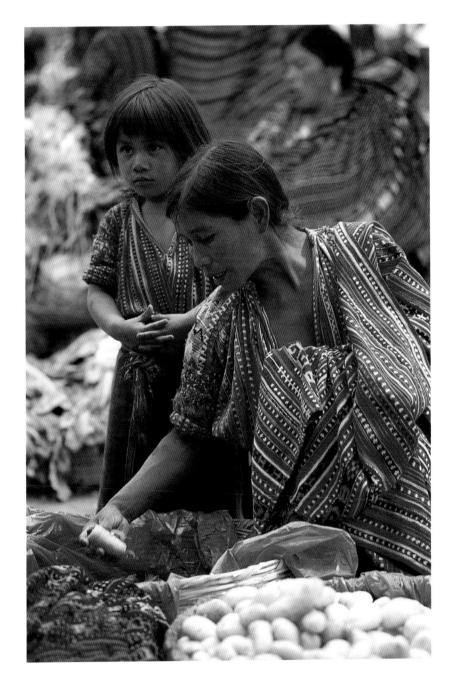

Mother and daughter stay close together in the market at Sololá. The textures of the baskets and the combination of ikat and solid colored stripes in their textiles create a strong visual impression. In this town men still wear *traje*. Guatemala

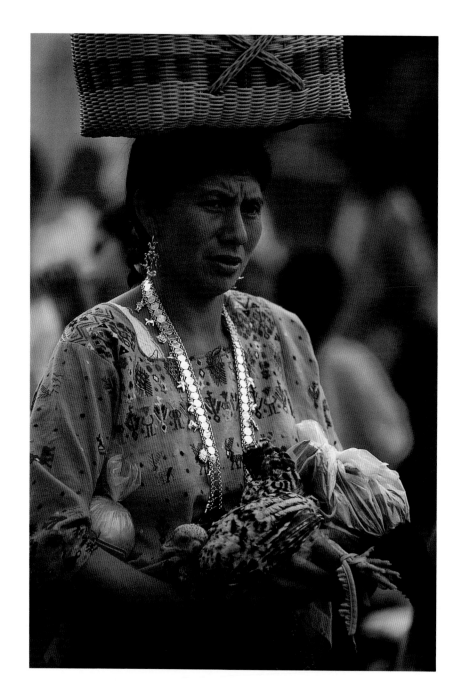

With a basket on her head, a live chicken in her arm, and a silver necklace typical of the Alta Verapaz area, this woman negotiates the narrow pathways of the busy market at Tactic. *Huipiles* here used to be densely brocaded, and red was a favorite color; the choice of yellow may be a recent innovation. Guatemala

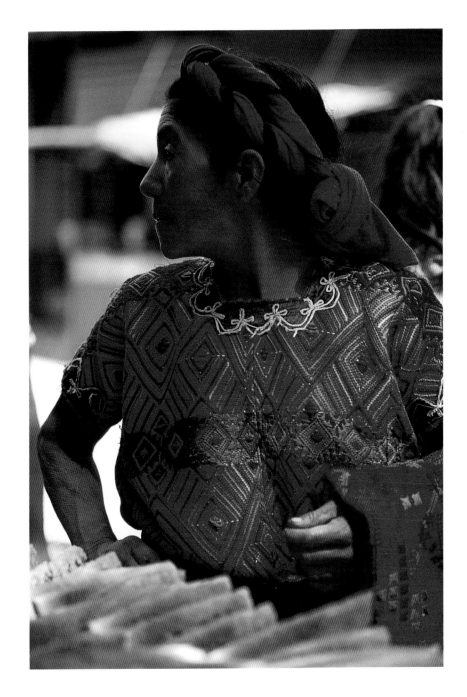

Pausing for a refreshment of sliced watermelon, a woman keeps a watchful eye on some of the other treats in the market at Santa María de Jesús. Her *huipil* and *tzute* are brocaded with expensive silk floss imported from China. Guatemala

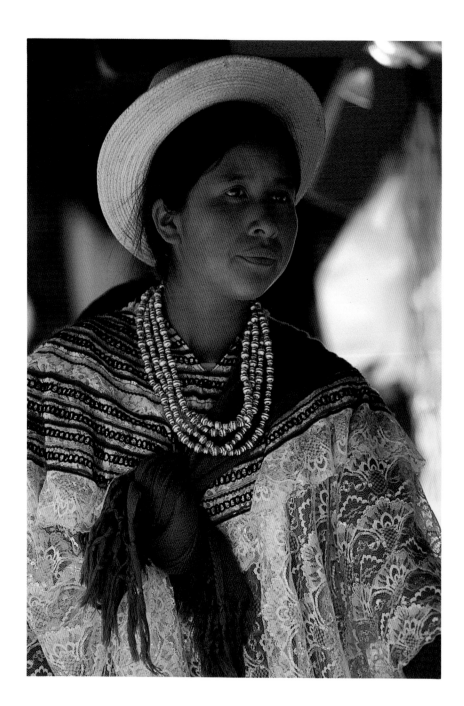

Shaded by a cloth canopy, a seller of plastic goods offers a wide range from dishes and jugs to brightly colored toys. San Pedro Soloma, Guatemala

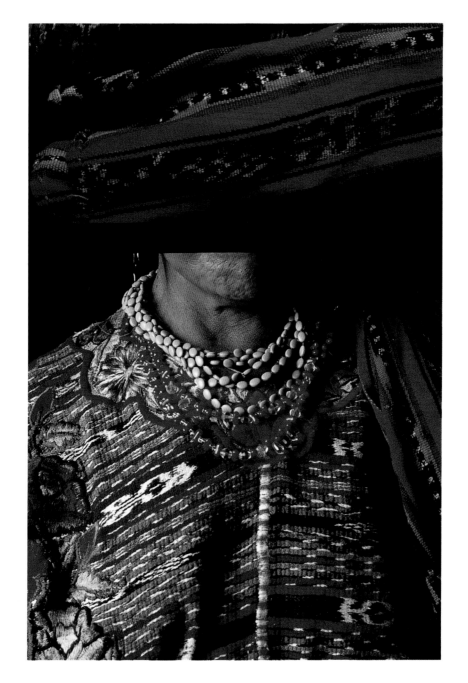

Shade is a valued commodity; the thin fresh high mountain air of Quezaltenango can also turn chilly with the passing of a cloud. The headcloth or *tzute* comes in handy in any condition. Guatemala

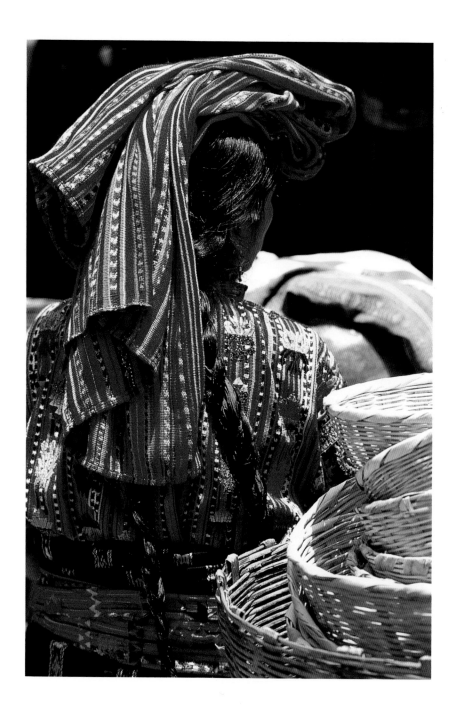

The colors, curves, and
textures of the market at
Sololá, not to mention
the movement, smells, and
sounds, are an aesthetic
delight. Guatemala

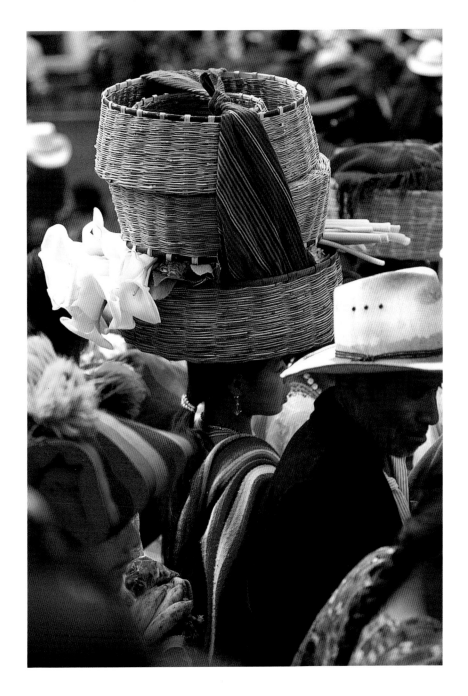

A detail of the Tactic market shows the local textile style as well as the bamboo baskets common in these mountain markets. Guatemala

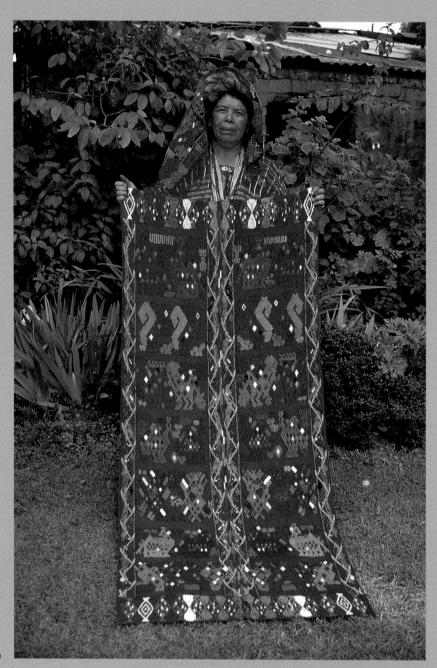

Juliana Shoshan Bachac travels around the highlands to sell textiles. Innovative large cloths covered with big motifs for special ceremonial use and for sale communicate that she is from Santo Domingo Xenacoj, Guatemala

MARGOT BLUM SCHEVILL

Innovation and Change
in Maya Cloth and Clothing

For over two millennia, Maya cloth and clothing have served as artistic expressions communicating layers of meaning both to the Maya themselves and to informed outsiders. This communication is a kind of visual literacy; becoming conversant in the language of Maya textiles is akin to learning how to read, only in this sense, it means learning how to read cloth, clothing, and the manner in which it is worn. For the uneducated visitor to the Maya world, the clothing worn by these indigenous peoples may impress and startle. It is handwoven or embroidered in rainbow colors with geometric, floral, animal, or human designs. A woman's dress ensemble includes a multicolored upper garment called a *huipil*, a solid colored or patterned skirt, an embroidered or woven belt, adornment for the head and hair, and a variety of multipurpose cloths. Men may wear shirts and trousers of tie-dyed or ikat cloth, short woolen kilts, black woolen overgarments, shoulder bags, and hats. In some areas both men and women wear *traje*, or traditional dress. Elsewhere women continue to create and to wear their distinctive cloth and clothing, while men have switched to Western-style pants and shirts, along with a handwoven belt or head cloth. Young women and girls may wear handwoven gathered or wraparound skirts and belts but, instead of *huipiles*, blouses of commercial cloth. By wearing such garments, they communicate a fashion trend among their age group.

In the past, outsiders stereotyped Maya communities as inherently conservative and resistant to change. Two conflicting principles, however, affect textile production: the artistic, creative impulse to innovate and the conservative constraint, which is tradition-bound. Artists of the loom respond to new materials, techniques, and patrons — who are tourists, entrepreneurs, or advisers to cooperatives, and who may be local or from foreign countries. While it can be risky to innovate and perhaps lose approval of the community, the result may be a pleasing artistic creation that engenders admiration from others. Innovation and change in design layouts and dress styles are inevitable, and they may occur when routine threatens to stifle imagination.

The rate of change is faster in garments made for sale to outsiders than in textiles intended for domestic use. At the same time, a revitalization of Maya culture is ongoing and, in some areas of the highlands of Guatemala, is expressed by a return to dress styles rescued from the past.

The notion of innovation and change in Maya cloth and clothing is supported by data from a microstudy of textiles from the late nineteenth and early twentieth centuries. These textiles, acquired in thirteen Maya communities in Guatemala, provide a base line for comparison with textiles from the same communities in the 1980s. The categories for comparison are continuities, discontinuities, and transformations in textiles and textile-related objects.[1]

In order to look at the change over time in Maya dress and clothing, viewers must compare and recognize the outside and internal influences. Costume changes occurred in Maya areas during the Colonial period following the Spanish conquest and have continued through the period of Independence to present times. Post-conquest adaptations of foreign origin remain part of the Maya traditional dress.

Maya women wear *huipiles*, blouselike garments of various lengths that envelop their bodies. For example, the design layout of the unseamed cloth of a blouse or *huipil* from Chichicastenango may be viewed symbolically: the head opening becomes the sun, and the four cloth medallions sewn to the *huipil* represent the four cardinal points of North, South, East, and West.[2]

Double-headed eagles and small animals relate the wearer to clan images and the natural world, where agrarian people live and labor. The designs form a cross, and the wearer is placed in the center of her universe surrounded by familiar and meaningful images. She feels protected and safe from supernatural harm. For the Maya, costume is memory, echoing Walter F. Morris, Jr.'s, suggestion that mythical history is woven into textiles.[3]

The Maya textile tradition embraces the Chiapan, Lacandon, Belizean, Yucatec, and Guatemalan Maya, who share a cosmologically informed world view, which is expressed in many aspects of daily life including language and dress.

A *huipil* from Chichicastenango woven in the 1900s with double-headed eagles and four cloth medallions. Guatemala

THE ANCIENT MAYA

Since there are few extant textiles of the ancient highland Maya, we must turn to alternate sources. Not only were these people artists of the loom, but they were fine painters, sculptors, ceramicists, and architects of monumental structures. Stela H, a three-dimensional freestanding sculpture at Copán, Honduras, suggests the dress of a noblewoman of the late Classic period,

Stela H, Copán, Honduras

short cape with woven designs, shin and wrist guards, and ornamented sandals. They both wear elaborate headdresses and jewelry. Additional information about the dress of the ancient Maya can be seen in the fine sculptures from Jaina, the murals in the temple at Bonampak, codices or painted screenfold books, and polychrome ceramics.

Sumptuary laws functioned like a class system: simple dress for commoners and slaves, and elegant dress for the upper classes. As with the Aztec, these laws probably mandated what kinds of fibers or other materials could be used: cotton, feathers, jewels, and other embellishments for the privileged, and rough vegetable fibers from the bast family for the lower classes.[5] Stylistic divisions indicated class and rank. Most of the Maya visual record shows the dress of privileged persons pictured in ceremonial and mythological scenes.

A.D. 600–900.[4] The figure wears a tall headdress that suggests quetzal feather ornaments. Her dress, possibly a long *huipil*, reaches to the ground; woven designs are visible. The garment is hard to discern as it is covered with beads, probably jade. A wide waistband also is decorated with beads. Elaborate sandals complete the ensemble. Situated across from Stela H is Stela A, a stone portrait of a nobleman or ruler. The ornate attire of both these figures indicates their privileged status.

At Yaxchilán, in Chiapas, Mexico, a carving on Lintel 24 in Temple 23 presents Lady Xoc in a patterned *huipil* engaged in a ritual bloodletting ceremony. Her husband, Shield-Jaguar, holds a torch for his wife; typically men and women participated in ritual acts together. Shield-Jaguar wears a loincloth, a belt, a

Lady Xoc in the act of bloodletting; Lintel 24, Temple 23, Yaxchilán, Mexico

Male slaves and commoners, women, and lords appear in some of the Bonampak scenes and on ceramics.

By an examination of the visual record, it is possible to identify a pan-Mesoamerican costume repertory in use at the time of the Spanish conquest.[6] Some of these garments may not have been worn by the Maya.

Men's dress
The following items, in various combinations, were among those worn by male figures:
• short or long cloak in square or rectangular shape
• a short skirt sometimes worn with a belt
• hipcloth
• loincloth
• open- or closed-fronted vest to the waist
• headdress
• wrist and shin guards
• jewelry
• slip-on padded armor
• ceremonial limb-encasing costumes
• ball game costumes
• sandals.

Women's dress
Women are not as frequently represented in Maya art as are men. As suggested for Stela H at Copán, female figures often were misidentified as male. Recent studies by Rosemary Joyce, Mary Ellen Miller, and Morris, among others, suggest the dress repertory of ancient Maya women:
• skirt, tubular or rectangular; worn in various ways — to the waist, as a sarong, or over one shoulder.
• short skirt usually worn over another skirt
• upper garment
• cape
• headdress
• jewelry.

The visual record, as well as the available archaeological material, mostly from the Sacred Cenote of Chichén Itzá, suggest that weavers employed a range of patterns and techniques, some of them still in use today. Included are warp and weft stripes and plaids; three types of plain weaves; twills; brocades created by supplementary wefts and supplementary warps; and warp floats. Other techniques include gauze with weft inlays, open work with wrapped wefts, bound warps,

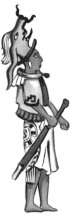
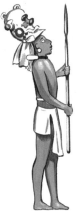
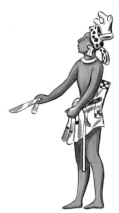
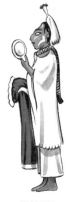
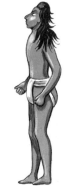

NOBLE WARRIOR COMMONER WOMAN SLAVE

Drawings of ancient Maya
from the murals of
Bonampak. Chiapas, Mexico

132

knotted warps, embroidery, both slit and wrapped tapestry, and tufted cloth or pile of looped wefts.[7]

Clothing construction was simple: four-selvedged pieces of cloth from the backstrap loom were sewn together to create loose garments. There was little cutting or fitting of cloth. One, two, or three pieces sufficed for the costume repertory. Some were embellished with designs, feathers, or embroidery, while other pieces were plain.

The Bonampak murals and Jaina figurines indicate that the basic colors of ancient weavings were red, blue, and violet; other hues were also used. These colors were derived from natural sources: cochineal and cinnabar for red, the mollusk *purpura patula pansa* for purple, and indigo for blue. Not only was yarn dyed, but there is evidence that cloth was painted.[8] Designs also could be applied by means of stamps, which are part of the archaeological record. Because the dyes were not fast, the designs would fade over time.

There are various stories concerning the origin of designs.[9] One story from the *Popul Vuh*, for example, describes one such investiture ceremony that involves women.

In the beginning the people wore plain white cloth. The first four men, made from corn, created out of stone gods from whom would descend the K'iche' Maya. The gods demanded human sacrifice, and sons of the leaders were abducted by the sacrificing priests, who were B'alam Kitze', B'alam Aq'ab', Iqib'alam, and B'alam Mujukutaq. The gods were known as Tojil, Awilix, and Jakawitz. One of their transformations was into handsome young men.

Unhappy about the killing of their children, the people decided to kill the priests, but first they wanted to defeat the gods. They formed a plan. Two beautiful maidens, daughters of the leaders, were selected to seduce these nahuales or spirits at the magical bathing place called Tojil's bath. The maidens were instructed to bring back a sign that the nahuales had looked into their eyes, for this would indicate successful seductions.

It was impossible, of course, to fool the gods. Instead they conferred with the sacrificing priests and agreed to send the people a sign or proof of their conversation with the young maidens. The priests were told to paint three capes, which would symbolize the gods and give them to the maidens to take to the people. B'alam Kitze' painted the figure of a jaguar, B'alam Aq'ab' painted an eagle, and B'alam Majukutaq painted hornets and wasps on his cloth. The maidens took the capes to the people, and the leaders thought their plan had succeeded. One lord put on the jaguar cloth. Next he tried on the second one and felt good covered with the eagle cape. Finally he put on the third cape and was bitten all over by the hornets and wasps painted on the surface.

The people learned from this experience that the gods were not to be deceived. One of these symbols was adopted by the K'iche' Maya, and they became known as the sons of the eagle. Eagle and other animal images still are present on the clothing of many K'iche' communities. Another lesson derived from this myth was that the gods preferred cloth with designs. Contemporary K'iche' Maya backstrap-loom weavers seldom produce plain white cloth and prefer to weave in supplementary weft designs.

Elsewhere in the *Popol Vuh*, there is a story about investiture of clan images assigned to the lords by the gods. The lords wore cloaks with animal motifs, which were woven, not painted, into the cloth. The figures on the lords' cloaks were placed *chuwach*, "on the face," or single-faced brocading. Other images are described as being *chupam*, "on the inside," two- or double-faced brocading.[10]

THE CONQUEST AND THE PERIOD OF *GENTILIDAD*
The seminal encounter of Maya leader Tekúm Umán

and Pedro de Alvarado took place in 1524.[11] It was a crucial encounter for the K'iche' and ultimately resulted in the conquest of Guatemala. Clothing of Maya nobility and warriors was a powerful weapon. Their fine attire projected status, power, and domination. The rulers' and officers' dress had a psychological impact on their enemies by engendering terror and admiration, while demanding unconditional obedience.

Tekúm's physical appearance had been an important factor in previous encounters with enemies. Ceremonially painted, he looked like a god in a crown and headdress of quetzal feathers, which also covered his arms and legs, and with jewels on his chest and forehead that looked like mirrors. His banner was gold-tipped and also adorned with jewels. Transformed into a godlike being, he "flew like an angel." The Maya were on foot, and the Spaniards on horseback moved above them, killing as they went. The Maya wore cotton breastplates, three fingers thick, as armor. When they were struck down, they could not easily get up. Four women disguised as warriors wore cotton armor and also participated in the battle. There were no Spanish fatalities.

Alvarado named the battlefield Quezaltenango, or the place of the quetzals, to honor the valorous Tekúm in all his feathered glory. Soon after, some K'iche's declared themselves vassals of Spain and were baptized. They dressed as their new lords, and the Spaniards allowed them certain privileges. One such privilege denied to the ordinary Maya was the acquisition of horses and mules.

In 1519, Cortés arrived in the New World, and the conquest of Mexico was completed by 1521. Along with gold, jewels, and feathers, cotton clothing in the form of mantles became an important tribute item.

Cortés sent much of this material to the Spanish ruler, Charles V. In 1520 the German artist Albrecht Dürer visited Brussels to view this first dispatch of tribute and wrote in his diary of the "strange garments, mantles, and all sort of strange objects for human use, all of them so beautiful that they are a marvel and were valued at a hundred thousand ducats. . . . I marveled at the subtle genius of men in distant lands."[12] The conquerors of Guatemala continued the practice of sending tribute to Spain.

The Colonial sources referred to the period just before the conquest as La Gentilidad, an expression of attitudes about the indigenous people, who were considered gentiles or heathens. Men wore capes of varying lengths, loincloths, and vests. Women wore *huipiles*, skirts, and headcloths or headdresses. Insignias on men's clothing may have indicated lineage or clan affiliations. Cotton and agave were fiber sources, while feathers were reserved for special garments. The Spaniards attempted to "civilize" the Maya. Christian baptism and Spanish clothing were two of the instruments for change.

THE COLONIAL AND INDEPENDENCE PERIODS
Innovations that were introduced during the Colonial and Independence periods allowed for an expanding range of garments. The Spaniards brought sheep along with horses to the New World. They also introduced the treadle or foot loom, a mechanism that was common in Europe. The main advantages of the treadle loom over the backstrap loom were the reduction of weaving time and the production of yardage, which could be cut and fitted into fashionable garments. Men were taught how to use the treadle loom and so began to enter into textile production, formerly women's domain. Both men and women spun and

wove cotton and wool. Women wove on the backstrap loom, and men created cloth on the treadle loom.

Another new fiber was silk yarn from China. In the sixteenth century, a small industry flourished for a brief period in Oaxaca, Mexico. Silk came on the Manila galleons, which were headed for Peru, where the viceroyalty required the fiber for their dress. Because of a series of embargoes on a direct Sino-Peruvian trade route, silk came to Guatemala first. After silk became available, Maya weavers used it along with other fibers for special cloths and garments.

Draw looms were adapted from the Chinese textile industry. Large pieces of surface-decorated cloth could be produced rapidly, and, in some communities, an assistant was required. The headband loom may have been a Maya invention, because it combines features of the loom used by the Spaniards with those of the backstrap loom. Weavers produced narrow headbands, or *cintas*, on these special looms.

As a result of these and other innovations, Maya men's dress began to change radically after the conquest. Some men learned Spanish and adopted European-style dress. Spanish and later Creole vendors sold *ropa de la tierra*, or local clothing, to those Maya who could afford it. Fine wool cloth and silk taffeta from Spain and Mexico also were purchased by the Spaniards for their tailored clothing.

Meanwhile in the jungles lived other Maya groups. They spoke various languages, and the chronicles give some information on their dress. The men wore loincloths made of bark and cotton and vests and belts of woven cotton. They adorned their long hair with headdresses. Feathers and paint provided body adornments. Women also had long hair and wore headdresses, short skirts, and ear and nose decorations, but no upper garment.

Maya clothing worn in New Spain, the Yucatán peninsula, and Guatemala absorbed foreign influences, and gradual innovations evolved. Some pre-conquest styles also persisted. In general less clothing was worn in the hot lowlands than in the colder altiplano. Women remained close to home and hearth while caring for their families. Unlike the men, they did not interact with the foreigners, so changes in women's dress were more conservative.

The few Spanish writers and historians who were interested in the indigenous peoples recorded the coexistence of pre- and post-conquest Maya costume.[13] It is possible, therefore, to suggest a pan-Maya costume repertoire for the Colonial and Independence periods.

MEN'S DRESS
Pre-conquest dress form survivals include capes, sandals of agave, loincloths, a form of hipcloth, and headcloths. European-influenced garments worn in the altiplano were *zaragüelles* or woolen split over-pants, often embroidered with cotton and later silk; *camisas* or cotton shirts with collars and set-in sleeves; close-fitting jackets called *jubones* made at first from wool from Oaxaca; *capisay* or *capixaij*, long woolen cloaks with sleeves; *calzones* or short loose pants and tight pants to the knee; *sombreros*; boots or shoes.[14]

Split over-pants are still worn in Todos Santos Cuchumatán; the style may have been adopted in the mid-nineteenth century when the French Navy visited Guatemala.[15] The French uniform included over-pants worn over white, ruffled long pants. Somehow this style traveled to the mountains of Huehuetenango and persists there to present times. The tailored long cape or *capisay* with sleeves and wide cuffs may have been modeled after a priest's robe or the Spanish riding coat.

135

The Maya version, however, is worn as a cape, with the sleeves tossed over the shoulders, revealing a decorative fringe.

In the lowlands and rural areas, men's dress did not experience great change. Men continued to wear white and colored cotton capes, sandals, and loincloths or short pants that were more appropriate for the environment.

WOMEN'S DRESS

Examples of pre-conquest dress that exist today include long and short decorated *huipiles* and wraparound skirts. In the Yucatán, the *huipiles* were worn to the knees with an underskirt to the ground. Headdresses and a variety of multipurpose cloths complete the woman's costume repertoire.

Veils were an important innovation. Worn as an act of reverence in the Catholic church, they were made of linen imported from Europe to Mesoamerica by Spanish traders. Eventually brides wore veils made from commercial lace or tulle, perhaps borrowed from a relative. Sometimes a ceremonial *huipil* served as a veil. Full gathered skirts with drawstrings at the waist, which allowed women to move more freely than the wraparound style, and blouses with inset sleeves and collars became popular in some areas. Some male community and business leaders wore jackets of imported material or fine wool, while the rest of the community wore rough, locally produced woolen garments. Cotton still was the basic fiber for women's cloth and clothing. As in pre-conquest times, dress and how it was worn indicated the social and economic status of the wearer.

European fabrics worn by the Spaniards excited artists of the loom, who excelled at surface decorations.

They continued to create the lovely white on white gauze weaves of pre-conquest origin and also employed a technique called ikat or *jaspe*, where the yarn is tied and dyed before weaving.[16] Already proficient in embroidery, they integrated new stitches, designs, and lace techniques into their textiles. These techniques were essential to Spanish dress, and later the Maya added some of the new decorative elements to their own clothing.

After independence from Spain in 1821, *ladinos*, or persons of mixed Indian, Spanish, and African descent, moved into what had been largely Maya countryside. During the late nineteenth century, coffee plantations were introduced into Guatemala, and Maya and *ladino* men were hired as migratory workers. Instead of bartering for their goods, they turned to a cash economy, and changes in dress accelerated. For example, traditional clothing became a source of embarrassment and alienation for men who worked on plantations or in mines. Both Maya workers and *ladinos*, therefore, dressed in Western-style work clothes. In some cases, only the use of a patterned shoulder bag connected the Maya men with their heritage. Women and children who lived with their husbands for part of the time in the migratory camps continued to wear their community-style dress, as did Maya men of Chiapas, who persisted in wearing traditional clothing not only within their communities but when visiting nearby cities. By so doing, they indicated to the *ladinos* with whom they interacted daily the symbolic power and pride invested in their clothing.

THE TWENTIETH CENTURY

Until the end of the nineteenth century, the Industrial Revolution had little effect on Maya dress. One major

innovation was the invention in 1856 of synthetic dyes that produced a wide range of colors for cotton. Maya weavers adopted these dyes, using them along with natural ones. An explosion of red textiles, which were dyed with synthetic madder or alizarin, can be observed in documented collections.[17] Commercially spun and dyed cotton has been available since the 1880s. Some yarns are locally produced, while others are imported. Dress styles changed slightly from one generation to the next. Designs became larger and more assertive as the weavers employed new materials and colors. Outside influences filtered in from influential *ladinos* or foreigners working or traveling in the region. Cross-stitch pattern books from Europe and Mexico featured floral and faunal designs that could be transferred to the loom. The fashion impulse was affecting weavers, and *muestras,* or samplers with new designs, could be borrowed or rented. Community sanctions about dress were gently eroding. Some women no longer wove all the clothing for their families. With the cash economy, a woman who sold textiles or vegetables could acquire some garments locally from a production weaver without the labor-intensive act of backstrap weaving.

By the late nineteenth and early twentieth centuries, scholars, photographers, archaeologists, anthropologists, and travelers were paying attention to Maya clothing. Noted British archaeologist Alfred Percival Maudslay and his wife, Anne Cary Maudslay, visited Guatemala in 1884. In an account of their trip, she discussed the Indians and their dress, and he described the Maya ruins.[18] By this time, community-specific dress was flourishing. Gustavus A. Eisen, a Swedish-American natural scientist, made an expedition to Guatemala in 1902. He traveled the central highlands, taking photographs of flora, fauna, and the Maya

and collecting "Indian dress" for the new museum of anthropology at the University of California, Berkeley.[19] In recent years, private collectors and museums in the United States and abroad have eagerly sought Maya textiles.[20]

A generic type of work clothing made of white commercial cloth was adopted by some Maya men who were farmers and also by *ladino* plantation seasonal laborers. When traditional Maya dress elements were worn, colors and motifs conveyed information about the status and geographic location of the wearer. Woolen overgarments called *sarapes,* pan-Mesoamerican garments popular in Mexico, had become part of the man's costume repertoire. Some special clothing was required by a community for practical, aesthetic, or ceremonial functions such as those used in the *cofradía* context.

Changes in women's dress were ongoing. In some communities, such as Quezaltenango and towns in Alta Verapaz, gathered skirts of treadle-loomed cloth were popular. Elsewhere the use of wraparound skirts was widespread. In some areas, *huipiles* also were the product of treadle looms. These looms could incorporate the changing styles rapidly, and production time was lessened. A variety of apron styles and later sweaters became part of a woman's dress. Rayon and pearlized cotton called *sedalina* partially replaced silk. Weavers used cheaper synthetic yarn, as well as hand- and commercially spun wool.

COSTUME AS COMMUNICATION

Before the 1970s, it was a commonly held notion that each community retained its own distinctive dress. Although basic garments were similar, there were differences from one community to the next in patterning, design layouts, number of webs, use of colors, manner

of wearing, and techniques. Maya clothing constituted in effect a "cultural identity badge," one that could be read by the educated viewer. Families made up a weaving unit and developed design configurations that could be recognized by community members.

The concept of a rigid "one town, one costume" model has recently come under scrutiny. In the early twentieth century, for example, women from Quezaltenango may have admired the *huipiles* from a well-known weaving center, San Martín Jilotepeque, Chimaltenango. I believe that one woman from Quezaltenango acquired such a *huipil*. In order to conform to community sanctions, she altered the garment by adding commercial cloth to the bottom and rounding the head opening.[21] There are other examples in museum collections and historic photographs of garment alteration to illustrate this flexibility of clothing adaptations. Contemporary textile scholars report on design sharing among weavers who live far away from each other. When a woman wears a *huipil* from another community, she makes a positive gesture, an assertion of pride in her design choice. She demonstrates her knowledge of the world outside her community and is admired for her innovative dress.[22]

Design innovation sometimes springs from unusual sources. Juliana's mother in Santo Domingo Xenacoj explained that in the 1960s she dreamed of large designs that would cover her utility cloths. She enlarged the animal, floral, and geometric designs on her weavings. Soon the whole community followed suit with their own particular forms. This innovation spread to the everyday *huipil*, while the ceremonial style remained more traditional in design.[23]

The *huipil* is the garment most subject to change. Certain older features survive, while others have been transformed. The most continuous features are technique and overall shape. New fibers and colors and the fashion impulse have affected the shape and decoration of the neck opening and the iconography. In some communities the *huipil* is no longer worn. Headbands and belts remain an integral part of women's clothing, and there is a separate class of weavings made for sale to outsiders.

A design element or motif may evolve over a long time period from representational, easy-to-read forms into abstract, geometric images. To the uneducated eye, these new images do not resemble the design source. The Maya, however, recall the original images and their symbolic meaning and can read the abstracted form. The double-headed eagle image on the men's headcloths of Chichicastenango is such a design element.[24] As discussed above, the eagle has special significance to the K'iche' Maya. Residents of Nahualá, who are K'iche' speakers, also use this image on their dress. The interpretations of uneducated viewers generally allude to the Hapsburg double-headed eagle of the Spaniards and ignore the original source within the Maya belief system. Although this image was conferred on the Nijaib K'iche' by the Spaniards, a hidden meaning was conveyed. The word *kot* in K'iche' refers to the two-headed eagle and to the god of the double sight: one to look forward and the other to look backward, one looking for good, the other for evil. Maya cosmology sees duality in all persons, gods, ancestors, and nature. In the 1990s the abstracted *kot* on the Chichicastenango men's headcloths represents the shared memory of a community and a reminder of the continuing uneasy coexistence between Christian and pre-conquest ritual practices.[25]

One may read in the popular literature that Maya cloth, clothing, and weaving traditions have been

compromised and eventually will cease to exist. This is unlikely, as weaving remains an ongoing and vital industry. Weavers continue to produce garments for their families and for sale despite internal and external social and economic pressures that threaten their very existence.

Women still wear *traje*, although they may not produce it all themselves. And it is a tribute to the Maya that, in some communities, men still wear everyday *traje*. Special garments, such as belts created with a sprang technique, bulrush raincoats, and the treadle-woven *sarapes* worn by the *cofradía* members of San Miguel Totonicapán, are no longer available. In other communities, older styles coexist with new ones. Certain men's and women's textiles still serve special functions, such as fiestas, weddings, and religious ceremonies.

Color is particularly susceptible to change. In the Kaqchikel community of Santa Catarina Palopó on Lake Atitlán, both men and women wear *traje*. In the past, the predominant colors were red and white. In recent years, garments have been heavily brocaded in blues and greens with geometric designs. In nearby Santiago Atitlán, many different clothing styles are acceptable. Some women wear old-style *huipiles* similar to those worn in the 1950s. The increase in the number of Protestant religions practiced in this community may have affected the rate of change in clothing innovations. Both Protestant and Catholic women, however, are creating textiles with new colors, design motifs, and techniques. In the past, women would embroider animal and floral images on background cloth of white with purple or red stripes. Now brocaded dense designs are popular, and the background cloth may be light blue and purple. Traditional red ikat wraparound skirts with ikat patterns are still worn along with purple ikat ones.[26]

In the late nineteenth century, men in Todos Santos Cuchumatán wore red-and-white striped pants and white shirts with brocaded collars woven by women on the backstrap loom. Over-pants of treadle-loomed wool, sewn on the sewing machine by the local tailor, reflected European influence; older men and some of the younger ones still wear this garment. Shirts now have multicolored stripes. Women's *huipiles* were also made with red and white stripes and, in the central section, a small area of brocading. The current style is multicolored stripes, with blue, lavender, and pink synthetic yarn adorning the brocaded area.

In San Andrés Larrainzar, Chiapas, women weave town-specific three-web *huipiles* with dark red brocading. Teenagers find weaving too labor-intensive, so some embroider similar designs onto their blouses. This style is also worn by older women who observe the latest fashions.

In Guatemala, a highland regional style is pervasive. Although not town-specific, this dress signals that the wearer is Maya and not a *ladina*. Instead of a *huipil*, women wear blouses of commercial cloth with machine-embroidered floral designs around the neck. Wraparound or gathered skirts of treadle-loomed ikat are worn with narrow belts to emphasize the waist. Multipurpose cloths complete this ensemble.

INTERNAL AND EXTERNAL MIGRATION[27]
Since the conquest, external migration has affected Maya cloth and clothing. In southern Belize, the Spanish never tried to develop or control the Maya. In 1600, they rounded up the indigenous Chol and shipped them to the Guatemalan highlands to serve as a labor force. In the 1640s, the British settled on the coast and presented a challenge to the Spanish influence in the

area. In 1862, after two hundred years of conflict, the country became known as British Honduras. During this time frame, a new group moved in from the south. These black Caribs are now called Garifuna. After the Caste Wars of the 1850s, there was a migration of Yucatec Maya into the country. Towns such as Punta Gorda and Barranco developed around logging and agricultural ventures. The Q'eqchi' and the Mopán, a lowland Maya group related to the Yucatec, continued their movement into the Toledo area, where they often intermarried. Independence came to the Republic of Belize in 1981 at a time when Maya and *ladinos* were flee-ing northwest Guatemala into Chiapas and Belize as a result of the counterinsurgency war waged between the army and the guerrillas.

Migration and intermarriage have produced a blend of physical characteristics, customs, and tradi-tional and contemporary clothing. Some people prefer to make their own garments, while others purchase them from kiosks in the market. The Maya women in the markets at Punta Gorda wear a variety of clothing: some wear the short blouses with a gathered skirt typical of the Cobán area in Alta Verapaz, where many of these people came from in the 1860s. The double-ikat cloth probably was woven in western Guatemala. Other women wear a blouse of commercial cloth with cross-stitched bands and set-in sleeves, and a gathered skirt with bands of commercial trim. At Maya Center, a community in the Toledo district, men and women produce items for sale. Men carve Classic Maya images on slate. Women weave cloth on backstrap looms, and others sew cross-stitched bands onto blouses. Men and some women wear Western-style clothing.

In the turmoil of the 1980s, a large number of ref-ugees who fled Guatemala settled in camps in Chiapas,

Mexico. Eventually Maya women started backstrap-loom weaving again, some of them alongside *ladinas*.[28] Weaving textiles was a means of income, and various development projects tried to help the weavers.[29] Five or six families left the camps and settled in San Cristóbal de las Casas. With outside assistance, they began to weave non-town-specific textiles, such as *huipiles* and bags; these hybrid textiles are beautifully executed and are popular with the Mexicans. The information they communicate, their motifs and color combina-tions, reflect the pan-Maya design repertoire. Some of these textiles, no doubt, will become part of museum collections, and researchers will ponder the origin.

In some towns new dress elements were adopted yearly instead of every generation. Returning to Santa María de Jesús in 1988 after a ten-year absence, I was astonished to see some women wearing San Antonio Aguas Calientes–style *huipiles* and carrying cloths. I expected the "one town, one costume" model. After some investigation and analysis, I discovered that a woman had married out of the community into San Antonio and learned their weaving patterns and tech-niques.[30] When she returned to Santa María, she taught these new designs to other women who were eager to learn. The double-faced supplementary weft technique, a signature of San Antonio weaving, is a difficult tech-nique to master. Some women were able to achieve the same designs without learning the double-faced technique. One must look closely at the textile to see the difference, and thus a new style is accepted into the community to coexist along with the older ones.

WEAVING COOPERATIVES
Throughout southern Mexico and Guatemala, weav-ing cooperatives have helped to preserve the patterns

and techniques of Maya garments. In 1974, on my first visit to San Cristóbal de las Casas, Chiapas, I was both impressed and startled to see the Maya in their traditional dress. Both Tzeltal and Tzotzil men and women were doing business in the market and on the streets. Trips to the communities of Zinacantán, Tenejapa, and Chamula revealed that distinctive clothing was an integral part of the cultural context. Unfortunately, these garments were not for sale.

Thanks to the efforts of Walter F. Morris, Jr., Pedro Meza Meza, consultants, and many Maya weavers, this situation has changed.[31] With some assistance at first from the Mexican government and later from interested outsiders, Morris and Meza started a weaving cooperative in San Cristóbal called Sna Jolobil. It developed into a very successful venture. Morris and Meza studied older textiles from the area and organized free workshops so the weavers could learn the designs and natural dyeing techniques, which were no longer practiced. Yarns were made available to weavers, who worked at home and later brought the completed textiles to the cooperative. Prices for textiles were high compared to those available in the markets and shops, but Sna Jolobil textiles were exceptional. Following the success of Sna Jolobil, women in other communities such as Chenalhó and Chamula started cooperatives. Social issues were part of their agenda as economic circumstances had deteriorated and alternate means of income were essential. Women also needed to talk about domestic concerns, and cooperatives provided a context for exchange of information.[32]

In Guatemala weavers and entrepreneurs have initiated a variety of cooperatives, associations, and alternate trading organizations (ATO). As in Chiapas, both the government and outsiders have aided these efforts in order to help Maya artisans improve their economic situations. TRAMA, the Spanish word for weft, is an umbrella organization with local representatives in seventeen communities in Quiché, Sololá, Quezaltenango, Sacatepéquez, and Huehuetenango. Weavers supply finished pieces of cloth, and TRAMA does the marketing. Building on familiar patterns and colors from their traditional dress, such as the man's white pants with black-and-white ikat stripes, women produce on their backstrap looms large pieces of cloth, which serve as tablecloths or bed covers. The association supplies the yarn, and the weaver is paid by the piece. The profits are divided at the end of the year. TRAMA also offers training and technical advice to its four hundred members.

Zunil, a K'iche'-speaking town of 7,000 residents, is in a fertile river valley.[33] The Cooperative Santa Ana is located in a rented house next to the church.[34] A German priest, Father Fleiner, who came to Zunil in the 1960s, noted that only men were earning money. Children were not attending school because they had to work in the fields. He took some of the local weavings to friends in Guatemala City and discovered that there was a market for these fine textiles. Annie Westphel, a friend of his, encouraged women to weave for sale to outsiders and showed them how to market their products. In 1970s the cooperative was named after her. By 1990, there were 150 people involved. As is the case with the other cooperatives discussed, weaving is decentralized. Women weave at home, so that they can take care of families. Men work elsewhere. On my visit the cooperative's shelves were full of textiles, including new and used traditional clothing, purses, mats, and tablecloths. The adjacent room was full of yarn. Someone recently dyed a blue batch.

Cooperative members receive a small income, and at the end of the year profits are divided according to the type of pieces sold. Some textiles are more costly than others to make. Cooperative prices are higher because colorfast, high-quality yarn is more expensive.

In the Cuchumatanes mountains in northwestern Guatemala are the Mam-speakers of Todos Santos Cuchumatán, which has 12,000 residents, most of whom are Maya. Geographic isolation has contributed to the maintenance of local dress styles and language. Women weave on the backstrap loom; men crochet bags and spin wool on the Spanish-introduced spinning wheel and make woolen garments on the sewing machine. The Cooperativa Estrella de Occidente has been going for many years. Weavers buy yarn on credit. When the textiles are finished, they are brought to the cooperative, where they are sold on consignment. The weaver's name appears on a tag attached to the garment. Each month the weaver receives payment less 10 percent for operating costs. The men run the cooperative. Competition comes from a woman named Santiaga Mendoza, who started another cooperative nearby for widows in her family store or *tienda*. She has a large inventory and weaves colors that please tourists, thus introducing innovations that are soon adopted by other women. Mendoza is adapting to marketing pressures while maintaining her own cultural identity.

Maya textiles are sold through alternative trading organizations by means of catalogues or directly to the public in street stands or shops. In contrast to the cooperatives, weavers do not benefit as much from these enterprises, since expenses other than yarn and labor are involved in indirect marketing. One result of cooperatives and other marketing strategies is that weavers are producing piecework as well as *traje*. Some women cannot adjust to weaving that requires repetition and in which there is little room for innovation. One TRAMA member, Manuelita from Nahualá, bored with weaving the same images over and over again, was encouraged by a consultant to innovate and create something that pleased and interested her. The consultant gave her yarns in traditional Nahualá colors of men's headcloths. The rest was up to Manuelita. Starting with familiar designs, she began to enlarge and play with various combinations. She wove a triptych of three panels, as well as pillow covers with a single design derived from familiar animal images. Manuelita's triptych was featured in an art gallery in Guatemala City and received acclaim for its traditional and innovative aspects.[35]

REVITALIZATION OF MAYA CEREMONIAL LIFE
Because of the evangelical movements that became popular in the highlands, many converted women stopped wearing ceremonial *traje*. In other communities, however, there has been a revitalization of religious organizations such as *cofradías*, which customarily require special cloth and clothing. Sacapulas, Quiché, a municipality with a population of over 21,000, 94 percent of whom are indigenous Maya, is one example.[36] Women and men have responsibilities to care for the saints, an integral part of *costumbre*. Now there are only seven *cofradías*, some with names of women saints. A *cofrade* said that there used to be many more. As the number of *cofradías* diminished, Sacapultecas no longer required special cloth and clothing. A microstudy of twenty-eight ceremonial *huipiles* from Sacapulas reveals a consistency in design layout, motifs, technique, and colors from the 1880s to the 1960s.[37] There were

some changes when silk became difficult to obtain, and cotton was substituted. These highly valued textiles were handed down from one generation to the next. Some women wove a special mark into the cloth as a signature. Carmen Pettersen tells of an encounter between an old Maya man and a *ladino* artist.[38] The *ladino* wanted to buy a *huipil* more elaborate than the ones worn in the town, which consist of commercial cloth with a crochet trim on the bottom. He found an old man who kept his dead wife's *huipiles*. The old man opened a faded painted wooden chest and took out two old, worn, and ceremonial *huipiles* of a style unknown to the *ladino*. The *ladino* paid for them, and the two men embraced.

In the 1960s, treadle-loomed cloth from San Pedro Sacatepéquez, San Marcos, a far distant community, was substituted in a *huipil* in place of the backstrap-loomed cloth associated with the ceremonial style. This unusual *huipil*, however, has a neck treatment of commercial cloth appliquéd with embroidered images similar to the older examples.[39] On a visit to Sacapulas, I noticed that the women were wearing the everyday *huipil* and the distinctive head ribbon or *cinta* with large rayon and acrylic tassels. Inquiries about *cofradía* dress led to the home of Josefa Lancerio Aceituno.[40] Only four years ago, along with two other couples and two women, she and her husband started a new *cofradía*. They wanted to wear the old-style ceremonial *huipiles*. No longer weavers, they found relatives in nearby towns where weaving traditions continue, and, with the aid of an older *huipil* as a model, the weavers created new ceremonial-style *huipiles*. They combined rayon and cotton yarn for the wefts, commercial rayon cloth around the neck, and traditional embroidered designs of rayon and silk yarn. Josefa's initials, the wearer's

mark and not the weaver's mark, were added to one of the two *huipiles* I saw. For these women, innovation occurred as a result of rediscovering older forms, a replication that associates the wearer with the past in celebration of their new *cofradía*.

Educational opportunities for the Maya have expanded over the past ten years. Fellowships, scholarships, and other financial support enable men and women to study in Guatemala, in the United States, and elsewhere. When these scholars attend meetings, they often wear some elements of traditional Maya dress. Women wear the complete costume, while men wear ikat shirts and jackets that are made of Maya cloth. Native languages are taught along with Spanish in a few Guatemalan public schools. Organizations such as the Mayan Research Center (CISMA), Centro de Investigaciones Regionales de Mesoamérica (CIRMA), and the Academy of Mayan Languages (ALMG) contribute to the revitalization of Maya culture and languages. Some weaving cooperatives have empowered women. Participating weavers are shareholders and receive a legal economic part of the profits. Innovations expressed in cloth and clothing and revitalization of their cultures are authentic expressions of the Maya, an evolution of living traditions, not frozen in a timeless pattern that is either classic Maya or Colonial. Through their textiles, the Maya see themselves in mirrors that reflect the history of changing civilizations and their mythical history. With the introduction into the world market of new products made by the Maya, cloth and clothing also are an integral part of their future.

Innovation and Change

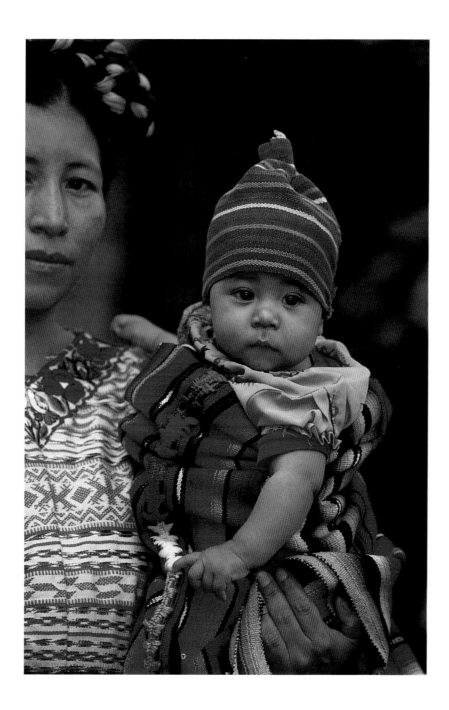

Mother and child in Santo Domingo Xenacoj. In some communities babies wear special hats or *gorras*. Guatemala

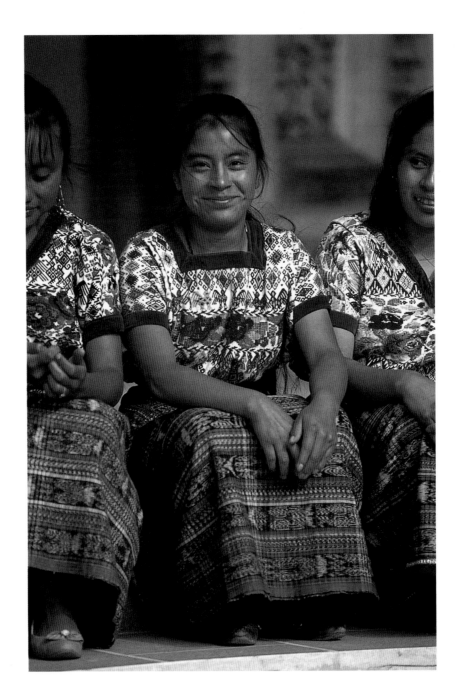

The bright spirit and intelligence of this young woman from Tecpán shows the strength of Maya women today. These friends have traveled to Santa Catarina Ixtahuacán for the saint's day celebration. Guatemala

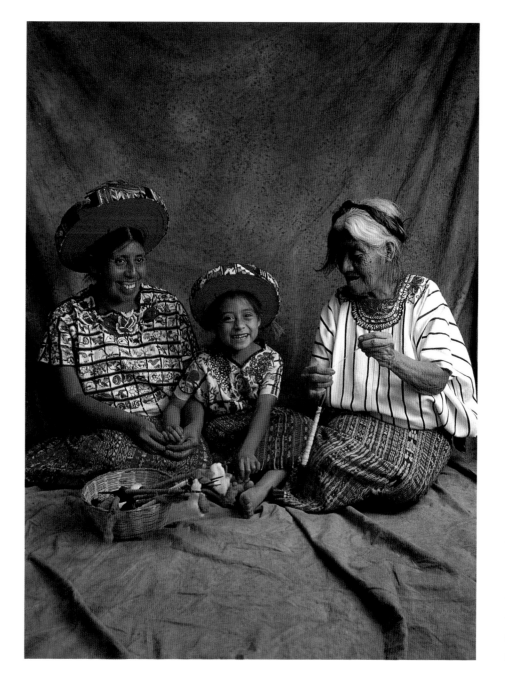

The Pop Pacach family
live in a house on the main
street of Santiago Atitlán.
Three generations of innov-
ative women spinners and
weavers are complemented
by the men in the family
who are also celebrated for
their fine embroidery.
Guatemala

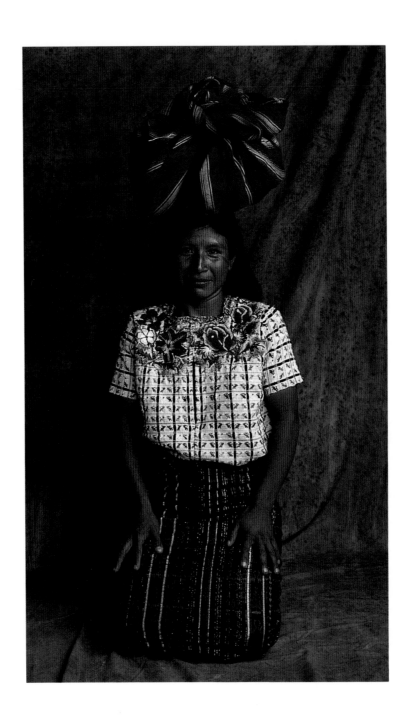

A young woman wears a typical Santiago Atitlán-style *huipil*, but her treadle-loomed skirt, a popular pan-Maya style, was woven in Totonicapán. Guatemala

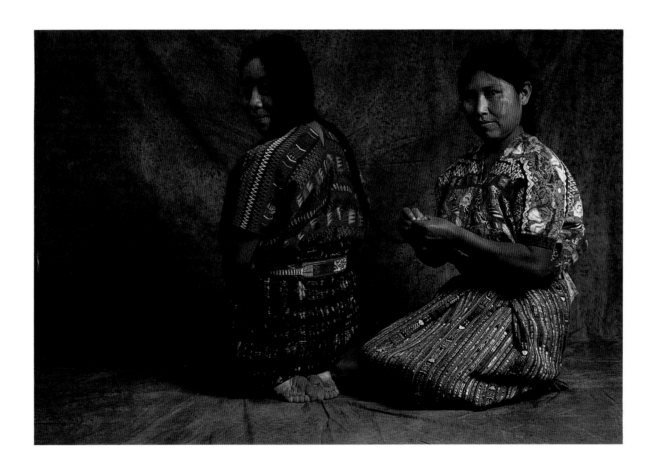

Mirsa Xicay and her cousin
Glendy Estrada from
nearby San Antonio Aguas
Calientes relax on a visit to
the Antigua home of col-
lectors Henry and Barbara
DuFlon. Guatemala

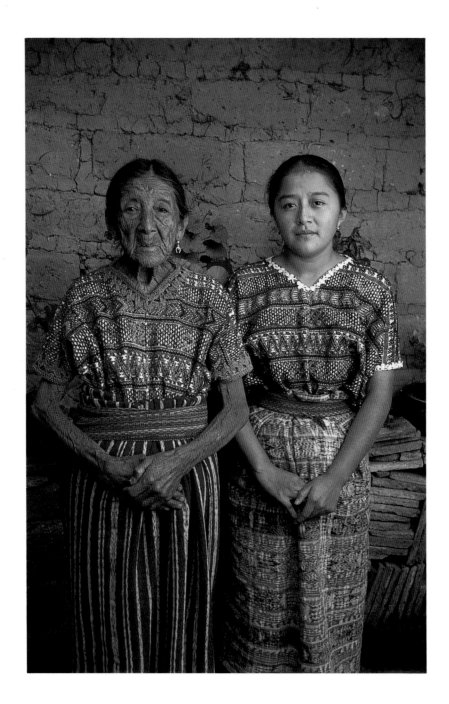

The genetic connection is as strong as the textile tradition; decades separate these two women yet they choose to wear similar ceremonial *huipiles*. Both are skilled weavers. San Martín Jilotepeque, Guatemala

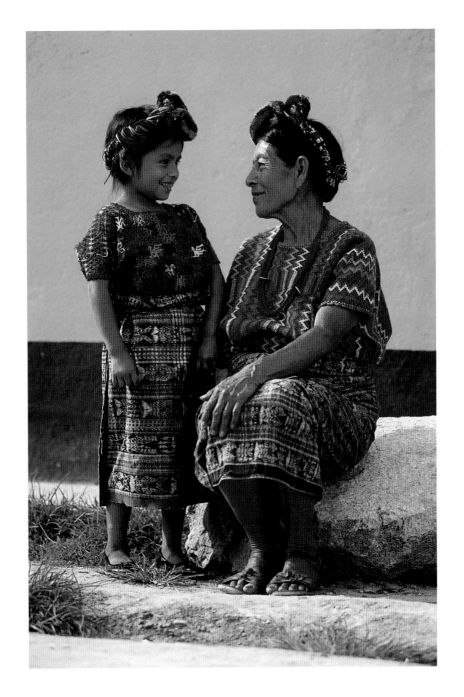

There are many levels of connection between this grandmother and granddaughter. From the textile perspective we see two different *huipil* styles within the same family: the grandmother wears the appropriate one for her generation, while the granddaughter's style is the innovative new one. San Miguel Chicaj, Guatemala

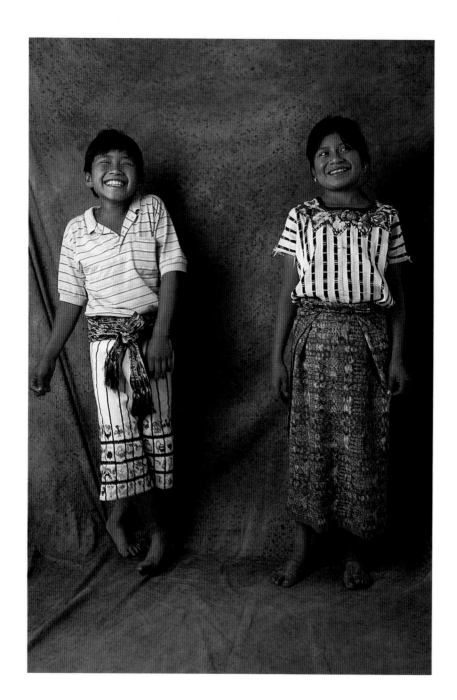

In some communities, boys and girls dress as their parents do. In both photographs, the excitement was in response to being asked to hold hands when the tradition is one of gender separation. Santiago Atitlán, Guatemala

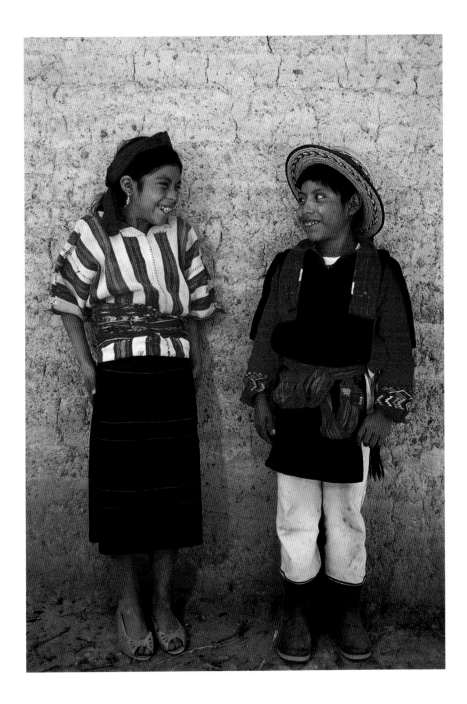

San Juan Atitán, Guatemala

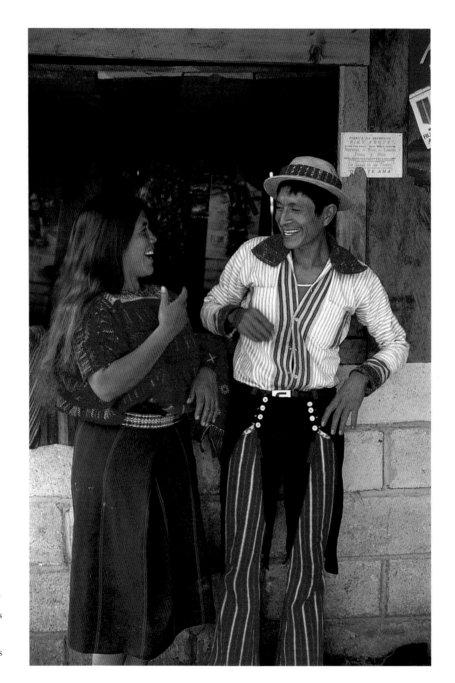

Desiderio, dressed in
European-introduced over-
pants, got slapped for
taking "Gringo liberties" by
attempting to pose with his
arm around the shoulder
of Andrea Valasques. Todos
Santos Cuchumatán,
Guatemala

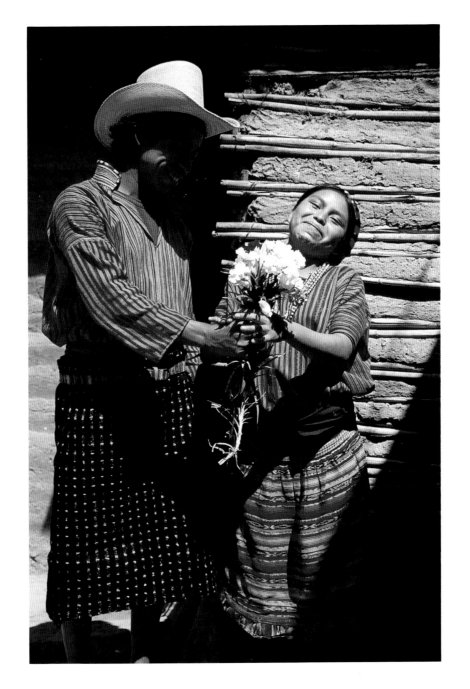

It is not often that an unmarried man speaks with an unmarried woman. In a family compound in San Antonio Palopó, the suitor of a young woman presents her with flowers, to her uncontrolled joy. His woolen wraparound hip blanket, or *rodillera*, resembles a similar garment worn by the ancient Maya. Guatemala

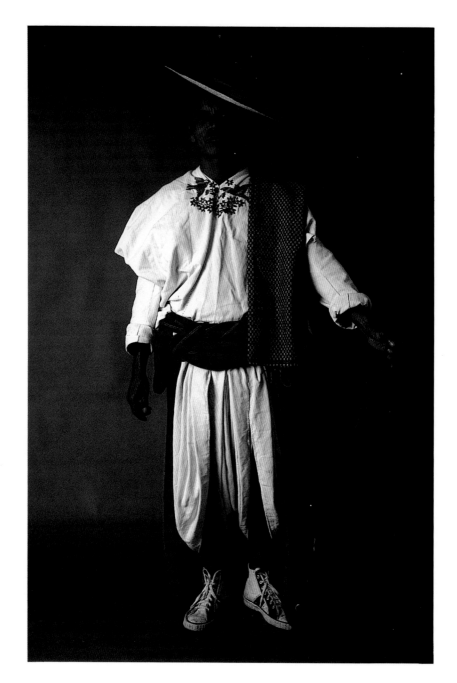

Representatives of all the hamlets of the Chiapas highlands gathered for a political rally, all dressed in their finest traditional costume. The man is a policeman from Huistán; his dress combines pre-Columbian costume elements like the long loin cloth with "high-tops." Mexico

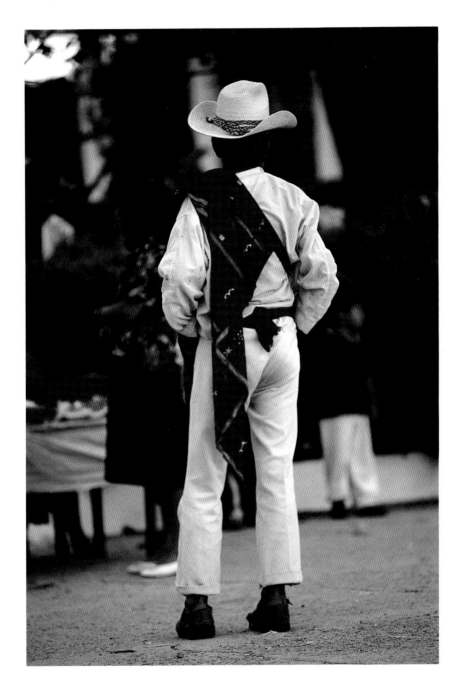

Combined with his western-style shirt and pants are traditional elements of *traje*, which include the belt, or *faja*, and a shoulder cloth, or *tzute*. In front of the church San Rafael Arc Angle, Suchitepéquez. Guatemala

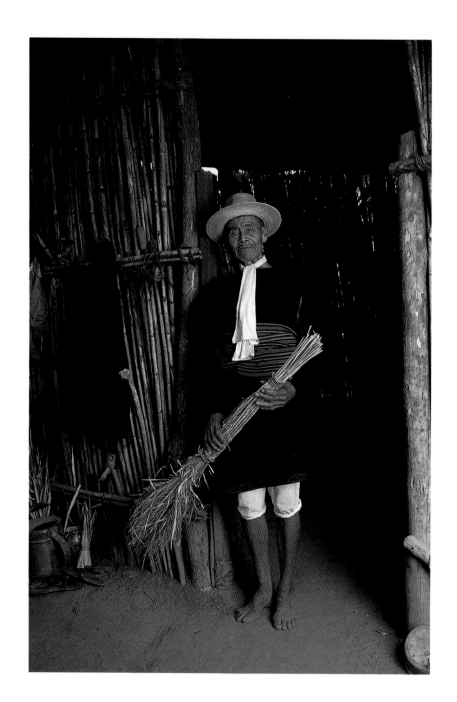

Only three men in San Antonio Aguas Calientes still dress in the old *gabón* or woolen over-shirt. One of them is Estavan Carmona. Guatemala

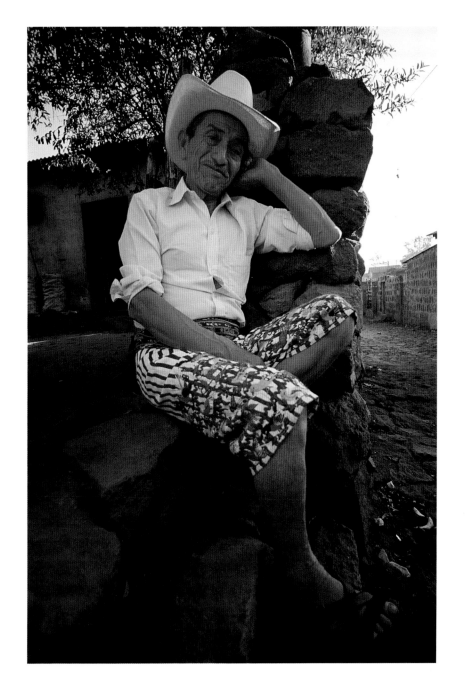

Dressed in the embroidered pants typical of Santiago Atitlán, a man enjoys the end of the day sitting on his front steps observing the activity on the street. Guatemala

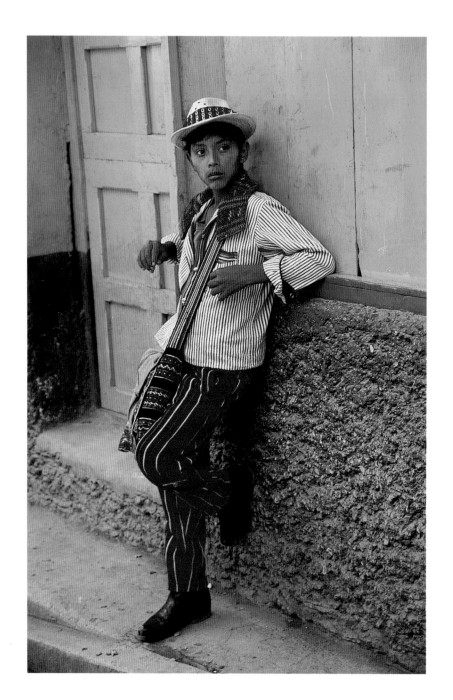

A young man from Todos
Santos Cuchumatán does not
wear the traditional woolen
overpants that were part
of men's *traje*, possibly a new
fashion trend. Guatemala

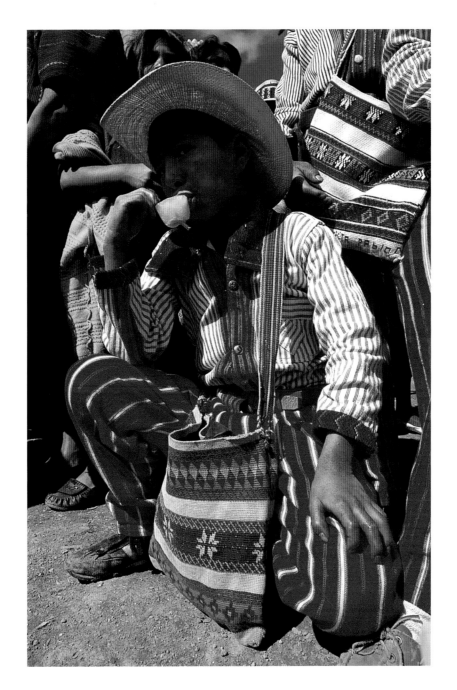

Dressed for the *Dia de los Muertos*, or Day of the Dead, fiesta, a young man joins a circle of friends observing traditional dances in front of the church. Men crochet the colorful shoulder bags, now a popular tourist item. Todos Santos Cuchumatán, Guatemala

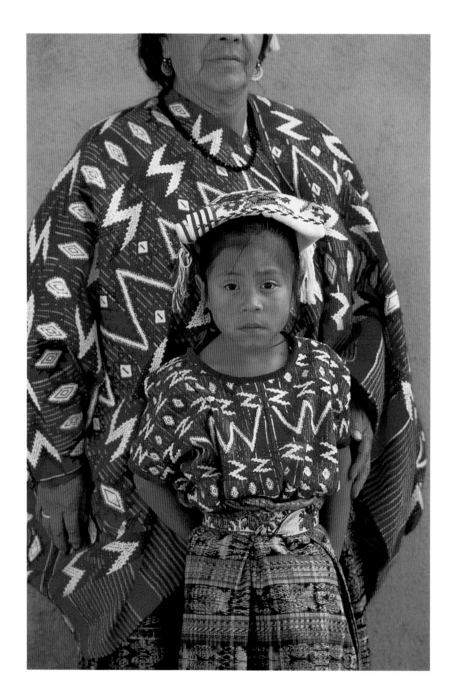

A timeline in textile tradition places the grandmother and granddaughter from Tecpán in a perfect progression. They wear contemporary versions of an old style ceremonial *huipil* or *pequeño ri'j po't.* Color, seriousness, and dignity are present in full measure. Guatemala

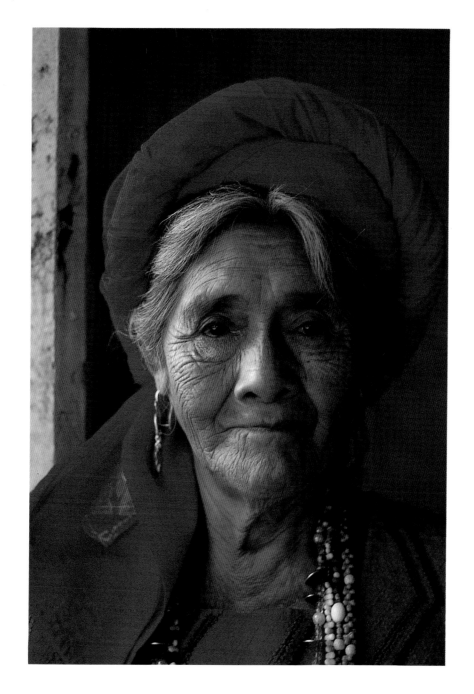

Mature beauty photographed in the church at Tamahú. She wears the red coiled headdress or *bagbal* that symbolizes the coral snake. Guatemala

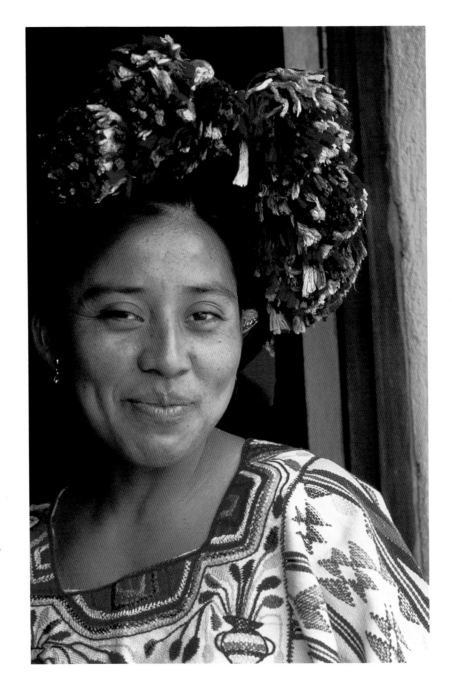

The niece of Pedro Allegria Ramos models the *huipil* that belonged to his mother. As part of the revitalization of Maya cultural life, a group of men and women formed a new *cofradía* for which new ceremonial-style *huipiles* were woven – a tradition almost lost but now revived. Sacapulas, Guatemala

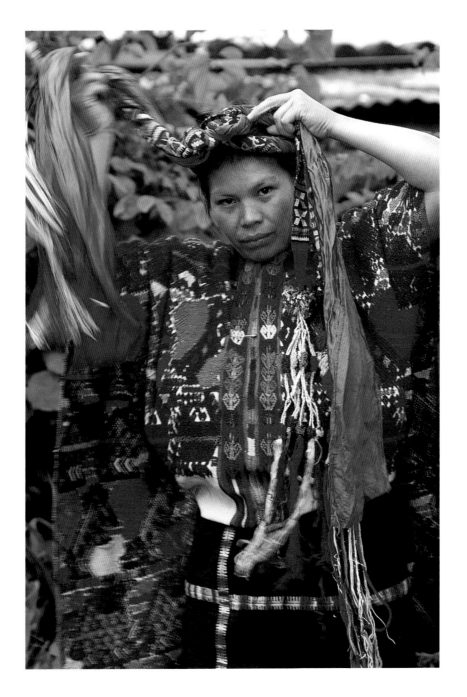

A woman from Santo Domingo Xenacoj, wearing a ceremonial *huipil*, wraps her hair with commercial cloth and a quetzal *cinta* woven especially for her town in Totonicapán. Guatemala

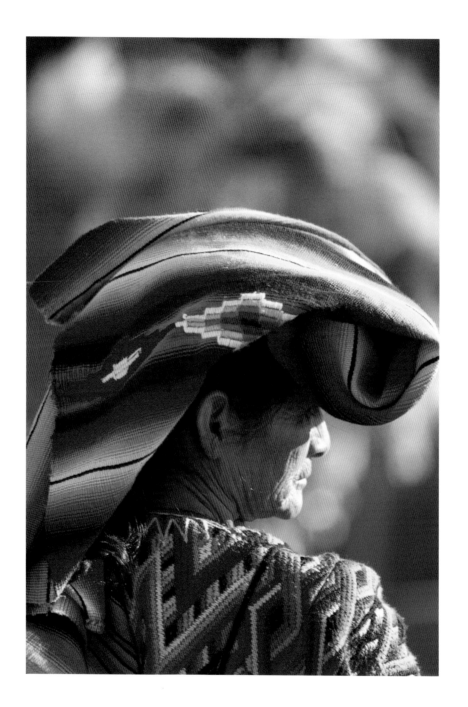

A woman peers across a sea of similarly dressed women from surrounding communities. Each of these women came to Chichicastenango to celebrate the winter solstice. Guatemala

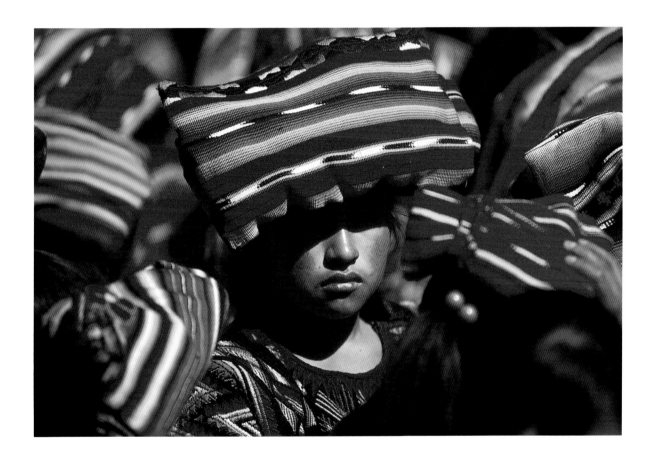

Women wear headcloths or *tzutes* to shade the bright sun, which shines on the crowd at the solstice celebration. Chichicastenango, Guatemala

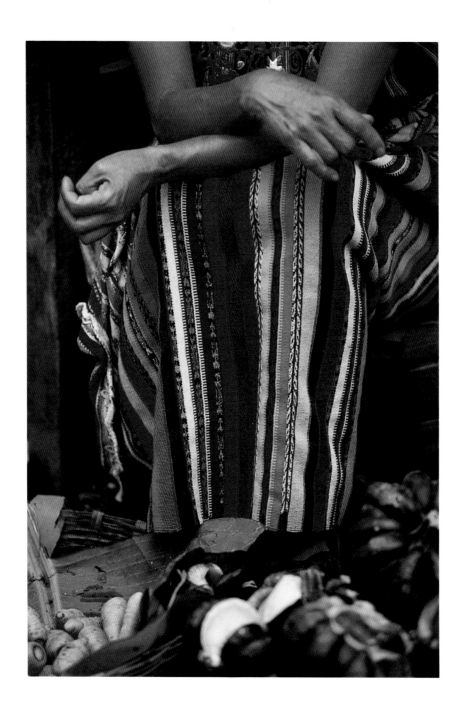

Handwoven, brightly colored textiles in the market environment blend vertical stripes with squash and bananas (left), or provide a backdrop for a vendor's foot at rest. Left: Antigua; right: Zunil. Guatemala

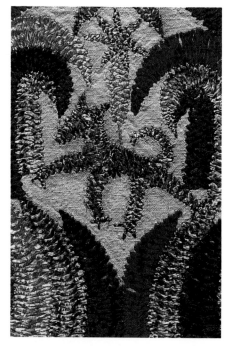

UPPER RIGHT: Detail of ceremonial veil (*paya*) embroidered with stem and encroaching satin stitch. Patzún, Department of Chimaltenango. Collection of the Museo Ixchel (P-509). c. 1945. Linguistic group: Kaqchikel. Guatemala

LOWER RIGHT: *Huipil* detail, image of a male deer. Its technical excellence together with the type of thread (*lustrina*) and the thread count elevates this item into ceremonial status. Tactic, Department of Alta Verapaz, DuFlon Collection. c. 1984. Linguistic group: Poqomchi'.

UPPER LEFT AND LOWER LEFT: Details of a *huipil* from Comalapa. The animal designs that are brocaded in these garments represent a style used for two decades ending in the 1960s. Department of Chimaltenango. Collection of Lucy Hempstead. c. 1940. Linguistic group: Kaqchikel.

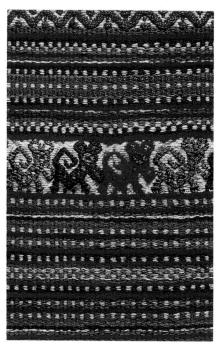

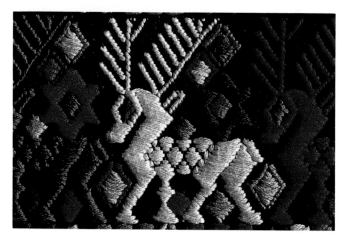

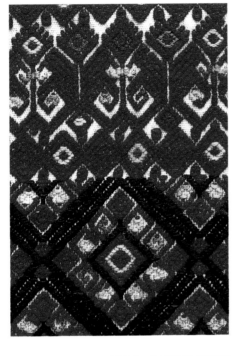

UPPER LEFT: Flowering corn symbol on a sampler; supplementary weft brocade; San Andrés Larrainzar, Chiapas; Collection of Jeffrey Jay Foxx. c. 1990. Linguistic group: Tzotzil. Mexico

UPPER RIGHT: Santa Cruz symbol; from Chenalhó, Chiapas, on a sampler; supplementary weft brocade; Collection of Sna Jolobil Weavers' Cooperative. c. 1972. Linguistic group: Tzotzil. Mexico

LOWER LEFT: Holy toad design; from Tenejapa, Chiapas; supplementary weft brocade; Collection of Sna Jolobil Weavers' Cooperative. c. 1974. Linguistic group: Tzotzil. Mexico

LOWER RIGHT: (bird) Detail of everyday blouse, San Mateo Ixtatán, embroidered with plain satin stitch; Collection of the Museo Ixchel (00833). c. 1965. Huehuetenango; Linguistic group: Chuj. Guatemala

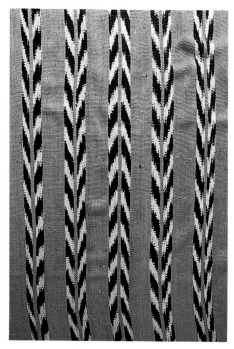

UPPER LEFT: Blouse detail woven on backstrap loom, embroidered with running and plain satin stitch. Cobán, Alta Verapaz. Collection of the Museo Ixchel (00724). c. 1955. Linguistic group: Q'eqchi'. Guatemala

UPPER RIGHT: Detail of a garment worn by women at special ceremonies. Quezaltenango. Collection of Lucy Hempstead. c. 1963. Linguistic group: K'iché. Guatemala

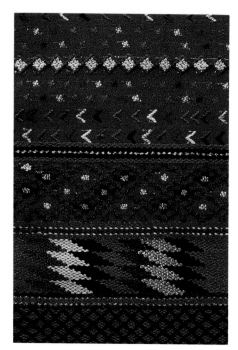

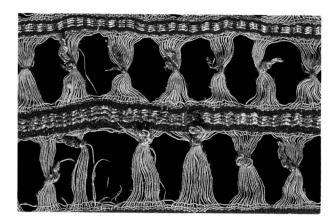

LOWER LEFT: Detail of a blouse woven on backstrap loom, supplementary weft brocading in silk and cotton. San Antonio Aguas Calientes, Sacatepequez. Collection of the Museo Ixchel. 1930s. Linguistic group: Kaqchikel. Guatemala

LOWER RIGHT: Detail of a ceremonial mantle used for special events for the *cofradías* of Quezaltenango, Department Quezaltenango. Collection of the Museo Ixchel (P-405). Woven on a foot loom and brocaded in silk, c. 1910. Linguistic group: K'iché. Guatemala

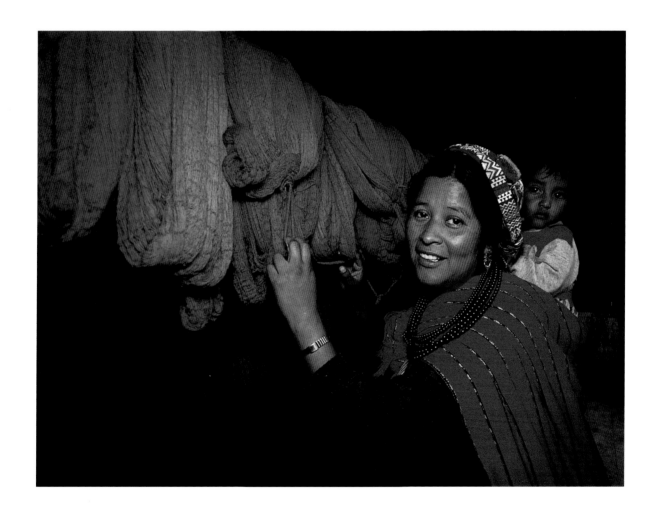

Indigo-dyed skeins of
wool on sale at the Santa
Ana weavers' cooperative
in Zunil. Guatemala

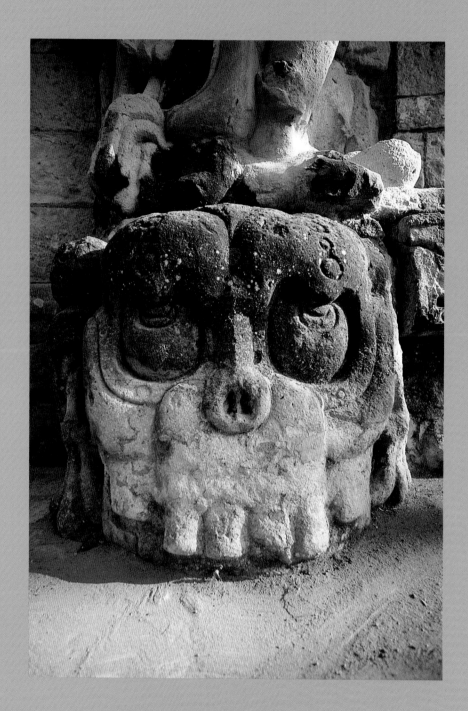

Since ancient times the
Maya have believed that life
originates from death, in
fact, that death sustains life.
This is a primary reason for
the common depictions in
Maya art of skeletal motifs.
A skull sculpture at Copán
is one of two on both sides
of a doorway on Temple 22,
overlooking the eastern
plaza. Honduras

ROBERT S. CARLSEN

Ceremony and Ritual

in the Maya World

The Maya world, covering parts of Guatemala, Mexico, Honduras, and Belize, is remarkable for its cultural antiquity, its geographical beauty, and certainly its internal diversity. It is common within just a few square miles of that area to encounter more geographical and cultural diversity than can be found within entire nations. Towns that were already ancient countless centuries before the Spaniards discovered the "New World" continue to be inhabited by Maya Indians. Yet the languages of neighboring Maya towns, their economies, even the styles of handwoven dress their inhabitants wear are often entirely different. Still other towns within the area may be more closely tied to European culture than to anything indigenous. Within those same few square miles a checkerboard of maize fields may rise steeply up volcanic escarpments, give way to frigid cloud-producing rain forests, and then drop just as precipitously to steamy lowland jungles dotted with the long-abandoned pyramids of a "mysterious" Maya past.

At first glance Maya religious ceremony and ritual appears to be yet another expression of this diversity. The area's towns and villages may at times seem almost a clutter of saints in procession or of dancers masquerading as deer, as jaguars, or as shamans. One might even happen upon the ritual dispatch of some unfortunate chicken under a shaman's very real blade. This diversity of ceremony and ritual is only amplified when the ancient Maya are taken into account, for instance, when pondering ancient ceremonial pageantry such as that depicted on stone monuments and so easily imagined when gazing at one of the aforementioned pyramids.

First glances, however, may be deceiving. In reality, amid an otherwise highly diverse Maya world, religious ritual has actually long constituted a characteristic and even a unifying element. By tightly linking the individual with the community and its leaders and ultimately with the cosmos beyond, religious ritual has long provided a primary organizing force in Maya culture.[1] In fact, this ritually forged cultural nexus has been pivotal in Maya cultural survival.

Indigenous ceremony and ritual can be a window into the cosmic order of the Maya world and, in turn,

on the ceremonial maintenance of that world. While the primary focus of this chapter is on the post-conquest Maya, it is impossible to entirely escape the ancient Maya, as their vibrant shadows continue to loom large on the contemporary landscape.[2]

Throughout, the role of ceremony and ritual in Maya culture is illustrated through analysis of aspects of indigenous textiles and textile production. Considerable attention is given to the Tz'utujil Maya community of Santiago Atitlán, located on the southern shore of Lake Atitlán in Guatemala's central highlands. While it is clearly impossible for any single community to exemplify the vast Maya population, examples from Santiago Atitlán illuminate widespread features of Maya ceremony and ritual.

THE FOCUS OF MAYA RITUAL

The two young foreigners had only just peeked in through the door when a look of pity showed across their faces. The message was unmistakable enough that it might just as well have been scripted in words declaring, "Oh my, look at the sorry state to which these Indians have sunk." Confronting the two — who, I was later to learn, were down from the States on a two-week religious mission — was a smoke-filled room strewn with disheveled men and women. Many of those inside were passed out on benches or on the floor, while others offered staggering support to partners as they engaged in something that resembled dancing. Overwhelming the atmosphere inside was a smell of liquor. Even as the two looked in on this spectacle, someone was actually pouring even more drinks. Moving from person to person while occasionally having to rouse would-be drinkers from their stupor, the purveyor dumped shots of some sort of almost-clear liquor into a dirty shot glass. Although

extreme inebriation already reigned, after mumbling a few words virtually everyone downed their shots in single gut-wrenching belts.

Piercing through all of this were what can only have sounded to the newly arrived onlookers like incoherent shrieks, coming from men cloaked in animal skins and chasing each other. As the two scanned the scene, the look of pity draped across their faces turned to scorn. In part it may have been that they noticed a large wooden statue situated amid candles and flowers and seemingly presiding over the revelry. More important, they had spotted me slumped on a bench and reflecting every bit the three days and nights that I had passed in the room. Apparently they thought it distasteful that one of their own countrymen would set such a bad example for the natives. Just then, however, a man emerged from within, hooked a hand around the neck of one of the two, and yanking him close slurred some declaration directly into the face of the startled onlooker. Perhaps it was the clamminess of the hand, or perhaps the blast of stale liquor breath. For whatever reason the foreigners turned and quickly fled from their face-to-face encounter with so-called Maya folk Catholicism.

So what exactly was this raucous scene that the two missionaries had happened upon? In general terms it was a ceremonial fiesta. The setting was in Santiago Atitlán and inside what local Maya sometimes refer to as a "dawn house" or an "adorned house," but what in Spanish is called a *cofradía* house. More specifically, it was one of ten local *cofradías*, religious organizations each dedicated to the veneration of a particular "saint." Had these visitors (or any other visitor for that matter) asked to which saint this specific *cofradía* was dedicated, they most likely would have been directed to the wooden statue surrounded by flowers and

candles and have been told that it was Saint John the Baptist (San Juan Bautista). Upon further investigation, however, a far different picture of the actual persona of the venerated image would emerge.

Indication of that persona is given graphic display in the wooden figure itself. Adorned with the identifying headcloth of local *cofradía* members, it appears to hold a baby lamb (symbolic of Saint John the Baptist). Upon closer inspection, however, the lamb exhibits black spots, whiskers, and fangs protruding from its mouth. In reality, it is no lamb at all, but instead a baby jaguar. The fact is that the entity in question is Lord of the Wild Animals. In this sense, its Saint John component, which unarguably derives from the New Testament, should be understood as constituting little more than a foreign actor in what is really an identifiably local Maya production. The question that of course arises then is, what is that production?

To approach that question, it is helpful to return to the men cloaked in animal skins running after each other in the *cofradía*, to the Deer-Jaguar Dance. During my years studying and participating in religious ceremonies in Santiago Atitlán, I have witnessed the dance many times. The typical performance entails a dancer draped in a jaguar hide, who yells out words in the local Maya dialect (Tz'utujil) and chases another dancer cloaked in a deer hide. Sometimes, especially if the dance is performed at night when participants may run for hours through the streets, there can be ten or so dancers. I have heard accounts of the significance of the performance on various occasions. Perhaps the best explanations have been those of Juan Ixbalam, who incidentally was one of the men passed out on a bench when the two foreigners paid their brief visit. Juan explained that the dance re-creates a myth from the Maya primeval past. In vivid narration of the lengthy myth, he recounts how Wind Jaguar relentlessly chases First Human. As Wind Jaguar runs after the rattled and confused individual, who although created fully grown has the knowledge of a newborn, he yells out the names of surrounding geographical locales, places like Skull Sweeper and Medicine Mushroom Place. During interludes from the chase, the bewildered First Human is approached by Skunk. Calmly puffing on a big cigar – after all, he is the inventor of tobacco – Skunk poses the question, "You don't get it, do you?" Eventually First Human does "get it" and is thereby able to coax Deer into sacrificing his life in order that humans might inhabit the world. Cloaking himself in Deer's skin, First Human then proceeds to entice Wind Jaguar into giving chase, finally tricking the demigod into impaling himself on a cyprus tree.

Sitting in the *cofradía* that night, watching the deer and jaguar dancers weaving through the revelry, I recalled Skunk's monumental question, "You don't get it, do you?" Contrary to the two fleeing foreigners, who no doubt felt that the raucous scene reflected the most complete ignorance, those inside the *cofradía* did get it. But get what? Just as the Deer-Jaguar Dance is about sacrifice and the necessity of human intervention in that sacrifice, the Maya participants in the *cofradía* are explicit that the days on end demanded by the grueling ceremony is also about sacrifice and is absolutely essential for fueling the world's vital operations.

It is precisely those operations that underlie Skunk's question and also constitute a general focus of Maya ceremony and ritual. In forming the question, Skunk utilizes the Tz'utujil Maya word *na'oj*. This word can be roughly translated as "wisdom," yet it is wisdom in an indigenous sense and entails a distinctly Maya view of the world. Although that view is really

fairly simple, as it runs contrary to the future orienta-tion of contemporary Western world view, it can, nonetheless, be elusive.

To understand the Maya world view, and in turn Maya ritual, one must abandon the future orientation of the West and shift one's gaze backward, literally back in time. Although that view certainly encompasses the exploits of mythical heroes such as First Human, its focus reaches back even to that timeless realm which prefigured the very moment of all creation. It was out of that realm from which life emerged, that myste-rious ember which, through ritual, has been recycled through countless permutations of birth and death. (*K'aslemal*, the word for life in some Maya languages, literally means "emberness.") To "get it" is to under-stand that even today it is the original life spark that sustains the living, the past that sustains the present.

About the primary realm prefiguring creation, the ancient Maya text *Popol Vuh* states, "Whatever there is that might be is simply not there," and equates it with pooled water and the calm sea.[3] In other cases it incorporates the World Tree, a widespread concept in ancient and contemporary Maya world view. Accord-ing to the Maya of Santiago Atitlán, before there was a world (what we would call the universe), a solitary deified tree was at the center of all that was. As the world's creation approached, this deity became preg-nant with potential life; its branches grew one of each thing in existence. Not only did gross physical objects like rocks, maize, and deer hang from the branches, there were also such elements as types of lightning, and even individual segments of time. Eventually this abundance became too much for the tree to support, and the "fruit" fell. Smashing open, the fruit scattered their seeds; and soon there were numerous seedlings at the foot of the old tree. The great tree provided shel-ter for the young "plants," nurturing them until finally it was crowded out by the new. Even then, the essen-tial essence of the old tree continued to sustain its descendants. Since that time, this tree has existed as a stump at the center of the world. This stump is what remains of the original "Father/Mother" (*Ti Tie' Ti tixel*), the source and end point of life. The focus of local ritual is, in one way or another, oriented back to the Father/Mother, the original tree. This tree, if properly maintained, renews and regenerates the world.[4]

Three underwriting principles of this myth define primary characteristics of Maya world view, as well as of associated religious ceremony and ritual. First, as discussed above, Maya ritual tends to be focused back in time. On occasion the target is the moment of creation, that instant to which can be traced the origi-nal ember of life. Additionally, the myth exposes a characteristic repetitive and circular nature. In other words, exemplary incidents from the mythical past are continually replicated in the actual present. While this is apparent in ceremonies such as the Deer-Jaguar Dance or the Dance of the Conquest, at other times this aspect reflects a more general primordial sense. In such cases it may include the conceptualization of the primordial World Tree (often in the form of a maize plant) and accordingly is talked about by the Maya using vegetational metaphor. Finally, the rationale for the Maya performance of ceremony and ritual is imbedded in the considered myth.

The backward focus of Maya ritual is pervasive and is given myriad expression in past and present Maya societies. This focus is often associated with "ancestor worship." At times, however, references to the World Tree indicate that such ancestry predates human ances-tors. For the ancient Maya, a major body of evidence comes from Palenque, Mexico, a Classic period (ca.

A.D. 200–900) site whose stone monuments have been described as illustrating "the basic structure of Meso-american religion."[5] Primary objects of worship as depicted in Palenque monumental art are skeletal deities from which grow World Trees. Whether in the form of an actual tree or a maize plant, the World Tree forms an axis between the underworld and the heavens above. Depicted in the Temple of the Foliated Cross, for instance, are Maya kings ritually sacrificing their own blood to a skeletal deity at the base of the World Tree. That deity, commonly identified by the sterile title G-II, has been variously identified as an "ancestral and a vegetation deity," a god of "generations, ancestry, and lineages," and as a "seed from which a corn plant containing the Ancestors grows."[6]

In its contemporary context, the backward focus of Maya ritual typically falls under the general category *costumbre*, a vastly important component of post-conquest Maya culture, one that even today tends to be shrouded in secrecy. *Costumbre* might be defined as "old inherited ways of knowing and doing," which can be glossed to mean simply "the Old Ways." Importantly, *costumbre* is often used in verb form, as in to *do costumbre*. Certainly one of the more widespread examples in the contemporary Maya world of doing *costumbre*, one that points directly to a focus on the past, is the Day of the Dead ceremonies, which take place on the second day of November. While there exists regional variation in the exact form and meaning of Day of the Dead rituals, in virtually all cases graves are adorned with vegetation in the form of flowers and fruit. In various highland Guatemalan communities (for example, Santiago Atitlán and Santiago Sacatepéquez), Day of the Dead ceremonies also include the ritual flying of kites, which form axes between the underworld, the earth's surface, and the celestial realm above.

The backward focus so apparent in ritual is even found in aspects of the Maya textile tradition. In some highland towns, for instance San Andrés Semetebaj, people say that they continue to wear the local style of costume because it "puts them in the form of the ancestors." That same belief is found in Santiago Atitlán, where it also is expressed in the weaving process itself. In that town, cloth is believed to be not merely woven but, in fact, born in an ancestral form.

Indicative of the weaving-as-birthing concept are the names of various components making up the backstrap loom. At the top of the loom is the *r'wa kiem* (back loom bar in English), which means "the weaving's head." At the other end of the loom is the *r'chaq kiem* (front loom bar), or the "bottom (butt)" of the weaving. The Tz'utujil word for the "lease stick," as used in brocading, is *tkr* (or rib). Of particular importance is the *r'way kiem* (shuttle), around which is wound the weft yarn. *R'way* translates as "sustenance." The sustenance is added to the loom by way of the heart, the *r'kux*. In English this is called the "shed," and is the space allowed by the loom mechanism so that the shuttle can pass unhampered through the maze of warp yarns. (Some Guatemalan towns use a Spanish term for the shed, calling it *boca del tejido* or "mouth of the weaving."[7]) In the course of weaving, the shed is in a constant process of opening and closing, opening and closing, suggestive of the beating of a heart.

Fundamental to weaving with a backstrap loom is a post or tree on which to secure the loom. In the Tz'utujil language this is called *r'tie chie*, or "mother tree," an aspect of the World Tree. The Mother Tree supports the assembled loom by way of a rope called *yujkut*, which local Maya recognize as synonymous with the umbilical cord and hence a connection to the ancestors. Where this umbilical cord forms an evident

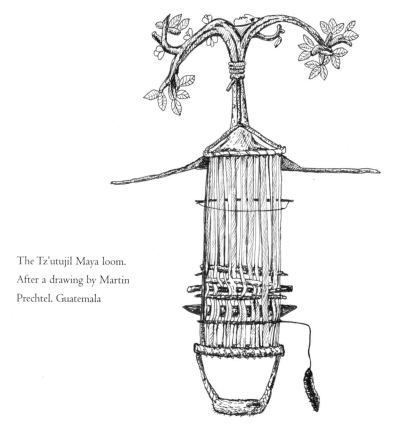

The Tz'utujil Maya loom.
After a drawing by Martin
Prechtel. Guatemala

motion also mirrors that of a woman in childbirth. Again the batten is slammed, and again the weaver bends forward. Heart open, give the weaving sustenance. Lean back, slam the batten. Bend forward, more sustenance, pull back, heart beating, more sustenance, bend forward, heart beating, feed the weaving, pull back, slam the batten, and on and on. Slowly the bare bones of the loom give way to cloth, to an entity that is at once alive yet is sustained by an ancestral, even primordial, past.[8]

The backward focus of Maya ritual and world view grades seamlessly into another enduring component of Maya culture: its circular and repetitive nature. This dimension is apparent in a continual life-to-death-to-life progression, and the Maya commonly speak of it using vegetational imagery and metaphor. Such a continuum is apparent, for instance, in the *Popol Vuh* when the creator deities ponder how the soon-to-be-emergent world should be "sown" and "dawned." *Popol Vuh* translator Dennis Tedlock likens the terms "dawning" and "sowing" to a moebius strip, explaining:

If we start with the literal meaning of sowing in the present context, the reference is to the beginning of plants; but if we trace that idea over to the other side of our strip, the sprouting of those same plants is expressed metaphorically as "dawning." If on the other hand, we start from the literal meaning of "dawning," the present reference is to the first of all dawns; but if we trace the idea back to the other side of the strip, the origin of that dawning is expressed as a "sowing."[9]

As Tedlock notes, the pairing of dawning and sowing can be expanded to include human birth and regeneration. In at least several Maya languages, including Tz'utujil (which incidentally means "Flower of the Maize Plant") and K'iche' ("Many Trees"), pregnancy is directly associated with sowing, and birthing is associated with dawning and simultaneously with sprouting. Here again the chief momentum is coming

link with the ancestors, at the other end of the loom sits the weaver, an evident link with the living.

Prior to weaving it has been traditional that local Maya women say prayers, upon which the weaver positions herself carefully in front of the Mother Tree and begins to give food to the loom. The weaving process, a nearly poetic and ceremonial act, has begun. With the shed (the heart) open, the weaver passes the shuttle through. She then leans back and slams down the batten, which results in a loud "pop." Tension on the loom is eased as the weaver bends forward. More sustenance is given the weaving. Again the weaver leans back. While the backward action of her hips provides necessary tension on the loom, this back-and-forth

from the past. The ancestral focus of this sowing/birthing is given clear articulation in Santiago Atitlán. Maize seeds that are to be sown may be called "interred ones," or at other times "little skulls."[10] With proper care the little skulls will sprout, eventually to become small plants. These plants are addressed as *tak aii*, "little ones," a name that, like "sprout," is used in reference to children. As reaffirmed in the following standardized prayer from Atitlán, it is the dead who sustain the cycles of life, the past that sustains the present.

What was said, lives.
It has become a jewel,
and it flowers.

But it is something now lost,
Something relegated to death.
Lost in dust, lost in earth.

It holds us like a baby.
It guards us like a child.
It trusses the World at the edges, like a house.
It holds up the sky.

Giver of life.
Giver of food.
Giver of water.

You who are the great-grandmothers and great-grandfathers,
We are your flowers, we are your sprouts.
We are the ones who fall off the trees,
We are the ones who fall off the vines.[11]

This leads to a concluding point about the focus of Maya ritual. Maya have long held that whether they entail dawning, sprouting, or birthing, the cycles

of existence do not just automatically come about. Quite the opposite: the very continuity of the world demands human intervention in the form of religious ritual. Only through ritual can the world be renewed and regenerated, can life be made to sprout from death. Associating this process with an ancient tree root that sustains the world, one resident of Santiago Atitlán said: "The village cannot go on living without it because it is an original thing: it is tied to the beginning of the world."[12] Of central importance is the belief that ritual fuels the world's vital cycles and hence gives it form, the true meaning of "cosmos." Short of such ritual, existence must revert to a world such as that ruled by Wind Jaguar, or even to its original state of formlessness, to primeval chaos.

THE MAYA CEREMONIAL LANDSCAPE

Basic to Maya culture and religiosity is a unique relationship of the people to the earth. This relationship is evident in the common reference to the earth as Dios Mundo, or World God. Some Maya even speak of having an "umbilical" relationship with that deified entity. In several Maya languages, the word for earth is *ruchiliew*, which means "face of the world." Accordingly, some Maya claim that the ground on which the people walk is literally the face of an ancestral deity, a benevolent force that sustains the living.

Connected as they are with the world about, it is perhaps natural that Maya project themselves symbolically on the surrounding landscape. While the best contemporary examples come from the highlands of Guatemala and Chiapas, Mexico, such projection is to be found among Q'eqchi' Maya in lowland Belize as well. Q'eqchi' shamans in San Pedro Columbia associate pulse points in the wrists and ankles with the "four sides of one's being," with the four corners of one's

home, with one's cornfield, and by extension with the four corners of the world.[13] Relationships between the internal human microcosm and the external cosmos also are found in the K'iche' Maya community of Momostenango. Located within that highland Guatemalan town is a sacred hill, Paclom, which is understood to constitute the "heart" or center of the world, and which is "spiritually connected" to four surrounding hills representing the world's four corners.[14] Consistent with an earlier point is a local Maya association of the body with the world, in which biological time "flows from the ancestors to descendants who, in turn correspond to the spatial categories east and west and to the dawning, or 'birth,' of the sun and the setting, or 'death,' of the sun each day."[15]

The Maya of Santiago Atitlán also confirm a relationship between ritual and geographical/chronological place, and in so doing point to a topic that will require considerably more discussion: the link between geography, ritual, and survival (cultural and otherwise). In Santiago, followers of the *costumbres*, the Old Ways, refer to their town as the Umbilicus of the World (*R'muxux Ruchiliew*), which is to say its primordial center. From Santiago's position on the southern shore of Lake Atitlán, those individuals project a virtual calendar on the volcanic peaks and mountainous crags that form the towering upper reaches of the Lake Atitlán basin. The progression of locales to the east where the sun dawns, or is born, forms half of this construct, while the other half consists of the western locales where it sets throughout the year. In its entirety, this construct is called Footpath of the Dawn, Footpath of the Sun. It is believed that rituals throughout the year which fuel the ceaseless progression of Footpath of the Dawn, Footpath of the Sun are of vital importance. Underwriting those rituals is

a necessity for the smooth progression of the seasons and hence of the agricultural cycles on which hinge the community's very survival.

At first glance — at least to those not subscribing to the Old Ways — it might seem farfetched that such beliefs and rituals could actually have contributed to Maya survival. Yet, although not always in the manner that the Maya participants explain, hundreds of years of such survival demonstrate that in this case the seemingly unlikely is, in fact, true. Key to this scenario has been the interplay of (a) geographical obstacles to Hispanic and Maya interaction with (b) indigenous rituals that have maximized the potential social autonomy offered by those obstacles.

Some fifty years ago, commenting on the influence of geography on highland Maya culture, the cultural geographer Felix McBryde observed that there is probably "no region in the New World that surpasses western Guatemala for illustrating the relationship between culture and nature. Here is one of the largest concentrations of individualistic Indian populations, preserving much of its Maya background."[16] McBryde explained this individuality and cultural conservatism in terms of a high degree of microgeographic diversity. About the Lake Atitlán region, for instance, he noted that "many of the villages may be separated from their neighbors by two miles or less, and yet being isolated by physical barriers such as precipitous headlands, cliff shores, and a dangerous lake surface, they may have distinct economies, dress, and even vocabularies." If regional geography has impeded interaction between neighboring Maya communities, the effect on these communities' interaction with the region's few and far between non-Indian communities has been even more profound.

This sort of dynamic has not been limited to the highland Maya area. While the lowland region may

exhibit few precipitous headlands and dangerous lake surfaces, that area's natural environment has historically offered zones of cultural refuge every bit as potent as those of the highlands. Ironically, where in the highlands such refuge has reflected difficulty of movement, in the lowlands it has stemmed from quite the opposite, from ease of movement. Unimpeded by barriers to flight, and surrounded by vast expanses of virtually uninhabited jungle, "the conquered have been free to drift away, abandoning the conqueror."[17] The very existence even today of the jungle-dwelling Lacandon Maya stems directly from this sort of flight several centuries ago.

Based on the above, the casual observer might surmise that Maya cultural survival merely reflects accidents of geography combined with external disinterest in southern Mesoamerica. To be sure, openness or hostility of terrain notwithstanding, had the region been rich in gold or precious gems the Maya and their culture would long ago have been overwhelmed by foreign intruders. Yet to dismiss Maya survival as merely stemming from an absence of natural resources prized by outsiders would be overly simplistic, as well as unacceptably ethnocentric. Such a view entirely discounts the Maya role in shaping the history of the region in which they remain the majority population, utterly ignoring their capacity to resist, to subvert, and to adapt – in short, to think. The fact is that the Maya have actually buttressed the region's marginal status and have thereby maximized their own sociocultural autonomy and survival. And Maya religion and religious ritual have been vital in this process.

To put this situation into focus it is helpful to recall that Maya culture is a ritually forged cultural nexus linking the individual with the community and ultimately with the cosmos. Figuring into this cultural mosaic has been an interplay of religion with political power and community consolidation. Whether in ancient or more contemporary Maya communities, the most important religious leaders also have commonly been the most important political leaders. Given that the very maintenance of the cosmos hinges on the performance of religious ritual, and that the most important rituals must be performed by religious leaders, a cultural path has existed for those same leaders to consolidate their political power. It is difficult to escape the conclusion that Maya political power has long been a consequence of esoteric knowledge and religious ritual.

While this general process has been widespread throughout the Maya world, there has existed considerable variation in the actual form through which it has been manifested. In the southeastern frontiers of Colonial period Yucatán, for instance, religious leaders legitimized their influence over their followers through the interpretation and communication of ancient calendrical (katun) prophecies. On the other hand, in contemporary highland Guatemala and Chiapas, followers of the Old Ways legitimize their power through such diverse actions as performing rituals to the "saints" of folk Catholicism or through the dancing of ancient sacred bundles.

Whether through prophecy or through bundle ceremonies, the derived power has had tremendous impact on the nature and course of Maya culture and history. Not only have community civil-religious leaders directed local governmental affairs, but they also have typically received community authority to negotiate with outside cultural and economic interests. In this way potential disruption to traditional ways of life often have been minimized. By way of example, throughout the Maya world indigenous leaders have utilized funds raised by the cofradías as instruments of

barter with Catholic priests, in fact to buy considerable degrees of cultural autonomy. One is even led to suppose that *cofradías* existed, at least in part, to provide bribes or presents to potentially intrusive outsiders. If a priest refused to be "bought off," protests could range from refusals to pay his stipends to attacks on his person.[18] On numerous occasions, intrusions into Maya community affairs have even led to full-scale indigenous insurrections.

The point has been made by numerous scholars that far more than the "tribe," and certainly more than the nation, it is the local community that has been the primary locus of group identification for most Maya. For much of the past five centuries, it has been the local community whose autonomy Maya have most fiercely defended. Importantly, religious ceremony and ritual have been wielded as primary weapons in that fight and have helped to buttress the otherwise fragile walls of Maya existence. The importance of ceremony and ritual in this regard is evident in the pivotal role in Maya religiosity of a "symbolism of center," in particular the conception of a specific locale as constituting the actual center of existence. Various Maya communities lay claim to that central distinction. Disregarding logical inconsistency, of particular significance is that the cosmic importance of central geographical place and of the performance of associated rituals weld the allegiance of a given local population to its individual community and civil-religious apparatus.

Perhaps nowhere is such community allegiance given better graphic expression than in textiles. While the so-called town-specific costume in which the members of an individual community may wear a specific costume style certainly comes to mind, other aspects of the Maya textile art reveal even more about the nature of the relationship of the individual Maya

with his or her community. In Santiago Atitlán, for instance, many women continue to weave and to wear a style of blouse (*pöt*) whose collar is embroidered with representations of the volcanoes surrounding the Umbilicus of the World, Santiago Atitlán. By wearing this garment the local Maya woman claims her birthright as a citizen of Santiago Atitlán and simultaneously situates herself symbolically at the center of the world.

Another local type of garment is even more precise about the relationship of the individual with the community. Various older men in Atitlán continue to wear a style of backstrap-loomed shirt (*ktuon*) with a decorative cross-shaped cloth appliqué at the belly level. According to all accounts this odd appendage, matter-of-factly called a *r'muxux* (umbilicus), is a distinct reminder to the wearer of his umbilical connection to the town and to the ancestral past which sustains the living.[19]

A Tz'utujil backstrap-loomed shirt or *ktuon* with symbolic umbilicus. Guatemala

Textiles such as these form part and parcel of the cultural nexus that, through ceremony and ritual, links the Maya with their community and ultimately with the cosmos. Whether it be a weaving pregnant with symbolic content or a ceremonial dance invoking ancient heroes, individual aspects of that nexus constitute receptacles for the storage of traditional Maya knowledge. This entire construct is inherently conservative and has been key to Maya cultural survival. Yet, it is equally clear that over the centuries Maya culture — associated ceremonies and rituals included — has undergone significant change. To offer ideas on the nature of that change the present exploration of Maya ritual and ceremony turns to a defining aspect of post-conquest Maya culture, the so-called cult of the saints.

MAYA "SAINTS" AND CATHOLIC "IDOLS"

The saints of Catholicism gained their initial toeholds in the Maya world, even as the first Spanish *conquistadores* and accompanying Catholic friars blazed their way across the region. That the cult of the saints remains vital in contemporary Maya culture indicates that the pioneering friars were at least superficially successful in the Maya "spiritual conquest."[20] Given the continuing importance of the saints in Maya religion and religious ceremony, and that the saints are of clear and distinct foreign origin, they offer an opportune window onto change in the Maya world.

Perhaps the best way to approach an understanding of the nature and role of the saints in the Maya world is through consideration of their place in Maya religious ceremony, in particular in what is called the fiesta system. The fiesta system is the institutionalized celebration of regularly occurring fiestas throughout the year, virtually all of which are celebrated in accordance with Catholic saints days. Depending on histor-

ical and regional nuance, the fiesta system in the Maya area may be referred to as the "*cofradía* system" and/or the "cargo system." In its modern form, the fiesta system typically includes some form of "cargoes" or nonpaying periodically rotated positions.[21] While the term "cargo" comes from Spanish and means position, duty, and responsibility, it also may connote a load or burden. In terms of the fiesta system, this connotation is evident in the Tzotzil Maya community of Zinacantán, Mexico, where cargo includes a relation to the "Year Bearer" symbolism of the Maya calendar in which segments of time are conceived of as burdens carried on one's back.[22]

The fiesta system was introduced into the Maya world within a decade of the conquest, when the Spanish imported *cofradías*. In Guatemala, for instance, the earliest known *cofradía* was Cofradía de la Inmaculada Concepción de Nuestra Señora, established in Santiago de los Caballeros in 1527.[23] In Spain, *cofradías* existed since at least the mid-twelfth century as voluntary lay organizations whose primary purpose was the veneration of a particular saint.[24] Eventually Spanish *cofradías* assumed the task of constructing hospitals for their members as well as providing funerals and taking care of members' widows.

The *cofradía* prototype in the Maya world matched closely its Spanish counterpart, including the provision of social services. The reason for the institution's introduction, however, had little to do with this. Rather, it was the Spaniards' intent that *cofradías* provide for both the collection of revenues and the Maya integration into the Church. The Maya came to utilize *cofradía* revenues to "buy off" priests; those priests, who were often itinerant and living in distant towns, came to be reliant on the funds paid by *cofradías* for the saying of mass on saints days. Typically having direct control

neither over the *cofradía* funds nor over the amount of the stipend, it is of little surprise that they were forced to concede to certain Maya demands, including the right to an amount of cultural autonomy.

Because *cofradía* payments came to be a primary source of clerical income, the Church would not aggressively attempt to regulate the institution. More importantly, to attempt to have done so would have risked Spanish loss of control over the region's huge Maya population. For instance, in 1770 Guatemalan Archbishop Cortés y Larraz stated that tampering with the *cofradías* would have led to indigenous revolts, the Maya wholesale abandoning of their towns, as well as their disowning of the very name "Christian."[25] The archbishop cited an incident in Sololá in which suppression of the local *cofradía* system led the Kaqchikel population to abandon the Church and refuse to have their children baptized. These and numerous other such incidents led the archbishop to conclude that "the [Maya] do not want anything Spanish, neither religion, doctrine, nor customs."[26]

If the Spaniards' intention that *cofradías* provide for the collection of funds was only marginally successful, their hope that the institution facilitate the Maya integration into the Church was even less so. To be sure, the institution proved to be immensely popular with the indigenous population and enjoyed explosive growth. In 1787 there were 3,153 authorized *cofradías* in Guatemala alone.[27] This type of reception was no doubt a source of great inspiration to the pioneering friars. It was those first missionaries' intention to establish a New World church that would re-create the primitive church of the apostles of Christ; to establish what they called the New Jerusalem. They felt that Divine providence had already sown the seeds of that utopia in the newly conquered lands and that, shown the way,

the native population would flock to the new religion like lambs unto Christ.

The magnitude of the Maya response to the *cofradías*, however, would eventually arouse the Church's curiosity, and finally pique its horror. In short, evading the scrutiny of their pious overlords, the Maya used the *cofradía* to transfer important aspects of pre-conquest religious ritual, refabricating the institution into something according to a 1740 document reportedly "so perverted, that piety is converted into pernicious tyranny, saintliness into interest and greed, and sacredness into sensuality and drunkenness."[28]

In hindsight, it was predictable that the Maya would fuse important aspects of pre-conquest religion and religious ritual with Catholicism. From the outset of the post-conquest period, a dearth of Spaniards, compounded by a preference for the company of their own countrymen in the region's relatively few non-Indian settlements, insured a high degree of Maya religious self-administration. As a result of "approaching the conversion of Indian communities through their traditional leaders, missionaries insured that the persons who played an active role in the establishment of the new cult . . . would in many cases be exactly the same individuals who before the conversion had occupied comparable positions in the spiritual life of the community, with obvious implications for the kind of Christian observance which took root."[29]

To shed light on the kind of observance that did take root, it is useful to consider the "barrier" aspect of *cofradías*.[30] Given that the *cofradía* system was ostensibly Catholic, as long as patently idolatrous gear was kept from sight the system was on the whole at least minimally acceptable to the Church. Which is certainly not to say that "idolatry" disappeared. To the contrary, it flourished, and in important ways, the *cofradía*

system has provided the platform for that survival. On the one hand, enough of the accoutrements of Catholicism were present in the *cofradías* to deflect outside Spanish intervention. At the same time, the system constituted a barrier, the occult side of which offered a venue for the celebration of distinctly non-Catholic ritual.

In 1648 the apostate Catholic priest Thomas Gage wrote of highland Maya *cofradías*, "they yield unto the Popish religion, especially to the worshipping of saints' images, because they look upon them as much like unto their forefathers' idols."[31] In fact, conforming to a distinct "chameleon nature" of Maya gods, the saints lining the walls and altars of the *cofradías* and parishes in many cases merely came to represent aspects of far more inclusive Maya deities. Not only would the addition of one more guise to the multiple permutations each deity already possessed have hardly fazed the Maya theologians, but a need to explain why the old gods had failed to deter conquest would have been answered by the incorporation of the foreign invaders' gods, the saints.[32] For their part, purely pre-conquest images might merely be carted off to nearby caves or simply hidden in the *cofradías* and parishes. It is noteworthy that various ancient stone images remain important in the practice of the Old Ways.

Before continuing, it would be an injustice to the Maya and their culture not to consider the meaning of "idolatry." Critics often point to a diabolic element in their analysis of what they call Maya idolatry — or virtually any other element of Maya religiosity. Where orthodox Catholics might well target any figurine of an indigenous flavor, Protestant critics tend to be quick to include the "little sticks" (*palitos*) or saints of orthodox Catholicism as well. To the Maya followers of the Old Ways, not only is such criticism tremendously insulting, but viewed in the light of their essential world view, it is also rather nonsensical. It should be recalled that to Maya the world is not merely some potential economic resource but sacred, even alive. Of course, it must be treated as such, ceremony and ritual providing the vehicle.

Maya rituals sometimes are spoken of as "feeding." While this feeding is most often approached through the burning of copal incense, praying, or singing to an image, it can be literal. In Santiago Atitlán, for instance, the first drops of a ritual shot of liquor are commonly poured directly on the ground, on *Ruchiliew*, literally on the Face of the Earth. The Maya of Santiago, like others elsewhere, believe that only as long as the world is "fed" can it continue to sustain the living. Where the very world constitutes an idol in this sense, ceremonies to other considerably smaller images are similarly explained. In all cases, the object represents an attribute of a particular living and vital force. Being alive, the force must be fed, and to be fed it must have a mouth; hence the so-called idol. Only in feeding as such can the rain come, the corn grow, and in turn the people themselves eat.

As the perceived need to sustain these vital forces may indicate, fiesta-system ritual invariably is concerned with some given aspect of community welfare and survival.[33] Nonetheless, there exist fundamental differences in the goals of the ritual performance. In this regard, it is useful to designate two primary categories of fiesta-system ritual: those that address micro-issues of local existence and those concerned with the larger cosmic rhythms affecting the community and even the world beyond. On the micro level, it is common that individual saints are associated with particular important aspects of community life, most commonly related to birthing, healing, subsisting, or dying.

Depending on the community, San Nicolás could be Lord of Shamans, San Juan might be Lord of Wild Animals, and Concepción associated with the planting of maize. In assessing such roles, it is important to keep in mind that fiesta-system "saints" are typically like foreign actors in a local production. A local saint may share little more than a name with his or her orthodox Catholic namesake: hardly the stuff of the Pope's Catholicism.

On a larger level, fiestas throughout the Maya world are often concerned with the smooth functioning of cosmic patterns, particularly the annual solar cycles and the progression of the seasons. Since ancient times Maya have believed that these sorts of processes require human intervention in the form of ritual. Most commonly, that intervention falls on the shoulders of fiesta- or cargo-system participants. It is believed that a given fiesta fuels, or "feeds" as it were, the world's essential operations until the next fiesta on the ceremonial calendar can pick up the burden. Only in this way is the world allowed its power of movement, thus enabling it to progress through its endless cycles of birth and death and birth and death.

In Santiago Atitlán, the nature of the cargo-system rituals is indicated by the name for male cofradía members. In Tz'utujil Maya that word is "working man" (ajsamaj acha), which is a direct reference to the carrying of a burden. Despite the "merry drinking" that is almost invariably part of rituals throughout the Maya world, to anyone who has ever attempted to participate in the many days of a fiesta, it soon becomes painfully obvious that they are not as much fun as exhausting. As might be suspected, attempting to "muscle" the sun across the sky, even in a spiritual sense, is grueling work. To be sure, synesthesia, a blending of the senses brought on by the intensity of sounds, smells, sights,

liquor, and fatigue, occasionally leads to periods of ecstasy, even to what might be described as a one-mind-edness within the group. Just as commonly, however, the experience is defined not by the copal incense and song but by fatigue, nausea, sweat, heat, and dust, all of which commonly cause participants to pass out on a bench or on the floor. Yet, as local cofradía members are quick to point out, "without sacrifice it does not work."

These processes are given graphic illustration in a particular type of headcloth used in Santiago Atitlán. Upon initiation into the local cofradía, the ajsamaj acha or male cofradía member is allowed to wear a garment called x'kajkoj zut, while female cofradía members, the tixeli, have a corresponding garment. In its traditional form the x'kajkoj zut is woven in a simple warp-faced technique, but modern versions tend to include substantial amounts of elaborate ikat or tie-dyed patterning. Until a couple of decades ago custom mandated that the piece be woven in handspun yarns or batzin batz. In the modern version, however, commercially spun yarn is the norm. Formerly these garments contained a great deal of natural brown cotton (x'kajkoj kexoj), but this has gradually been replaced by a predominance of synthetically dyed red.[34] The garment has tassels, sometimes made of silk floss, at each corner, as well as one in the middle of each of the two shorter edges. The primary woven design elements are lengthwise purple stripes along the sides separated by an orange or yellow stripe down the middle; ikat versions usually include numerous other designs.

The symbolic statement of the x'kajkoj zut is one of the burden the "working man" must carry and symbolically reflects the full 360-degree horizon as viewed from Santiago Atitlán. From the time of the winter solstice until that of the summer solstice the sun rises and sets, or is born and dies, daily in a more northerly

position. Meanwhile, the days get longer. From June until December the sun reverses its path and moves in a southerly direction, with the days becoming consistently shorter.

Cofradía members in Santiago perceive the complex of sunrises and sunsets as a circle, the points where the sun rises forming one half, and the positions where the sun sets forming the other half. To carry the sun full circle along this path — what was earlier identified as "Footpath of the Dawn, Footpath of the Sun"— is central to local *cofradía* ceremony and ritual. It is prominently depicted on the *x'kajkoj zut*, that most definitive of local *cofradía* garments. Specifically, the progression of locales at which the sun rises throughout the year represents one of the narrow edges of the *x'kajkoj zut*, while the places where it sets figure symbolically on the opposite edge. The tassels at the corners represent the sun's rising and setting points at the solstices. Similarly, the yellow stripe down the middle of the headcloth is indicative of the path that the sun takes at the equinoxes, the tassels at each end of that stripe representing the rising and setting points on those days.

If worn correctly, the yellow stripe down the middle of the *x'kajkoj zut* appears across its wearer's forehead. Ikat versions may contain more than one such band running along the middle of a garment. As such, the garment forms an elegantly simple statement of the burden that the Maya have borne across the centuries, and in so doing it offers a powerful, even defiant, statement of Maya identity.

SUBVERSIVE THREADS

In countless ways, the Maya have deflected intrusive dictums about who they must become. In fact, a remarkable quality of the Maya has been their very refusal to be conquered. While over the centuries they have sometimes engaged in outright resistance, more commonly they have relied on fierce passivity. The Maya tenacity in this regard is evident even in handwoven cloth, what might be called their "subversive threads." At times, Maya costume has been used to designate and to buttress indigenous civil authority. Still other times, it has served as a statement of spiritual belief, intelligible only to Maya eyes.

Over the centuries almost no aspect of Maya culture has been left untouched by contact with outsiders. Yet, even today many aspects of Maya culture can nonetheless be traced to a pre-conquest past.[35] The changes that have occurred in the Maya world have often been adaptive changes. This is, for instance, exemplified in the Maya rejection of Spanish culture combined with their adaptation to that same culture through the adoption of certain foreign cultural elements. However, as is underscored in the Maya successful "conversion" of the Catholic saints to Maya beliefs, such adoption can itself be a form of resistance. Far from integrating nonindigenous cultural elements in order to emulate foreigners, the Maya have often done so in ways that have preserved important aspects of their own culture. For much of the past five centuries, the net result has been gradual evolutionary change.

At present, Maya in Chiapas, and even more so throughout Guatemala, are facing threats to their economic, cultural, and physical survival, threats that rival even those unleashed by the Spanish conquest. Believing that richness of culture and history not only strengthen a people from within, but can allow a defense from without, it is hoped that *The Maya Textile Tradition* may benefit those to whom that living tradition truly belongs.

Ceremony and Ritual

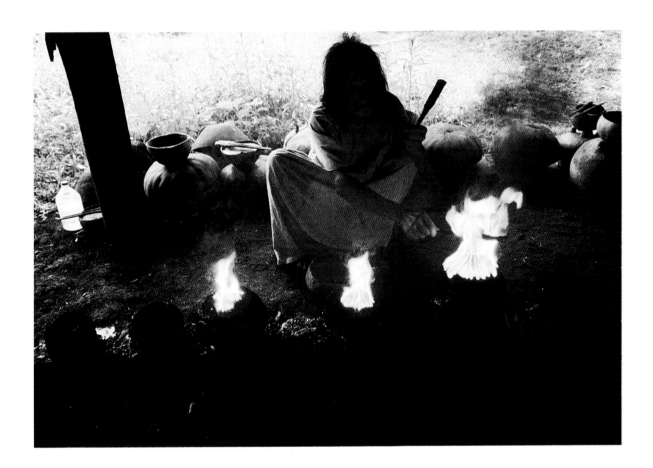

Old Mateo the Curer performed a ceremony to cure his headache. When it was over he asked for aspirins. When queried about why he needed them, he answered, "They help the gods do their work." Nahá, Chiapas, Mexico

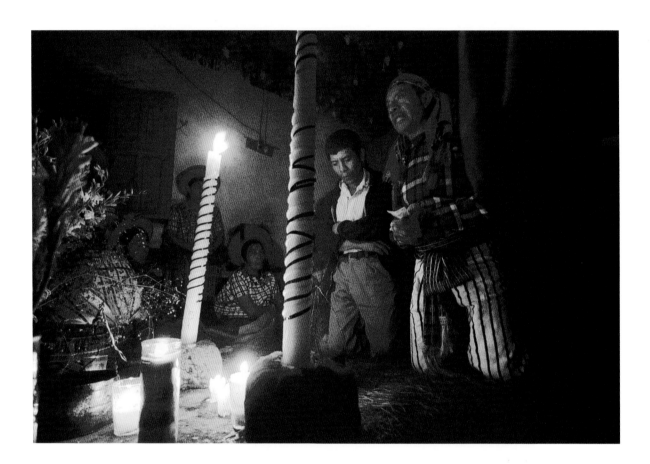

Prayers for a special purpose or problem can be sponsored by the person in need who is escorted through the ritual by a holy man. The women in their traditional dress sit in a gallery and participate. San Juan *cofradía* in Santiago Atitlán. Guatemala

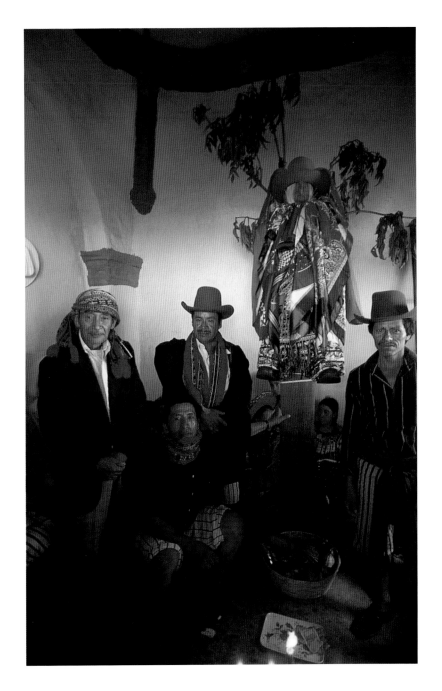

A thousand people gathered in the main plaza in Santiago Atitlán for the procession of *Maximón*, who is dressed in traditional men's clothing and an array of scarves. He rides aloft the shoulders of the shamans and is paraded in an air of fiesta. The destination was the *Maximón cofradía* near the church. Guatemala

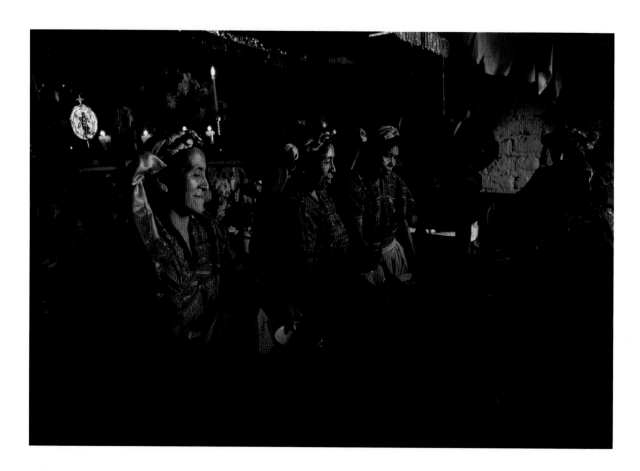

In *cofradía* settings the serving
of food is in itself a ritual
act. The women in ceremo-
nial *huipiles* are serving
tamales to everyone present
in San Martín Jilotepeque.
Guatemala

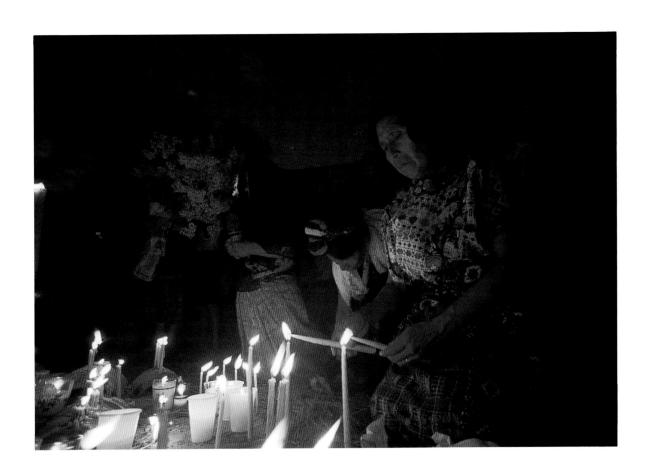

In Rabinal, the last light
of the day is still present in
the sky as the candles and
prayers begin. Guatemala

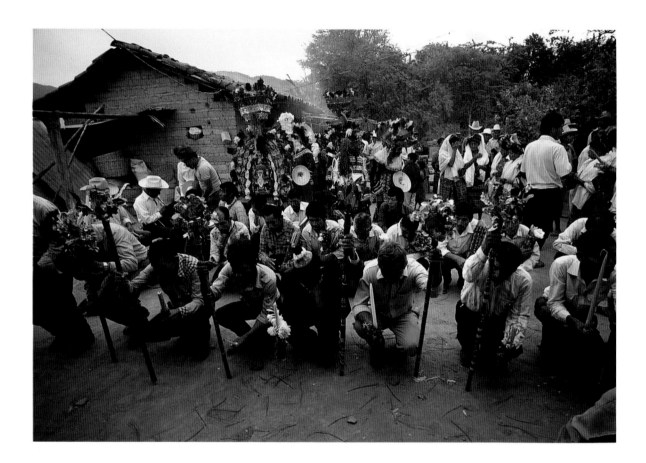

On the saint's day, tall altars wend their way through the streets of Rabinal, preceded by men carrying poles to raise the electric wires for safe passage. When the altar is returned there are prayers to the saint. The festivities are about to begin with the sound of the flute and a drum. Guatemala

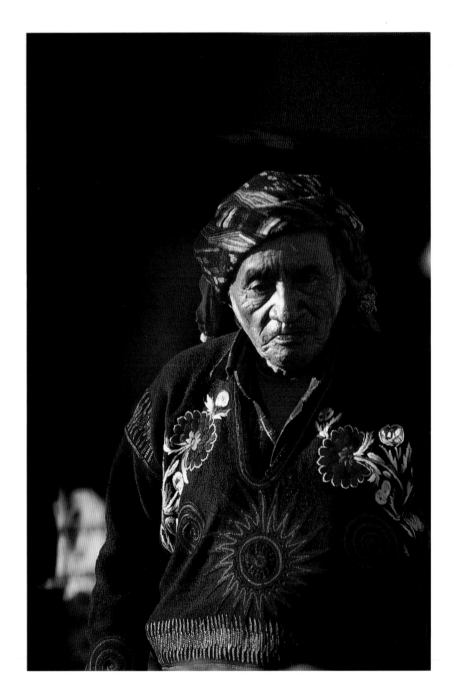

The men of Chichicaste-
nango embroider their
woolen shirts and pants
worn for *cofradía* ceremonies.
Women weave the fine head-
cloths or *tzutes* on the back-
strap loom. Guatemala

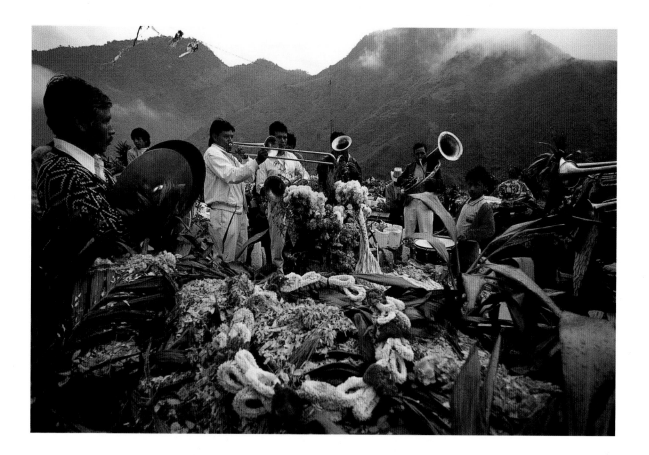

Dia de los Muertos, or Day of the Dead, is a pre-Hispanic ritual in which whole towns gather at graveside to commune with the spirits of their ancestors. Trails of marigold petals are left to guide the souls back to the homes. In some towns elaborate kites are flown. The brass band is playing in the dramatic setting of the cemetery at Zunil. Guatemala

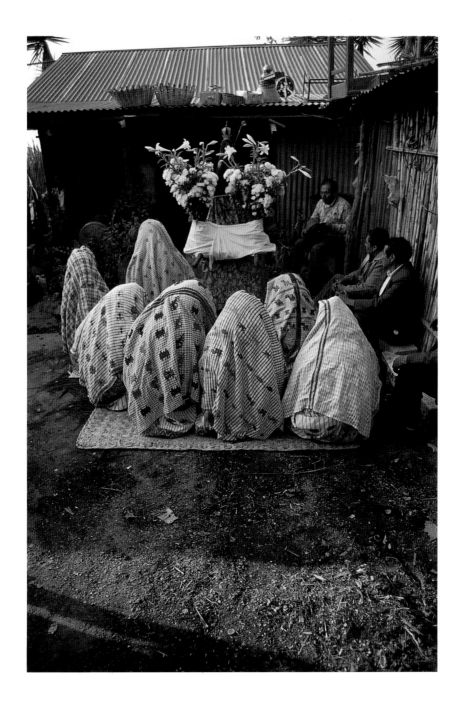

A procession with a saint on a sedan chair left the church in Santa María de Jesús in the late afternoon and made its way to the *cofradía*. The kneeling women covered with their ceremonial headcloths or *tzutes* are facing the saint with flowers on the altar. Guatemala

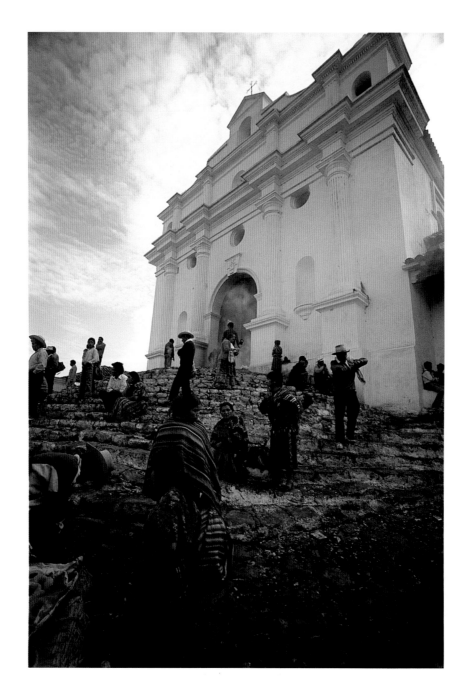

The main church in Chichi-
castenango has been the
setting of many ritual events
for over a hundred years.
It faces a great plaza where
there is a pulsating market a
few times a week and masks,
food, flowers, and countless
other goods can be bought.
Incense from burning *copal*
floats from inside the church.
Guatemala

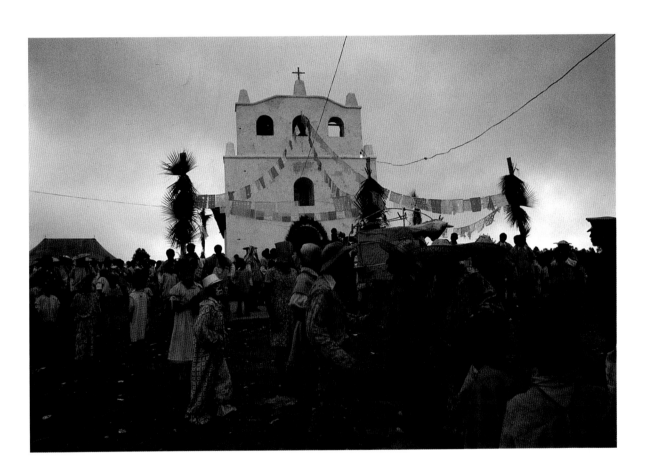

The church in Pasté, Zinacantán, is the remote setting for a fiesta with clowns, fireworks, and music. Chiapas, Mexico

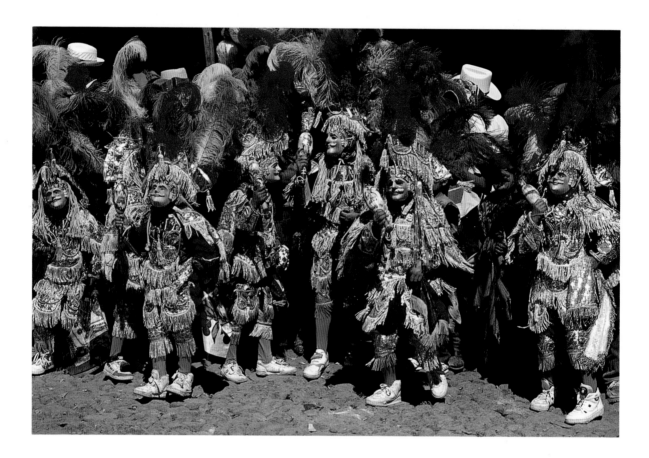

A troop of young dancers await their turn to perform. Sisters and mothers stay close with water to cool them down in the hot sun. The Dance of the Conquest often is performed at fiestas. Dancers wear masks of animals and of Alvarado, the *conquistador*. In the Maya version the animals conquer the Spaniards. Guatemala

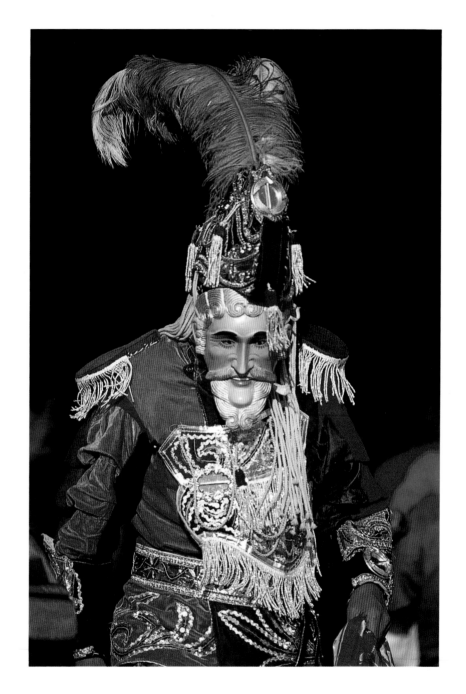

Recognizable by his blond hair and beard is the figure of Alvarado. His costume of commercial cloth and trimmings and mask are rented from a costume house or *morería* for this occasion in Chichicastenango. Guatemala

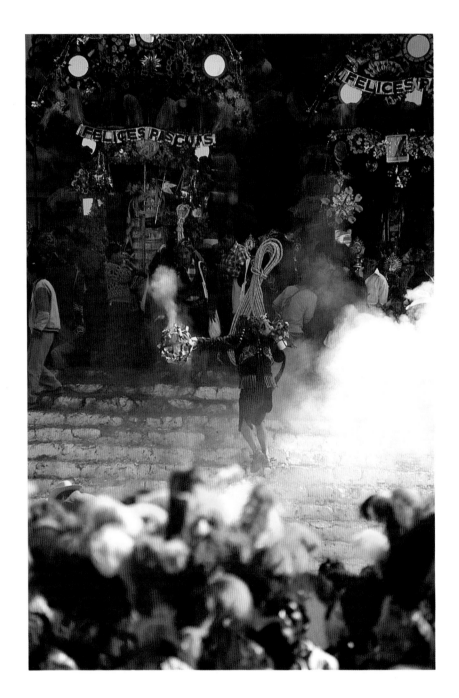

A scene of fireworks and a row of altars on the steps of the church at Chichicastenango. The look of this event hasn't changed; it was painted by watercolorist Carmen Pettersen decades ago. Guatemala

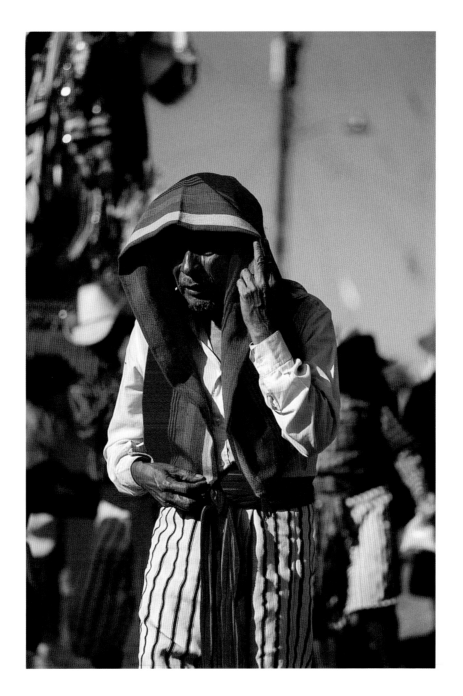

Diego Soquel is a *cofradía* member and a prophet, or *k'as ruma*. He is seen participating in a procession of Saint Santiago through Santiago Atitlán. The scene is a direct link to events like this going back centuries. He is wearing a headcloth or *xk'ajkoj suut*, which has important symbolic meanings. Guatemala

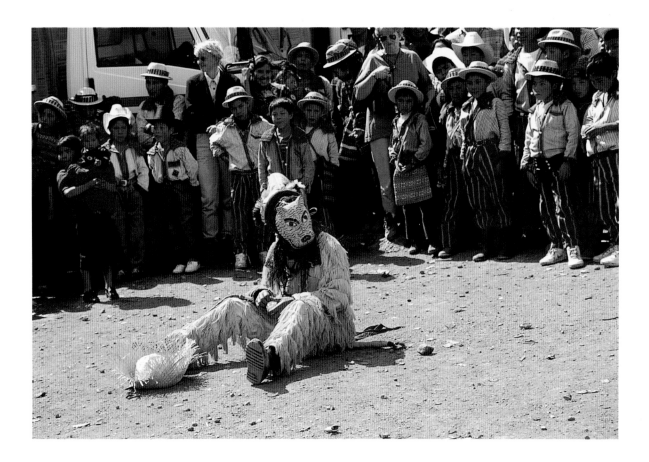

The feared and dangerous clown has a great hunger for children who have not behaved. Parents inform the clown of problems and in this setting symbolic punishment can take place. All Saints Day, Todos Santos Cuchumatán, Guatemala

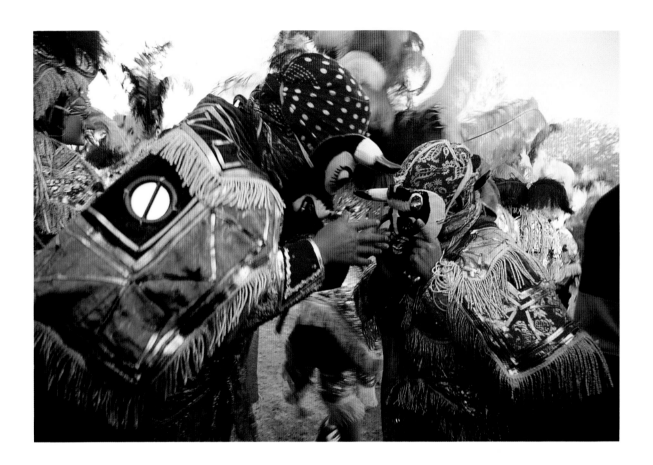

Two bulls lock horns in a ritual dance in Chichicastenango where mask-making is an industry. Guatemala

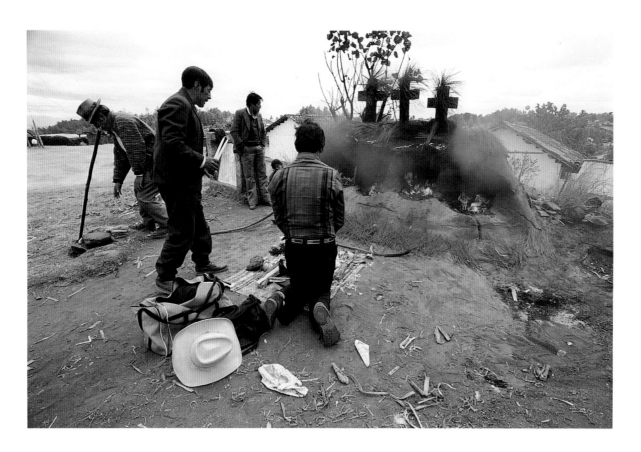

Momostenango is famous for its shaman priests whose rituals revolve around the ancient Maya calendar. On this sacred mountaintop there are several altars with curing and other ceremonies going on daily. The crosses on the altar are the only signs of Christianity here. Guatemala

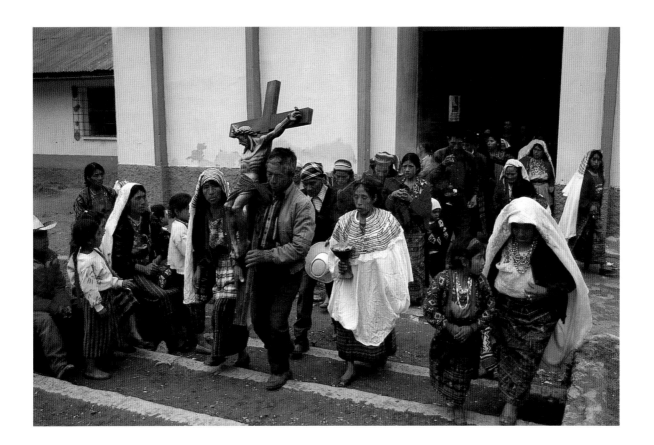

A procession leaves the
church in San Juan Ixcoy.
Women wear a ceremonial
over-*huipil* that also serves
as a veil. Guatemala

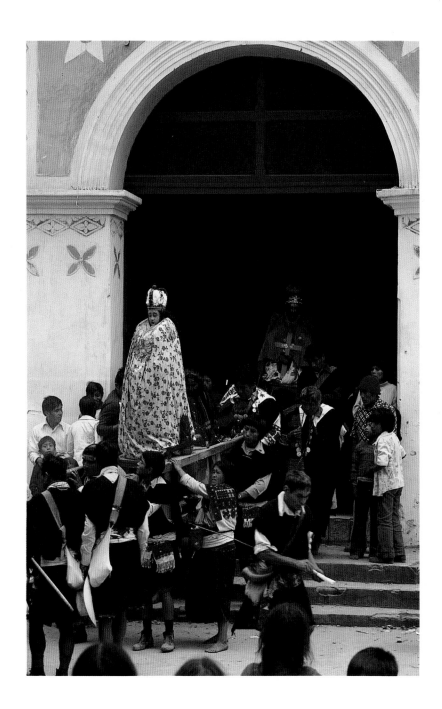

Saints from the church at
Tenejapa, Chiapas, embark
on a procession through
the town before a crowd of
onlookers. Mexico

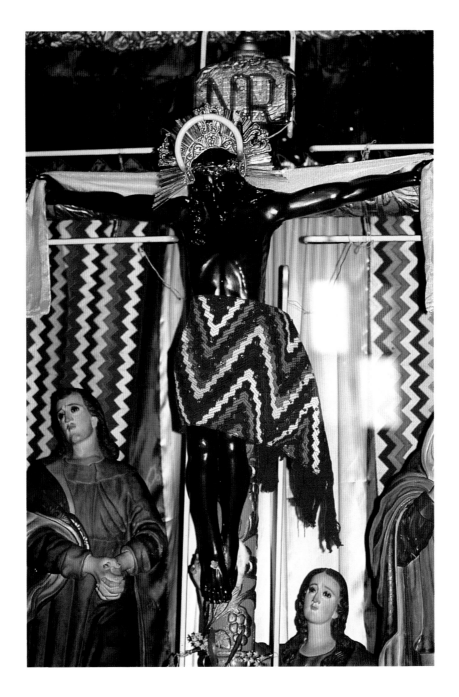

Only the best weavers have the honor to weave garments for the saints in the church. These vestments on the Black Christ in the church in Esquipulas are brought by pilgrims from the highland town of Almolonga. Guatemala

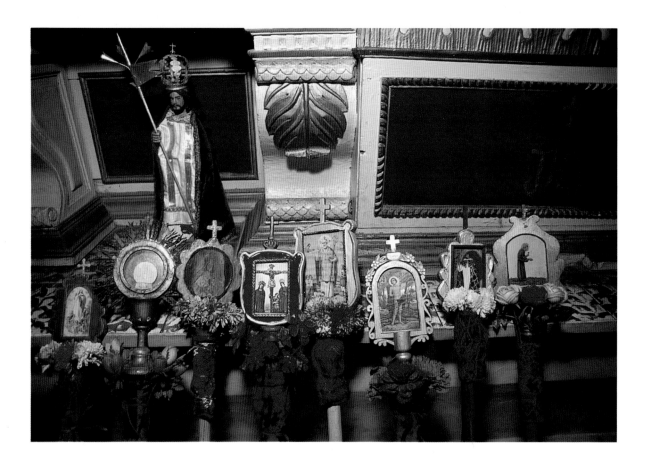

After a procession the
scepters are put back in
the church. On view are the
religious icons atop the
scepters. Santa María de
Jesús, Guatemala

Bibliography

Anawalt, Patricia Rieff. *Indian Clothing before Cortés.* Norman: University of Oklahoma Press, 1981.

———. "Prehispanic Survivals in Guatemalan Dress." *Beyond Boundaries: Highland Maya Dress at the Museum of International Folk Art.* Santa Fe: Museum of New Mexico, 1984.

Anonymous. "Relación de los caciques y principales del pueblo de Atitlán." *Anales de la Sociedad de Geografía e Historia de Guatemala* 26 (1952), pp. 435–38.

Arriola de Geng, Olga. *Los tejedores en Guatemala y la influencia española del traje indígena.* Guatemala City: Litografías Modernas S.A., 1991.

Asturias de Barrios, Linda. "Cambio e Hibridismo en el Traje Sololateco." *Tzute y Jerarquia en Sololá,* ed., Guisela Mayén de Castellanos. Guatemala City: Museo Ixchel del Traje Indígena, 1986.

———. *Comalapa: Native Dress and Its Significance.* Guatemala: Museo Ixchel del Traje Indígena, 1985.

———. "Cofradía y Hermandad." *Santa María de Jesús: Traje y Cofradía,* Linda Asturias de Barrios et al. Guatemala City: Museo Ixchel del Traje Indígena, 1989.

———. "Cofradía and Brotherhood."

Santa María de Jesús: Costume and Cofradía, Linda Asturias de Barrios et al. Guatemala City: Museo Ixchel del Traje Indígena, 1991.

———. "Women's Costume as a Code in Comalapa, Guatemala." *Textile Traditions of Mesoamerica and the Andes: An Anthology,* eds. Margot Blum Schevill et al. New York: Garland Publishing, 1991.

———. "Mano de Mujer, Mano de Hombre: Producción artesanal textil en Comalapa, Guatemala." Ph.D. dissertation. Albany: State University of New York, 1994.

Asturias de Barrios, Linda, and Dina Fernández García, eds. *La indumentaria y el tejido mayas a través del tiempo.* Guatemala City: Museo Ixchel del Traje Indígena, 1992.

Asturias de Barrios, Linda, and Idalma Mejía de Rodas. "Beyond Native Dress." *Comalapa: Native Dress and Its Significance,* Linda Asturias de Barrios. Guatemala City: Museo Ixchel del Traje Indígena, 1985.

Atran, Scott. "Itzá Maya Tropical Agro-Forestry." *Current Anthropology* 34(5) (1993), pp. 633–700.

Barrios E., Lina E. *Hierba, montañas y el árbol de la vida en San Pedro Sacatepéquez,*

Guatemala. Estudio aproximativo de su indumentaria tradicional. Guatemala City: Museo Ixchel del Traje Indígena, 1983.

Boremanse, Didier. "La Indumentaria de los Mayas Lacandones y grupos vecinos en las tierras bajas del sur en el siglo XVII." *La indumentaria y el tejido mayas a través del tiempo.* eds., Linda Asturias de Barrios and Dina Fernández García. Guatemala City: Museo Ixchel del Traje Indígena, 1992.

Butzer, Karl W. "The Americas before and after 1492: An Introduction to Current Geographical Research." *Annals of the Association of American Geographers* 82(3) (1992), pp. 345–68.

Carlsen, Robert S. "Analysis of the Early Classic Period Textile Remains – Tomb 19, Rio Azul, Guatemala." *Rio Azul Reports, Number 2, The 1984 Season,* ed. R. E. W. Adams. San Antonio: Center for Archaeological Research, University of Texas at San Antonio, 1986.

———. "Discontinuous Warps: Textile Production and Ethnicity in Contemporary Highland Guatemala." *Crafts in the World Market: The Impact of Global Exchange on Middle American Artisans,* ed. June Nash. Albany: State University of New York, 1993.

Carlsen, Robert S., and Martin Prechtel. "The Flowering of the Dead: An Interpretation of Highland Maya Culture." *MAN* 26 (1991), pp. 23–42.

Carlsen, Robert S., and David A. Wenger. "The Dyes Used in Guatemalan Textiles: A Diachronic Approach." *Textile Traditions of Mesoamerica and the Andes: An Anthology*, eds. Margot Blum Schevill et al. New York: Garland Publishing, 1991.

Carmack, Robert M. *The Quiché Mayas of Utatlán*. Norman: University of Oklahoma Press, 1981.

Carmack, Robert M.; Janine Gasco; and Gary H. Gossen. *The Legacy of Mesoamerica*. Upper Saddle River, N.J.: Prentice-Hall, 1996.

Carrasco, Davíd. "Religions of Mesoamerica." *Religious Traditions of the World*, ed. H. Byron Earhart. New York: Harper and Row, 1993.

Coe, Michael D. *The Maya*. New York: Thames and Hudson, 1993.

Cohodas, Marvin. "The Iconography of the Panels of the Sun, Cross and Foliated Cross at Palenque: Part III." *The Art, Iconography and Dynastic History of Palenque, Part III*, ed. Merle Greene Robertson. Pebble Beach: Robert Louis Stevenson School, 1976.

Cortés y Larraz, Pedro. *Descripción geográfico-moral de la Diocesis de Goathemala* (2 volumes). Guatemala City: Biblioteca de la Sociedad de Geografía e Historia, 1958.

Culbert, T. Patrick. *The Lost Civilization: The Story of the Classic Maya*. New York: Harper and Row, 1974.

Denevan, William M. "The Pristine Myth: The Landscape of the Americas in 1492." *Annals of the Association of American Geographers* 82(3) (1992), pp. 369–85.

de Vos, Jan. *Las fronteras de la frontera sur*. Mexico City: Universidad Juárez Autónoma de Tabasco, Centro de Investigaciones y Estudios Superiores de Antropología Social, 1993.

Dewalt, Billie R. "Changes in the Cargo Systems of Mesoamerica." *Anthropological Quarterly* 48 (1975), pp. 87–105.

Early, John. "Some Ethnographic Implications of an Ethnohistorical Perspective on the Civil-Religious Hierarchy Among the Highland Maya." *Ethnohistory* 30 (1983), pp. 185–202.

Eber, Christine, and Brenda Rosenbaum. "'That We May Serve Beneath Your Hands and Feet': Women Weavers in Highland Chiapas, Mexico." *Crafts in the World Market: The Impact of Global Exchange on Middle American Artisans*, ed. June Nash. Albany: State University of New York, 1993.

Eliade, Mircea. *The Myth of the Eternal Return*. Princeton: Princeton/Bollingen, 1991.

Farriss, Nancy M. *Maya Society Under Colonial Rule: The Collective Enterprise of Survival*. Princeton: Princeton University Press, 1984.

Fisher, Abby Sue. "European Influence on Clothing Traditions in Highland Guatemala." M.A. thesis. Chico: University of California, 1983.

———. "Influencia europea en la indumentaria tradicional: Análisis selectivo de prendas masculinas de la colección del Museo Ixchel." *La indumentaria y el tejido mayas a través del tiempo*, eds. Linda Asturias de Barrios and Dina Fernández García. Guatemala City: Museo Ixchel del Traje Indígena, 1992.

Foster, George M. "Cofradía and Compadrazgo in Spain and Spanish America." *Southwestern Journal of Anthropology* 9 (1953), pp. 1–28.

Freidel, David A. "Children of First Father's Skull." Paper presented at the 68th Annual Meeting of the American Anthropological Association, November 19, 1987. Chicago: n.d.

Gage, Thomas. *Thomas Gage's Travels in the New World*, ed. J. Eric S. Thompson. Norman: University of Oklahoma Press, 1985.

Gallencamp, Charles. *Maya*. New York: Penguin, 1987.

Galo de Lara, Carmen María. *Como esta la escuela primaria en Guatemala*. Guatemala City: Asociación de Investigación y Estudios Sociales, 1990.

———. *Educación familiar en comunidades indígenas*. Guatemala City: Asociación de Investigación y Estudios Sociales, 1995.

García Añoveros, Jesús María. *Población*

y estado socioreligioso de la diocesis de Guatemala en el último tercero del siglo XVIII. Guatemala City: Editorial Universitaria, 1987.

Goldin, Liliana. "Organizing the World Through the Market. A Symbolic Analysis of Markets and Exchange in the Western Highlands of Guatemala." Ph.D. dissertation. Albany: State University of New York, 1986.

———. "De plaza a mercado: La expresión de dos sistemas conceptuales en la organización de los mercados del occidente de Guatemala." *Anales de Antropología* 23 (1989), pp. 243–61.

Gossen, Gary H. *Chamulas in the World of the Sun: Time and Space in a Maya Oral Tradition.* Prospect Heights: Waveland Press, 1974.

Henne, Marilyn G. "La comida Quiché." *Estudios cognocitivos del sur de Mesoamérica.* ed., Helen L. Neuenswander. Guatemala City: Instituto Lingüístico de Verano, 1997.

Hill, Robert II, and John Managhan. *Continuities in Highland Maya Social Organization: Ethnohistory in Sacapulas, Guatemala.* Philadelphia: University of Pennsylvania Press, 1987.

Ivic de Monterroso, Matilde. "La tejeduría en Guatemala durante la época colonial." *La indumentaria y el tejido mayas a través del tiempo,* eds., Linda Asturias de Barrios and Dina Fernández García. Guatemala City: Museo Ixchel del Traje Indígena, 1992.

Jones, Grant D. *Maya Resistance to Spanish Rule: Time and History on a Colonial Frontier.* Albuquerque: University of New Mexico Press, 1989.

Joyce, Rosemary A. "Dimensiones simbólicas del traje en monumentos clássicos mayas: La construccion del género a traves del vestido." *La indumentaria y el tejido mayas a través del tiempo.* eds., Linda Asturias de Barrios and Dina Fernández García. Guatemala City: Museo Ixchel del Traje Indígena, 1992.

Keleman, Paul. *Medieval American Art, a Survey in Two Volumes.* New York: Macmillan, 1942.

Klüssman, E. "El mito de Markao y el Tzu." *Crónica* (Jan. 1988).

Knoke de Arathoon, Bárbara. "La indumentaria maya en la epoca colonial segun fuentes españolas y criollas." *La indumentaria y el tejido mayas a través del tiempo.* eds., Linda Asturias de Barrios and Dina Fernández García. Guatemala City: Museo Ixchel del Traje Indígena, 1992.

Little-Siebold, Christa. "Indumentaria maya del periodo clássico en la cerámica policromada de las tierras bajas." *La indumentaria y el tejido mayas a través del tiempo.* eds., Linda Asturias de Barrios and Dina Fernández García. Guatemala City: Museo Ixchel del Traje Indígena, 1992.

Lothrop, Joy Mahler. "Textiles from the Sacred Cenote." *Artifacts from the Cenote of Sacrifice, Chichén Itzá, Yucatan,* ed. Clemency Coggins. Cambridge, Mass.: Peabody Museum, Harvard University, 1992.

MacLeod, Murdo J. *Spanish Central America: A Socioeconomic History, 1520–1720.* Berkeley: University of California Press, 1973.

Mahler, Joy. "Garments and Textiles of the Maya Lowlands." *Handbook of Middle American Indians,* Vol. 3, ed. Robert Wauchope. Austin: University of Texas Press, 1965.

Maudslay, Alfred Percival, and Anne Cary Maudslay. *A Glimpse at Guatemala.* London: John Murray, 1899.

Mayén de Castellanos, Guisela. *Tzute y Jerarquia en Sololá.* Guatemala City: Museo Ixchel del Traje Indígena, 1986.

McBryde, Felix W. *Cultural and Historical Geography of the Southwest.* Washington, D.C.: Smithsonian Institution, Institute of Social Anthropology, Publication No. 4, 1947.

Means, Philip Ainsworth. *History of the Spanish Conquest of Yucatán and of the Itzás.* Cambridge, Mass.: Peabody Museum, Harvard University, 1917.

Mejía de Rodas, Idalma. "Comalapa." *Comalapa: Native Dress and Its Significance,* Linda Asturias de Barrios. Guatemala City: Museo Ixchel del Traje Indígena, 1985.

———. "Atavíos de señores y guerreros." *La indumentaria y el tejido mayas a través del tiempo,* eds. Linda Asturias de Barrios and Dina Fernández

García. Guatemala City: Museo Ixchel del Traje Indígena, 1992.

Mejía de Rodas, Idalma, Rosario Miralbés de Polanco, and Linda Asturias de Barrios. *Change in Colotenango: Costume, Migration, and Hierarchy.* Guatemala City: Museo Ixchel del Traje Indígena, 1989.

Mendelson, E. Michael. *Religion and World-View in Santiago Atitlán.* Ph.D. dissertation, University of Chicago, 1956.

Miller, Mary Ellen. *The Murals of Bonampak.* Princeton: University of Princeton Press, 1986.

Miralbés de Polanco, Rosario. "Materials and Procedures" and "Costume." *Change in Colotenango: Costume, Migration, and Hierarchy.* Idalma Mejía de Rodas, et al., 1989.

———. "Materials and Procedures." *Santa María de Jesús: Costume and Cofradía*, Linda Asturias de Barrios et al. Guatemala City: Museo Ixchel del Traje Indígena, 1991.

Miralbés de Polanco, Rosario; Eugenia Sáenz de Tejada; and Idalma Mejía de Rodas. *Zunil: traje y economía.* Guatemala City: Museo Ixchel del Traje Indígena, 1990.

Morgan, Lewis Henry. *Ancient Society.* Chicago: Charles H. Kerr, 1877.

Morley, Sylvanus Griswold, and George W. Brainard. *The Ancient Maya.* Stanford: Stanford University Press, 1956.

Morris, Walter F., Jr. *A Millennium of Weaving in Chiapas.* Privately published by the author, distributed by Sna Jolobil, San Cristóbal de las Casas, Chiapas, Mexico, 1984.

———. "Fall Fashions: Lagartero Figurine Costumes at the End of the Classic Period." *Palenque Round Table Series, Volume VII.*, eds. Merle Greene Robertson and Virginia M. Fields. San Francisco: Art Research Institute, 1985.

———. "The Marketing of Maya Textiles in Highland Chiapas, Mexico." *Textile Traditions of Mesoamerica and the Andes: An Anthology*, eds. Margot Blum Schevill et al. New York: Garland Publishing, 1991.

Morris, Walter F., Jr., and Jeffrey Jay Foxx. *Living Maya.* New York: Abrams, 1987.

Murphy, Robert. *The Dialectics of Social Life: Alarms and Excursions in Anthropological Theory.* New York: Columbia University Press, 1971.

Nash, June, ed. *Crafts in the World Market: The Impact of Global Exchange on Middle American Artisans.* Albany: State University of New York, 1993.

Nash, Manning. "Guatemalan Highlands." *Handbook of Middle American Indians*, vol. 7, ed. Robert Wauchope. Austin: University of Texas Press, 1969.

Nembhard, Jessica Gordon. *The Nation We Are Making.* Belize: Cubola Productions, 1990.

O'Neale, Lila M. *Textiles of Highland Guatemala.* Publication 567. Washington, D.C.: Carnegie Institution of Washington, 1945.

Orellana, Sandra L. "La introducción del sistema de cofradía en la region del lago de Atitlán en los altos de Guatemala." *America Indígena* 35(4) (1975), pp. 845–56.

Pancake, Cherri M. "Fronteras de género en la producción de tejidos indígenas." *La indumentaria y el tejido mayas a través del tiempo*, eds. Linda Asturias de Barrios and Dina Fernández García. Guatemala City: Museo Ixchel del Traje Indígena, 1992.

———. "Textile Traditions of the Highland Maya: Some Aspects of Development and Change." Paper presented at the International Symposium on Maya Art, Architecture, Archaeology, and Hieroglyphic Writing. Guatemala City, 1977.

Pancake, Cherri M., and Suzanne Baizerman. "Guatemalan Gauze Weaves." *Textile Museum Journal* 19–20 (1981), pp. 1–26.

Pettersen, Carmen L. *The Maya of Guatemala.* Guatemala City and Seattle: The Ixchel Museum, distributed by the University of Washington Press, 1976.

Prechtel, Martin, and Robert S. Carlsen. "Weaving and Cosmos Amongst the Tzutujil Maya." *Res* 15 (Spring 1988), pp. 122–32.

Quirin, Herbert. *X Balam Q'ué, El Pájaro Sol· El traje regional de Cobán.* Guatemala City: Museo Ixchel del Traje Indígena, 1984.

221

Recinos, Adrián, translator and editor. *Popol Vuh: The Sacred Book of the Ancient Quiché Maya*. English translation by Delia Goetz and Sylvanus E. Morley. Norman: University of Oklahoma Press, 1950, 1972.

Recinos, Adrián, and Delia Goetz, translators and editors. *The Annals of the Cakchiquels*. Norman: University of Oklahoma Press, 1953.

Reina, Ruben E. *Shadows: A Mayan Way of Knowing*. New York: New Horizon Press, 1984.

Ricard, Robert. *The Spiritual Conquest of Mexico*. Translated by Lesley Byrd Simpson. Berkeley and Los Angeles: University of California Press, 1966.

Robicsek, Francis. *Copán*. New York: Museum of the American Indian, Heye Foundation, 1972.

Rodas, Flavio N. N.; Ovidio C. Rodas; and Laurence F. Hawkins. *Chichicastenango: the Kiche Indians*. Guatemala City: Unión Tipográfica, 1940.

Rojas Lima, Flavio. *La simbología del lenguaje en la cofradía indígena*. Cuadernos del Seminario de Integración Social Guatemalteca, no. 29. Guatemala City: Seminario de Integración Social Guatemalteca, 1984.

————. *La Cofradía: Reducto Cultural Indígena*. Guatemala City: Seminario de Integración Social Guatemalteca, 1988.

Roquero, Ana. "Materias tintoreas de Centroamérica: Conocimiento y uso entre los antiguuos Mayas." *La indumentaria y el tejido mayas a través del tiempo*, eds. Linda Asturias de Barrios and Dina Fernández García. Guatemala City: Museo Ixchel del Traje Indígena, 1992.

Rowe, Ann Pollard. *A Century of Change in Guatemalan Textiles*. New York: The Center for Inter-American Relations, 1981.

Roys, Ralph. *The Book of Chilam Balam of Chumayel*. Carnegie Institution of Washington, Publication Number 438. Norman: University of Oklahoma, 1968.

Sabloff, Jeremy A. *The New Archaeology and the Ancient Maya*. New York: Scientific American Library, 1994.

Sáenz de Tejada Samayoa, Eugenia. "Descripción analítica de los patrones alimentarios en Mesoamérica desde los tiempos prehistóricos hasta el presente, con especial atención a la triada," *Licenciatura Thesis*. Guatemala City: Universidad del Valle de Guatemala, 1988.

Sauer, Carl Ortwin. *The Early Spanish Main*. Berkeley: University of California Press, 1969.

Sayer, Chloë. *Costumes of Mexico*. Austin: University of Texas Press, 1985.

Schele, Linda. "Accession Iconography of Chan-Bahlum in the Group of the Cross at Palenque." *The Art, Iconography and Dynastic History of Palenque, Part III*, ed. M. G. Robertson. Pebble Beach: Robert Louis Stevenson School, 1976.

Schele, Linda, and David Freidel. *A Forest of Kings*. New York: William Morrow and Company, 1990.

Schevill, Margot Blum. *Evolution in Textile Design from the Highlands of Guatemala*. Berkeley: Lowie Museum of Anthropology, University of California, 1985.

————. *Maya Textiles of Guatemala: The Gustavus A. Eisen Collection, 1902*. Austin: University of Texas Press, 1993.

Schevill, Margot Blum; Janet Catherine Berlo; and Edward B. Dwyer, eds. *Textile Traditions of Mesoamerica and the Andes: An Anthology*. New York: Garland Publishing, 1991.

Scholes, F. V., and R. L. Roys. *The Maya Chontal Indians of Acalan-Tixchel: A Contribution to the History and Ethnography of the Yucatán Peninsula*. Carnegie Institution of Washington, Publication 560. Norman: University of Oklahoma Press, 1968.

Sharer, Robert J. *The Ancient Maya*. Stanford: Stanford University Press, 1994.

Smith, Carol A. "The Domestic Marketing System in Western Guatemala. An Economic, Locational and Cultural Analysis." Ph.D. dissertation. Ann Arbor: University Microfilms, 1972.

Tarn, Nathaniel, and Martin Prechtel. "Metaphors of Relative Elevation, Position and Ranking in Popol Vuh." *Estudios De Cultura Maya* 13 (1981), pp. 105–23.

Tedlock, Barbara. *Time and the Highland Maya.* Albuquerque: University of New Mexico Press, 1982.

Tedlock, Barbara, and Dennis Tedlock. "Text and Textile: Language and Technology in the Arts of the Quiché Maya." *Journal of Anthropological Research* 41(2) (1985), pp. 121–46.

Tedlock, Dennis. *Popol Vuh: The Definitive Edition of the Mayan Book of the Dawn of Life and the Glories of Gods and Kings.* New York: Simon and Schuster, 1985.

Thompson, J. Eric S. *Maya History and Religion.* Norman: University of Oklahoma Press, 1970.

———. *The Rise and Fall of Maya Civilization.* Norman: University of Oklahoma Press, 1966.

van Oss, Adriaan C. *Catholic Colonialism: A Parish History of Guatemala 1524–1821.* Cambridge, Mass.: Cambridge University Press, 1986.

Verillo, Erica, and Duncan MacLean Earle. "The Guatemalan Refugee Crafts Project: Artisan Production in Times of Crisis." *Crafts in the World Market: The Impact of Global Exchange on Middle American Artisans,* ed. June Nash. Albany: State University of New York, 1993.

Vogt, Evon Z. *Zinacantán: A Maya Community in the Highlands of Chiapas.* Cambridge, Mass.: Harvard University Press, 1969.

Warren, Kay B. *The Symbolism of Subordination: Indian Identity in a Guatemalan Town.* Second Edition. Austin: University of Texas Press, 1989.

Wasserstrom, Robert. *Class and Society in Central Chiapas.* Berkeley: University of California Press, 1983.

Whitmore, Thomas M., and B. L. Turner II. "Landscapes of Cultivation in Mesoamerica on the Eve of the Conquest." *Annals of the Association of American Geographers* 82(3) (1992), pp. 402–25.

Wilk, Richard. *Household Ecology: Economic Changes and Domestic Life Among the Kekchi Maya in Belize.* Tucson: University of Arizona Press, 1991.

Notes

CHAPTER 1
History and Ecology of the Maya World

1. Philip Ainsworth Means, *History of the Spanish Conquest of Yucatán and of the Itzás* (Cambridge, Mass.: Peabody Museum, Harvard University, 1917), p. 17.
2. Charles Gallencamp, *Maya* (New York: Penguin, 1987), pp. 60–61.
3. Ibid., pp. 61–62.
4. Ibid., p. 2.
5. Michael D. Coe, *The Maya* (New York: Thames and Hudson, 1993), p. 91.
6. Ibid., p. 20.
7. Jan de Vos, *Las fronteras de la frontera sur* (Mexico City: Universidad Juárez Autónoma de Tabasco, Centro de Investigaciones y Estudios Superiores de Antropología Social, 1993), p. 22.
8. T. Patrick Culbert, *The Lost Civilization: The Story of the Classic Maya* (New York: Harper and Row, 1974), p. 113.
9. Coe, p. 127.
10. De Vos, p. 24.
11. Jeremy A. Sabloff, *The New Archaeology and the Ancient Maya* (New York: Scientific American Library, 1994), p. 122.
12. Robert J. Sharer, *The Ancient Maya* (Stanford: Stanford University Press, 1994), p. 385.
13. Thomas M. Whitmore and B. L. Turner II, "Landscapes of Cultivation in Mesoamerica on the Eve of the Conquest," *Annals of the Association of American Geographers* 82(3) (1992), p. 416.

14. Carl Ortwin Sauer, *The Early Spanish Main* (Berkeley: University of California Press, 1969), p. 128.
15. Gallencamp, p. 6.
16. Murdo J. MacLeod, *Spanish Central America: A Socioeconomic History, 1520–1720* (Berkeley: University of California Press, 1973), p. 19.
17. Ibid., pp. 40–41.
18. F. V. Scholes and R. L. Roys, *The Maya Chontal Indians of Acalan-Tixchel: A Contribution to the History and Ethnography of the Yucatán Peninsula*, Carnegie Institution of Washington, Publication 560 (Norman: University of Oklahoma Press, 1968), p. 304.
19. Karl W. Butzer, "The Americas before and after 1492: An Introduction to Current Geographical Research," *Annals of the Association of American Geographers* 82(3) (1992), p. 352.
20. B. Thompson 1894, cited in MacLeod, p. 15.
21. Butzer, p. 347; William M. Denevan, "The Pristine Myth: The Landscape of the Americas in 1492," *Annals of the Association of American Geographers* 82(3) (1992), p. 370.
22. Robert Wasserstrom, *Class and Society in Central Chiapas* (Berkeley: University of California Press, 1983), p. 13.
23. MacLeod, pp. 225–26.
24. Thompson, cited in Wasserstrom, p. 32.
25. Wasserstrom, pp. 35–36.
26. Means, pp. 22–23.

27. Ibid.
28. Villagutiérrez, cited in Means, p. 35.
29. Sylvanus Griswold Morley and George W. Brainard, *The Ancient Maya* (Stanford: Stanford University Press, 1956), p. 127.
30. Ibid.
31. Scott Atran, "Itzá Maya Tropical Agro-Forestry," *Current Anthropology* 34(5) (1993), pp. 633–700.

CHAPTER 2
Weaving and Daily Life

1. Q'echi' language.
2. Herbert Quirin, *X Balam Q'ué, El Pájaro Sol: El traje regional de Cobán* (Guatemala City: Museo Ixchel del Traje Indígena, 1984), pp. 6, 11.
3. Walter F. Morris, Jr., and Jeffrey Jay Foxx, *Living Maya* (New York: Abrams, 1987), p. 113.
4. The concept of conquest has been debated by Indian leaders and scholars in the Americas. They favor the idea of a European invasion. In using Pre-conquest the author follows an editorial decision for this book. She prefers using Pre-Hispanic.
5. Idalma Mejía de Rodas, "Atavíos de señores y guerreros," *La indumentaria y el tejido mayas a través del tiempo*, eds. Linda Asturias de Barrios and Dina Fernández García (Guatemala City: Museo Ixchel del Traje Indígena, 1992).

6. On the influence of Spanish and European styles on Maya clothing, see Olga Arriola de Geng, *Los tejedores en Guatemala y la influencia española del traje indígena.* (Guatemala City: Litografías Modernas S.A., 1991), and Abby Sue Fisher, "European Influence on Clothing Traditions in Highland Guatemala" (M.A. thesis. Chico: University of California, 1983), and Fisher, "Influencia europea en la indumentaria tradicional: Análisis selectivo de prendas masculinas de la colección del Museo Ixchel," *La indumentaria y el tejido mayas a través del tiempo,* eds., Linda Asturias de Barrios and Dina Fernández García (Guatemala City: Museo Ixchel del Traje Indígena, 1992).

7. See Idalma Mejía de Rodas, Rosario Miralbés de Polanco, and Linda Asturias de Barrios, *Change in Colotenango: Costume, Migration, and Hierarchy* (Guatemala City: Museo Ixchel del Traje Indígena, 1989).

8. These data were collected by the author in Nahualá in August 1995.

9. See Cherri M. Pancake, "Fronteras de género en la producción de tejidos indígenas," *La indumentaria y el tejido mayas a través del tiempo,* eds. Linda Asturias de Barrios and Dina Fernández García (Guatemala City: Museo Ixchel del Traje Indígena, 1992), and Linda Asturias de Barrios, "Mano de Mujer, Mano de Hombre: Producción artesanal textil en Comalapa, Guatemala" (Ph.D. dissertation, Albany: State University of New York, 1994), on gender boundaries in textile production.

10. See Asturias de Barrios, 1994, pp. 88–89.

11. Most Maya words used in this article belong to the Kaqchikel language. Translations into English are generally provided in the same sentences.

12. Morris and Foxx, p. 64.

13. The author has made extensive research in Comalapa, a Kaqchikel town. See Asturias de Barrios, 1994, and *Comalapa: Native Dress and Its Significance* (Guatemala City: Museo Ixchel del Traje Indígena, 1985).

14. See Asturias de Barrios, 1994, pp. 411–37, for further details.

15. See Idalma Mejía de Rodas, "Comalapa," in *Comalapa: Native Dress and Its Significance*, Linda Asturias de Barrios, 1985, pp. 17–20.

16. See Carlsen, this volume, for more information on the *cofradía*.

17. See Linda Asturias de Barrios, "Cofradía and Brotherhood." *Santa María de Jesús: Costume and Cofradía,* Linda Asturias de Barrios et al. (Guatemala City: Museo Ixchel del Traje Indígena, 1991), pp. 35–54.

18. See Asturias de Barrios, 1985, pp. 95–104, and 1994, pp. 323–38.

19. Sergio Romero and Rebeca Rubio contributed data on Kaqchikel terms and translations.

20. Eugenia Sáenz de Tejada Samayoa, "Descripción analítica de los patrones alimentarios en Mesoamérica desde los tiempos prehistóricos hasta el presente, con especial atención a la triada," *Licenciatura Thesis* (Guatemala City: Universidad del Valle de Guatemala, 1988), p. 364.

21. Marilyn G. Henne, "La comida Quiché." *Estudios cognocitivos del sur de*

Mesoamérica, ed., Helen L. Neuenswander (Guatemala City: Instituto Lingüístico de Verano, 1997), pp. 62–88.

22. Carmen María Galo de Lara, *Educación familiar en comunidades indígenas* (Guatemala City: Asociación de Investigación y Estudios Sociales, 1995), pp. 46–63.

23. Carmen Maria Galo de Lara, *Como está la escuela primaria en Guatemala* (Guatemala City: Asociación de Investigación y Estudios Sociales, 1990), p. 30.

24. Isabel and Maria are generational characters who combine the experiences of several Kaqchikel women the author has known well from her research.

25. Museo Ixchel del Traje Indígena in Guatemala City will publish the second volume of its series *Tejidos de Guatemala* in 1996. This volume will be devoted to the use of natural brown cotton in Guatemala Maya textiles.

26. See Robert Carlsen, "Discontinuous Warps: Textile Production and Ethnicity in Contemporary Highland Guatemala," *Crafts in the World Market: The Impact of Global Exchange on Middle American Artisans*, ed. June Nash. (Albany: State University of New York, 1993).

27. Museo Ixchel del Traje Indígena has a committee called PROTEJE, which promotes high-quality weaving with natural brown cotton among several groups of backstrap-loom weavers.

28. For further details see Rebecca Rubio and Linda Asturias de Barrios in the upcoming publication of Museo

Ixchel del Traje Indígena on natural brown cotton.

29. For further details on these rituals, see Asturias de Barrios, 1985, pp. 105–8 and 1994, pp. 119–39.

30. See Asturias de Barrios, 1985, and "Women's Costume as a Code in Comalapa, Guatemala," *Textile Traditions of Mesoamerica and the Andes: An Anthology,* eds. Margot Blum Schevill et al. (New York: Garland Publishing, 1991), for more information on techniques used in Comalapa.

31. Ann Pollard Rowe, *A Century of Change in Guatemalan Textiles.* (New York: The Center for Inter-American Relations, 1981), documents the emergence of this technique in Santiago Atitlán.

32. See Asturias de Barrios, 1985, pp. 33–46.

33. For technical details see Cherri M. Pancake and Suzanne Baizerman, "Guatemalan Gauze Weaves." *Textile Museum Journal* 19–20 (1981), pp. 1–26.

34. For a semiotic analysis of Comalapan clothing, see Asturias de Barrios, 1996.

35. For further information on Comalapan painting, see Asturias de Barrios, 1994, pp. 411–37.

36. Asturias de Barrios, 1985, pp. 38–39.

37. Rosario Miralbés de Polanco, "Materials and Procedures" and "Costume." *Change in Colotenango: Costume, Migration, and Hierarchy.* Idalma Mejía de Rodas, et al., 1989, p. 43.

38. Lina E. Barrios, *Hierba, montañas y el árbol de la vida en San Pedro Sacatepéquez, Guatemala. Estudio aproximativo de su indumentaria tradicional* (Guatemala City: Museo Ixchel del Traje Indígena, 1983), pp. 34, 38.

39. Morris and Foxx, p. 106.

40. This myth version was published in Spanish by Klüssman, 1988. Jennifer H. Keller translated and adapted the text into English for this publication.

41. Martin Prechtel and Robert S. Carlsen, "Weaving and Cosmos Amongst the Tzutujil Maya." *Res* 15 (Spring 1988), pp. 122–32.

42. This case was documented by the author in Colotenango during a 1986–87 fieldwork sponsored by Museo Ixchel del Traje Indígena.

43. For a comparison of prices of different types of treadle looms in Comalapa, see Asturias de Barrios, 1994, pp. 267–79.

44. Duncan Earle, personal communication, 1988. See Erica Verillo and Duncan MacLean Earle, "The Guatemalan Refugee Crafts Project: Artisan Production in Times of Crisis." *Crafts in the World Market: The Impact of Global Exchange on Middle American Artisans,* ed. June Nash (Albany: State University of New York, 1993).

45. For more information on this topic, see Asturias de Barrios, 1994, pp. 246–315.

46. This survey was conducted by the author in 1991. See Asturias de Barrios, 1994, pp. 246–315.

47. The total number of hours invested in weaving a *huipil* on a backstrap loom depends on the size, amount of brocading, and type of brocading technique, among other variables.

48. Liliana Goldin, "De plaza a mercado: La expresión de dos sistemas conceptuales en la organización de los mercados del occidente de Guatemala." *Anales de Antropología,* 23 (1989), pp. 257–61.

49. Ibid., pp. 257–61.

50. For a symbolic analysis of markets in Guatemala's western highlands, see Liliana Goldin, "Organizing the World Through the Market. A Symbolic Analysis of Markets and Exchange in the Western Highlands of Guatemala" (Ph.D. dissertation, Albany: State University of New York, 1986). For an economic and locational analysis of them, see Carol A. Smith, "The Domestic Marketing System in Western Guatemala. An Economic, Locational and Cultural Analysis" (Ph.D. dissertation. Ann Arbor: University Microfilms, 1972).

51. Mejía de Rodas et al., 1989, pp. 21–23.

52. Miralbés de Polanco, 1989, pp. 25–28.

53. Asturias de Barrios, 1985, pp. 70–73.

54. Guisela Mayén de Castellanos, *Tzute y Jerarquia en Sololá.* (Guatemala City: Museo Ixchel del Traje Indígena, 1986); English version, 1988, p. 23.

55. Ibid., pp. 67–69.

56. Ibid., pp. 107–118.

57. Idalma Mejía de Rodas, personal communication, 1995. Data from her fieldwork in Sololá, 1985.

CHAPTER 3
Innovation and Change in Maya Cloth and Clothing

1. Margot Blum Schevill, *Maya Textiles of Guatemala: The Gustavus A. Eisen Collection, 1902* (Austin: University of Texas Press, 1993), pp. 213–41.

2. Chloë Sayer, *Costumes of Mexico* (Austin: University of Texas Press, 1985), p. 227; and Flavio N. N. Rodas, Ovidio C. Rodas, and Laurence F. Hawkins, *Chichicastenango: the Kiche Indians* (Guatemala City: Unión Tipográfica, 1940), p. 124.

3. Walter F. Morris, Jr., *A Millennium of Weaving in Chiapas.* (Privately published by the author, distributed by Sna Jolobil, San Cristóbal de las Casas, Chiapas, Mexico, 1984), p. 55.

4. Whether Stela H is actually a woman, wife of the ruler represented by Stela A, is a question for reconsideration. In their discussion of the ruler 18-Rabbit, who was responsible for the creation of these stelae or tree-stones, Linda Schele and David Freidel, in *A Forest of Kings* (New York: William Morrow, 1990), suggest that each sculpture bore his portrait in the guise of a god he had manifested through ecstatic ritual (p. 316). Francis Robicsek, in *Copán* (New York: Museum of the American Indian, Heye Foundation, 1972), mentions the "charming statuettes of young men" looking out from the coils of a mythological serpent; they may represent the God of Maize, always presented as a youth and a benevolent deity of the Maya. There is some thought that the image is not a woman, but someone dressed in a royal woman's garb, possibly 18-Rabbit.

5. The Río Azul burials in Petén, Guatemala, included one tomb in which a body was wrapped in a sisal-like shroud painted with cinnabar; on top was placed gauze-weave cotton.

Animal skins also were present. Robert Carlsen, personal communication, 1995. Also see Carlsen, "Analysis of the Early Classic Period Textile Remains – Tomb 19, Río Azul, Guatemala," *Rio Azul Reports, Number 2, The 1984 Season,* ed. R. E. W. Adams (San Antonio: Center for Archaeological Research, University of Texas at San Antonio, 1986).

6. The historical overview that follows is informed by Cherri M. Pancake, "Textile Traditions of the Highland Maya: Some Aspects of Development and Change," a paper presented at the International Symposium on Maya Art, Architecture, Archaeology, and Hieroglyphic Writing (Guatemala City: 1977) and articles in Linda Asturias de Barrios and Dina Fernández García, eds., *La indumentaria y el tejido mayas a través del tiempo* (Guatemala City: Museo Ixchel del Traje Indígena, 1992), by Little-Siebold, Joyce, Roquero, Mejía de Rodas, Knoke de Arathoon, and Boremanse.

7. See Joy Mahler Lothrop, "Textiles from the Sacred Cenote." *Artifacts from the Cenote of Sacrifice, Chichén Itzá, Yucatán,* ed. Clemency Coggins (Cambridge, Mass.: Peabody Museum, Harvard University, 1992), pp. 75–76.

8. See note 5. Plant fibers absorb dye with difficulty, and, for that reason, when synthetic dyes became available in the 1880s, they were adopted by weavers worldwide, including the Maya.

9. Adrián Recinos, translator and editor. *Popol Vuh: The Sacred Book of the Ancient Quiché Maya*, English translation by

Delia Goetz and Sylvanus E. Morley (Norman: University of Oklahoma Press, 1950, 1972). I have changed the Maya spellings in accordance with the standardized Maya alphabet.

10. See Barbara Tedlock and Dennis Tedlock, "Text and Textile: Language and Technology in the Arts of the Quiché Maya." *Journal of Anthropological Research* 41(2) (1985), p. 124. There are particular weaving techniques that allow images to appear on only one side or single-faced supplementary weft brocading; on one side while on the back a reverse of the design appears or two-faced supplementary weft brocading; and for identical images to appear on the front and back of the cloth or double-faced supplementary weft brocading. In addition to the archaeological record by Lothrop already cited, this information suggests that brocading techniques may have been employed by the ancient Maya.

11. The following account is informed by Freidel, Schele, and Parker, pp. 327–29, and by Robert M. Carmack; Janine Gasco; and Gary H. Gossen, *The Legacy of Mesoamerica* (Upper Saddle River, N.J.: Prentice-Hall, 1996), pp. 147–51.

12. Paul Keleman, *Medieval American Art, a Survey in Two Volumes.* (New York: Macmillan, 1942), p. 36.

13. Major sources for dress extrapolation are: native documents such as the *Popol Vuh, Annals of the Cakchiquel, The Titles of the Lords of Totonicapán;* writings of the *conquistadores*, quasi-ethnographic chronicles of Las Casas and Zorita, *relaciones* (reports) by Spanish officials;

chroniclers such as Remesal, Thomas Gage, Fuentes y Guzmán, Vásquez, and Ximénez.

14. Besides the written commentaries, a painting of the market and construction of the cathedral in Santiago de los Caballeros de Guatemala by Antonio Ramirez M. from 1678 provides visual information on men's and women's dress. See Asturias de Barrios and Fernández García, pp. 65, 69.

15. James Bell, personal communication, 1978. These pants may have been introduced at an earlier date.

16. Lothrop suggests that painted, tie-dyed, and ikated fabrics were known to have been used during the millennium of ceremonial use of the Cenote (p. 75).

17. See Carlsen and Wenger in Margot Blum Schevill, et al. *Textile Traditions of Mesoamerica and the Andes: An Anthology*, (New York: Garland Publishing, 1991), p. 378, for an over-view of the use of dyes in Guatemalan textiles from 1840 to 1950.

18. Alfred Percival Maudslay and Anne Cary Maudslay, *A Glimpse at Guatemala* (London: John Murray, 1899). The publication includes line drawings, photographs, and site maps, as well as archaeological and ethnographic information.

19. Schevill, 1993.

20. Documented collections by Guatemalan citizens include those of Lilly de Jongh Osborne, Mildred Palmer, Carlos Elmenhorst, Olga Arriola de Geng, and others. Some of these collections have become part of the archives of the Museo Ixchel del Traje Indígena, which has the finest single collection in the world. The Museo Ixchel also actively collects.

21. Schevill, 1993, pp. 10–15, 153.

22. These observations are based on my fieldwork in 1988, 1992, and 1994.

23. Juliana and her mother, personal communication, 1978.

24. See Margot Blum Schevill, *Evolution in Textile Design from the Highlands of Guatemala* (Berkeley: Lowie Museum of Anthropology, University of California, 1985), for an in-depth study of the evolution of the image of the double-headed eagle on *tzutes* or headcloths from Chichicastenango.

25. Schevill, 1985, pp. 7–8.

26. Robert Carlsen, personal communication, 1995.

27. This section is informed by Richard Wilk, *Household Ecology: Economic Changes and Domestic Life Among the Kekchi Maya in Belize* (Tucson: University of Arizona Press, 1991), pp. 42–74; Jessica Gordon Nembhard, *The Nation We Are Making* (Belize: Cubola Productions, 1990); and Wendy Berkelman, personal communication, 1995.

28. Duncan M. Earle, personal communication, 1992. It was not the custom of *ladinas* to weave on the backstrap loom.

29. For a discussion on projects aimed at helping the refugees in Chiapas, see Verillo and Earle in June Nash, ed., *Crafts in the World Market: The Impact of Global Exchange on Middle American Artisans* (Albany: State University of New York, 1993).

30. See Linda Asturias de Barrios, Idalma Mejía de Rodas, and Rosario Miralbés de Polanco, *Santa María de Jesús: Traje y Cofradía* (Guatemala City: Museo Ixchel del Traje Indígena, 1989), pp. 68–70.

31. The history of the cooperative, Sna Jolobil, is well documented in Walter F. Morris, Jr., and Jeffrey Jay Foxx, *Living Maya* (New York: Abrams, 1987), and in Walter F. Morris, Jr., "The Marketing of Maya Textiles in Highland Chiapas, Mexico," in Schevill, Berlo, and Dwyer, eds.

32. Christine Eber and Brenda Rosenbaum discuss these cooperative ventures in "'That we may serve beneath your hands and feet': Women Weavers in Highland Chiapas, Mexico," in June Nash, ed.

33. See Rosario Miralbés de Polanco, Eugenia Sáenz de Tejada Samayoa, and Idalma Mejía de Rodas, *Zunil: traje y economía* (Guatemala City: Museo Ixchel del Traje Indígena, 1990).

34. They now have a new building; Rosario Miralbés de Polanco, personal communication, 1995.

35. Linda Asturias de Barrios, personal communication, 1993; Lucina Cardenes, personal communication, 1995.

36. For an ethnohistory of Sacapulas see Robert Hill II and John Monaghan, *Continuities in Highland Maya Social Organization: Ethnohistory in Sacapulas, Guatemala* (Philadelphia: University of Pennsylvania Press, 1987); this section is based on my fieldwork in Sacapulas in January 1994.

37. The Sacapulas *huipiles* are in the Guatemalan textile collection of the P. Hearst Museum of Anthropology,

University of California at Berkeley. They are part of the Whittaker-Tellefsen Guatemalan collection gathered in the 1960s and donated to the museum in 1989. Since the collection lacked good documentation, the museum received a grant from the National Endowment for the Humanities to document and catalogue this fine collection, which numbers 365 textiles. I was the project coordinator for this project.

38. Carmen L. Pettersen, *The Maya of Guatemala* (Guatemala City and Seattle: The Ixchel Museum, distributed by the University of Washington Press, 1976), pp. 55–66.

39. Olga Arriola de Geng worked with me on the documentation of the Whittaker-Tellefsen Guatemalan textile collection in August 1992. She identified the textile I describe and gave the origin of the treadle-loomed cloth as San Pedro Sacatepéquez, San Marcos. She also pointed out that the neck treatment was similar to the backstrap-loomed ones.

40. Josefa Lancerio Aceituno, personal communication, 1992.

CHAPTER 4
Ceremony and Ritual in the Maya World

1. Nancy M. Farriss, *Maya Society Under Colonial Rule: The Collective Enterprise of Survival* (Princeton: Princeton University Press, 1984), p. 6.

2. While it might well be argued that the "conquest" of the Maya remains an ongoing process, the post-conquest period is generally accepted to have commenced immediately following the initial Spanish military forays into the area in the early 1520s.

3. Dennis Tedlock, *Popol Vuh: The Definitive Edition of the Mayan Book of the Dawn of Life and the Glories of Gods and Kings* (New York: Simon and Schuster, 1985), pp. 72–73.

4. Robert S. Carlsen and Martin Prechtel, "The Flowering of the Dead: An Interpretation of Highland Maya Culture." MAN 26 (1991), p. 27.

5. Marvin Cohodas, "The Iconography of the Panels of the Sun, Cross and Foliated Cross at Palenque: Part III." *The Art, Iconography and Dynastic History of Palenque, Part III*, ed. Merle Greene Robertson (Pebble Beach: Robert Louis Stevenson School, 1976), p. 155.

6. J. Eric S. Thompson, *Maya History and Religion* (Norman: University of Oklahoma Press, 1970), pp. 208, 227; Linda Schele, "Accession Iconography of Chan-Bahlum in the Group of the Cross at Palenque." *The Art, Iconography and Dynastic History of Palenque, Part III*, ed. M. G. Robertson (Pebble Beach: Robert Louis Stevenson School, 1976), p. 24; David A. Freidel, "Children of First Father's Skull." Paper presented at the 68th Annual Meeting of the American Anthropological Association, November 19, 1987, Chicago. n.d., p. 14.

7. Linda Asturias de Barrios, personal communication, 1988.

8. See Martin Prechtel and Robert S. Carlsen, "Weaving and Cosmos Amongst the Tzutujil Maya." *Res* 15

(Spring 1988), pp. 122–32, for a comprehensive treatment of the weaving as birthing belief in Santiago Atitlán.

9. D. Tedlock, p. 251.

10. Nathaniel Tarn and Martin Prechtel, "Metaphors of Relative Elevation, Position and Ranking in Popol Vuh." *Estudios de Cultura Maya* 13 (1981), p. 115. Also see Kay B. Warren, *The Symbolism of Subordination: Indian Identity in a Guatemalan Town.* Second Edition (Austin: University of Texas Press, 1989), for a description of agricultural metaphor in Maya culture. In her study of religious symbolism in the Kaqchikel Maya community of San Andrés Semetebaj, she states that this metaphor "likens the planting and harvesting of the agricultural cycle to creation and destruction as well as to birth and death" (p. 34).

11. Carlsen and Prechtel, p. 28.

12. E. Michael Mendelson, *Religion and World-View in Santiago Atitlán* (Ph.D. dissertation, University of Chicago, 1956), p. 65. Also see Carlsen and Prechtel, pp. 23–42, for a thorough analysis of the direct linkage of ancient with contemporary Maya ritual, particularly as it entails a Maya association with the cycles of life and death with agricultural metaphor.

13. James Boster, in Barbara Tedlock, *Time and the Highland Maya* (Albuquerque: University of New Mexico Press, 1982), p. 137.

14. B. Tedlock, p. 71.

15. Ibid, pp. 140–42.

16. Felix W. McBryde, *Cultural and Historical Geography of Southwest* (Washington,

D.C.: Smithsonian Institution, Institute of Social Anthropology, Publication No. 4, 1947), p. 2.

17. Grant D. Jones, *Maya Resistance to Spanish Rule: Time and History on a Colonial Frontier* (Albuquerque: University of New Mexico Press, 1989), p. 276.

18. Murdo J. MacLeod, *Spanish Central America: A Socioeconomic History, 1520–1720* (Berkeley: University of California Press, 1973), p. 192.

19. While I cannot testify to how widespread such an interpretation is, one elder (*principal*) from Santiago Atitlán explained that the lower part of this appliqué represents the underworld (the world's "root"), the horizontal member of the cross the world's surface, and the upper part the heavens (*r'kux kah* or "heart of the sky"). In this, the *r'muxux* appliqué is nearly identical to the *kan* cross of the ancient Maya.

20. The term "spiritual conquest" was coined by the French historian Robert Ricard (1966).

21. Billie R. Dewalt, "Changes in the Cargo Systems of Mesoamerica." *Anthropological Quarterly* 48 (1975), pp. 87–105.

22. Evon Z. Vogt, *Zinacantán: A Maya Community in the Highlands of Chiapas* (Cambridge, Mass.: Harvard University Press, 1969), and Gary H. Gossen, *Chamulas in the World of the Sun: Time and Space in a Maya Oral Tradition* (Prospect Heights: Waveland Press. 1974).

23. Flavio Rojas Lima, *La Cofradía: Reducto Cultural Indígena* (Guatemala City:

Seminario de Integración Social Guatemalteca, 1988), p. 59.

24. George M. Foster, "Cofradía and Compadrazgo in Spain and Spanish America." *Southwestern Journal of Anthropology*, 9 (1953), pp. 1–28.

25. In Jesús María García Añoveros, *Población y estado socioreligioso de la diocesis de Guatemala en el último tercero del siglo XVIII* (Guatemala City: Editorial Universitaria, 1987), p. 72.

26. Ibid, p. 187.

27. Sandra L. Orellana, "La introducción del sistema de cofradía en la región del lago de Atitlán en los altos de Guatemala." *America Indígena* 35(4) (1975), p. 847.

28. Adriaan C. van Oss, *Catholic Colonialism: A Parish History of Guatemala 1524–1821* (Cambridge, Mass.: Cambridge University Press, 1986), p. 110.

29. Ibid, pp. 21–22.

30. MacLeod, p. 328.

31. Thomas Gage, *Thomas Gage's Travels in the New World*, ed. J. Eric S. Thompson (Norman: University of Oklahoma Press, 1985), p. 234.

32. Farriss, p. 313. Also see Flavio Rojas Lima, *La simbología del lenguaje en la cofradía indígena. Cuadernos del Seminario de Integración Social Guatemalteca,* no. 29 (Guatemala City: Seminario de Integración Social Guatemalteca, 1984), p. 18.

33. Fiesta system ritual often contrasts with shamanic ritual in this regard, the latter typically being concerned with individuals rather than communities.

34. This type of cotton is generally re-

ferred to in the literature as *ixcaco* (or *cuyuscate*). In the Tz'utujil Maya dialect, however, there is no "i" sound preceding the word.

35. See Guisela Mayén de Castellanos, *Tzute y Jerarquia en Sololá* (Guatemala City: Museo Ixchel del Traje Indígena, 1986), and Linda Asturias de Barrios, "Cambio e Hibridismo en el Traje Sololateco," *Tzute y Jerarquia en Sololá*, ed. Mayén de Castellanos (Guatemala City: Museo Ixchel del Traje Indígena, 1986), for an interesting treatment of change in civil-religious hierarchy and costume in Sololá, Guatemala.

Acknowledgments

This book started out as an innocent rendezvous with friends Izzy and Crystal Seidman in Guatemala. By the time I got there they had become acquainted with Henry and Barbara DuFlon. Henry, a world-renowned collector of textiles, knew my work from *Living Maya*, and when we met his appreciation of cloth and my photographic passion reached critical mass and the energy to create this book was formed. Two years into it, Henry chose to drop out, leaving me with his encouragement and a valued friendship.

Several people provided assistance along the way. Linda Asturias de Barrios was a guiding force in Guatemala to the Ixchel Museum, where, with the permission of Evelyn de Robles, Rosario de Polanco, and Rosemary de Barillas, I was honored to photograph selected pieces from the Ixchel Collection. Lucy Hempstead's generosity came through when needed. Linda connected me with people and organizations that contributed to this photographic bounty, among them Flor de Maria Aguilar and Beatriz Zuñiga of the Kim' Arrin Travel Agency; José Miguel Gaitán, director of INGUAT, and Sandra Monteroso, and Alfredo Gomez Davis. The head of the Department of Tourism in Belize, Kevin Gonzalez, similarly supported my work and provided me a guide, now friend, in the person of Alvaro Ramirez.

Many people responded to my need for information, shelter, friendship, guidance, and love. These ranged from friends who joined me on portions of the journey: Audrey Supple, Christiana Dittmann, Phil Cantor, A. J. Saunders, Charlie Forster, Izzy Seidman, and David Goldbeck — to those who extended a hand in a variety of forms — Gerald and Jane and the people of Sueños del Quetzal, Daniel Toporoski, Vinny Stanzione and Angelika Bauer, Conrad Winter, Jane Swazey, Krystyna Deuss, Oscar and Crista Pellecer, José Antonio Gonzalez, Olga Slowing, Elías August, Frank Lee Mays, Javier Fortin, Harvey Lloyd, Ricardo Mata, Jami Savas, Jeff and Wende DuFlon, and the Attorney General of Guatemala, Telesforo Guerra.

Special thanks to Beverly Fazio Herter, who edited this, my third Abrams book; Judith Hudson, who designed it; and Marti Malovany. All the writers were a pleasure to deal with, and Margot Blum Schevill excelled!

For encouragement over the years, thanks to Larry LaBonté and Katheryn Shaw, Bruce McInnes, Roger Rosen, Peter Ketchum, Tilman Rascher, Garry Gross, Joan Canfield, Brigitte Knauf, the Rickens, Jeff and Cheryl Weisberg, Cora Foxx Greenwald, and my sister Patricia. For the photography in Chiapas, special mention goes to Pedro Meza Meza, John Burstein, Lou Casagrande, Cristina Taccone, and Chip Morris.

Many thanks also to Bruce Levy & Associates who negotiated this contract; Nikon's Lindsay Silverman, AVCOM's Richard Calloway, and Ed Meyers for his lead to Kodak's Michael More; and to Armando J. Alfonzo of Plumsock Mesoamerican Studies, and to CIRMA.

My profound gratitude to the indigenous peoples of Mexico, Guatemala, and Belize who gave me the benefit of the doubt and allowed me to photograph them, and to those whose images appear in these pages. It is with great pride that my father's drawings and map enhance the beauty of this book — thank you, Philip.

Jeffrey Jay Foxx

I wish to thank Rebecca Rubio, Sergio Francisco Romero, and Brenda Tevalán for assisting me in the preparation of this essay. Idalma Mejía de Rodas provided pertinent suggestions. Jennifer H. Keller edited this essay and provided some translations and adaptations from Spanish-language texts cited.

Linda Asturias de Barrios

I would like to thank the Guatemalan Academy of Mayan Languages (ALMG) for its suggestions about bringing my Tz'utujil spellings into accordance with its recently standardized format. Additionally, the guidance and inspiration of Vinny Stanzione is gratefully acknowledged.

Robert M. Carlsen

This chapter is dedicated to Mary E. Hartman and our children, Chris, Jamie, and Nick, who shared three excellent years with us in Guatemala. My thanks go to the U. S. Fulbright Scholars program, which supported us while we lived there, and to Conservation International for their continuing work for the survival of the biological diversity and indigenous peoples of the Maya region.

James D. Nations

I am grateful to Linda Asturias de Barrios, Robert Carlsen, Barbara Knoke de Arathoon, and Rosario Miralbés de Polanco for the helpful comments they made on an earlier draft of this essay. In addition, I thank James Schevill and Frank Norick for their suggestions and continued support for my research on Maya textiles of Guatemala.

Margot Blum Schevill

This project was sponsored in part by: Eastman Kodak Company; Color Edge Photographic Lab/NYC; Kim' Arrin Travel Agency, Guatemala City; INGUAT (the Guatemalan Tourism Institute); and the Department of Tourism of Belize.